Getting Your Shot

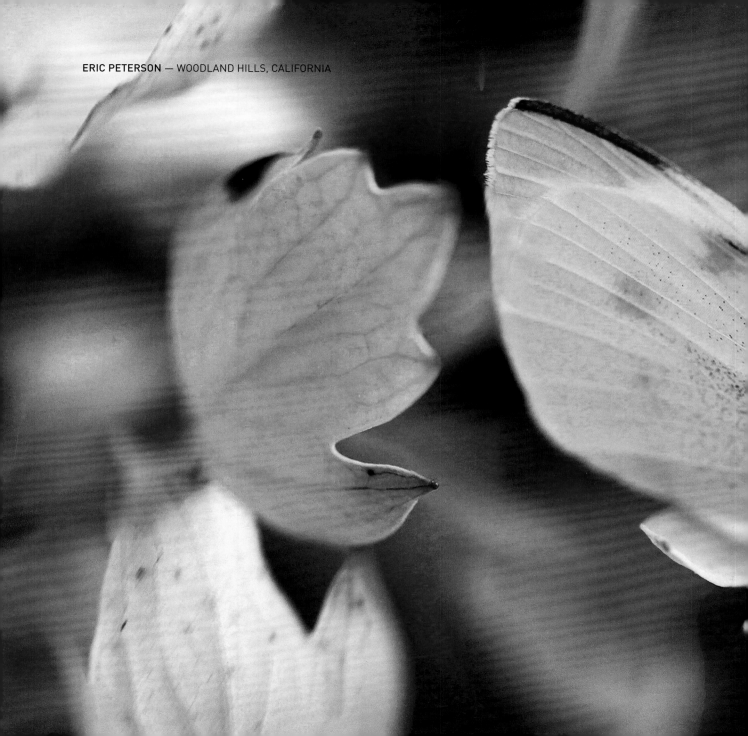

Getting Your Shot

STUNNING PHOTOS, HOW-TO TIPS,
AND ENDLESS INSPIRATION FROM THE PROS

NATIONAL GEOGRAPHIC

WASHINGTON, D.C.

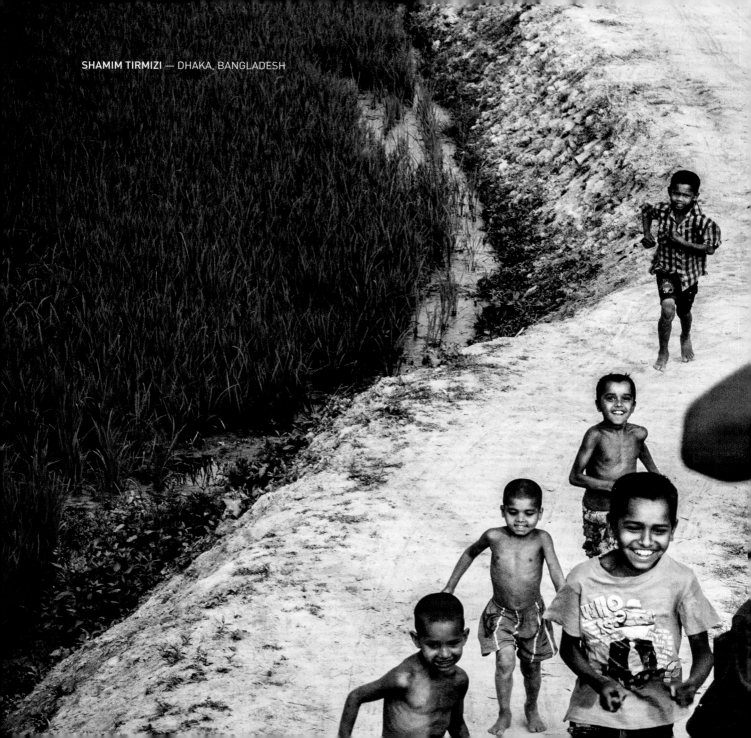

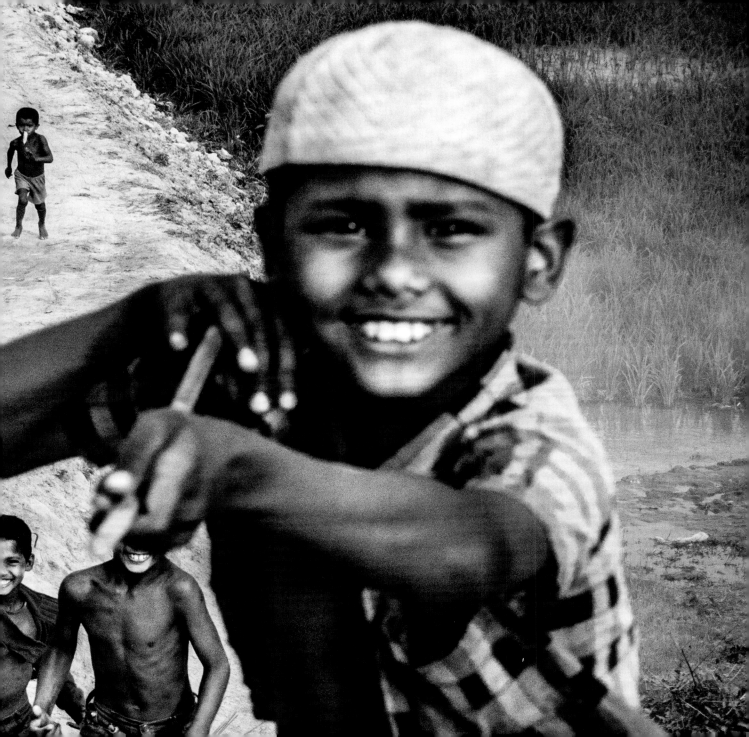

AGGELOS ZOUPAS — SKÁLA RACHONÍOU,
EAST MACEDONIA, AND THRACE, GREECE

Contents

Introduction

Many of us can trace our passions to a childhood experience, a second or a fleeting encounter woven into daily life, that seemed unremarkable at the time. A favorite teacher introduced you to a foreign idea, or a relative shared the story behind a treasured object, and curiosity was planted. This vividly recollected moment may have inspired you to become a traveler, a nature buff, a great cook . . . or a student of photography.

As a junior high school student, I discovered photo books in the school library. Heavy as doorstops, they leaned against the art books in a slim section that included *The Photographer's Eye* by John Szarkowski and *The Bitter Years,* monographs by Walker Evans and Dorothea Lange—the Farm Security Administration photographs. These FSA photographers were storytellers, documentarians of the Great Depression. I saw photographs of people who had been forced from their homes and people facing uncertain futures. I distinctly remember a feeling of awe that their personalities seemed to emerge from the page. I was a hatchling, imprinted for life by the power of the photographic image.

There is something magical about photography. For me, photography began as a place to hide—behind the camera, under the dark cloth, in the darkroom. But then it became a portal into the world. Through work as a newspaper photographer, on assignment for *LIFE* magazine and *Sports Illustrated,* and during the past 25 years shooting for *National Geographic*, I have logged countless miles to Zambia, Cambodia, Antarctica, and beyond. Today, the *National Geographic* magazines that carry my byline could fit in a knapsack—the same knapsack I am still filling with cameras to step back out through that door.

But the images on those magazine pages are just the highlights of voyages that stretched for years and, in the end, humbled me. I spent months in a remote village in China, where I mined photographs from everyday experience—like the image of a young Dong girl, wearing her favorite hair ribbons as she walked through the family rice field (right). What you don't see is me trudging miles to find the scene and then waiting days for the moment and the perfect light to come together. Mud up to our knees. You can't see the interpreter repeating every conversation three and four times so that we could understand every detail. You don't see the fact that this girl had just visited her coffin tree, planted at her birth to provide the wood she will be buried in.

It is difficult to teach someone how to choose the critical moment to save as a photograph. It has been

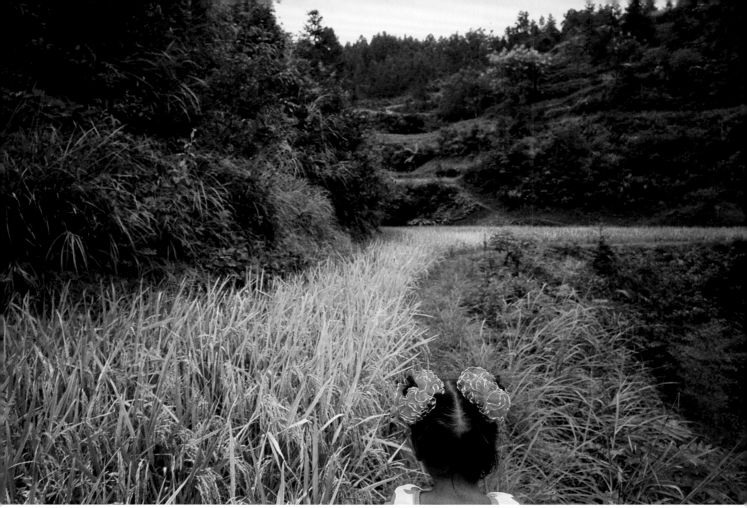

LYNN JOHNSON / A YOUNG GIRL WANDERS IN RICE FIELDS — DIMEN, GUIZHOU PROVINCE, CHINA

a challenge as well as a pleasure to share the magic of photography with students at the National Geographic Photo Camp in Botswana, in Kenya, and in the United States, and to mentor master's students at Syracuse University's S.I. Newhouse School of Public Communications. Each budding photographer is a visual storyteller who can open a door into a culture, an environment, or his or her own psyche. My role is to help them all sharpen their skills and aspire to excellence.

Being a judge for National Geographic's Your Shot felt like an extension of teaching. Your Shot is a global community in which the kind of learning and sharing I usually do with my students in person

takes place online. The field assignments and the gorgeous photos in this book represent some of the best content posted to this vibrant online community. *Getting Your Shot* pairs beautiful and powerful photos with new critiques and tips from National Geographic photography experts. I hope this combination will serve as both a learning tool and an inspiration to everyone who reads this book.

Your Shot began in 2006 as a way for aspiring photographers to get published on the pages of *National Geographic* magazine. After a dozen years in existence, Your Shot has almost a half million members from 196 countries.

Every month, a National Geographic photographer or editor posts an assignment that sends members out in the field to shoot photos based on a particular theme. Members then post their images on the Your Shot website and receive expert feedback and commentary from the National Geographic expert who is hosting the assignment.

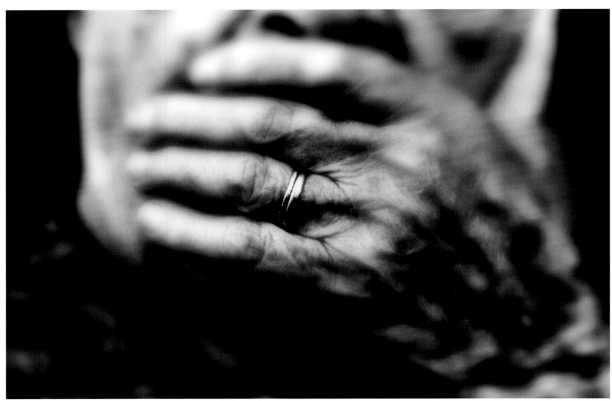

KONSTADINOS XENOS

I was asked to participate in the month of February, and the topic was love. Photo editor Elizabeth Krist, photographer Maggie Steber, and I were to judge the entries and choose our favorites.

It was two o'clock in the morning when I went to the pull-down menu on National Geographic Online and clicked Your Shot. My screen filled with images, studded with heart symbols and thumbnail portraits of Sai, Kristi, Hasan, Nikola. They were from India, South Carolina, Ukraine, Malaysia. A photo of a mountain in bland light. A shot of a favorite cat. This was love?

The pictures couldn't have been more different from my own. My assignments deal with subjects like life-threatening diseases, vanishing languages, and women challenged by rural poverty. This grid of cute puppies and sweethearts featured pastel colors, wandering framing, and a heavy dose of cuteness.

How, I asked myself, can I teach thousands of people with varied levels of expertise in photography about f-stops and lens choices? I decided to bypass technique and go straight to the heart: Together we dove into truth, frame design, emotional depth, and power. And I discovered that these photographers wanted not just to be seen, but also to be heard. As they shared their stories on the website, their intentions became clearer and the quality of their photographs improved. A standout photo appears at left.

This worldwide community can serve as an inspiration for photographers of all skill and experience levels. It doesn't really matter how expensive your camera is—DSLR or smartphone—or whether you call yourself a pro, a hobbyist, or a beginner. We are all driven and competitive. We are addicted to looking through that minuscule window to witness the wide world—addicted to the rush in the body, to the privilege of documenting a moment, to the sense of purpose that lifts us above the everyday.

As photographers, we can challenge biases with our deeply individual styles, diverse insights, and hard work. The most lasting exchange is not the recording of the image but the bond that develops from listening and sharing stories—right there in the living room, field, hut, truck. That is the story to honor. The image carries the power of the message within the beauty of form.

In those early-morning hours in my dark house, it was confirmed that what is important about photography is passion and love. The tiny strangers on my computer screen inspired my passion for growing, for changing, for thinking, for seeing, and for creating a community of seers who can show others how they see the world.

Never stop asking yourself:

Why do I photograph?

What am I trying to say?

All the rules presented in this book are valuable—composition, quality of light, the rule of thirds. Study them. Practice them. Then break them.

Through this book, we hope you will be inspired to make the world your own, on your terms, in your very own shots.

– LYNN JOHNSON, *National Geographic* Photographer

About This Book

Just as National Geographic photographers go on assignment to capture amazing images, *Getting Your Shot* sends you out on assignment—and provides the ideas and know-how to get you started. Beginning with the fundamentals of photography in "The Tool Kit," the book then moves into 17 themed photography assignments, each hosted by a National Geographic photography expert.

The stunning photos and exciting assignments in this book have been cherry-picked from Your Shot—National Geographic's vibrant online photo community, with almost a half million members around the world.

Your Shot is so visually breathtaking and inspiring that we decided to turn it into a book. We've added expanded commentary and hundreds of how-to tips from 22 National Geographic experts. Now it's time to take *your* shot!

THE TOOL KIT

The first section of the book introduces you to the basics of photography. It covers everything from what kind of camera and equipment you should use to basic information about composition, lighting, focus, and more.

THE ASSIGNMENTS

A National Geographic editor or photographer introduces each assignment, encouraging readers to shoot images based on a fun and challenging theme. Assignments are appropriate for photographers of all skill levels.

— Assignment Description

— About the Expert

• THE PHOTOGRAPHS

Our editors and photographers have selected Your Shot photos that successfully represent the theme of the assignment. These experts tell you what's great about the photos and why they were included. Some pages pair photos with how-to photography tips; others include the photographer's story behind the picture.

How-To Tips

Why This Photo Works

The Photographer's Story

• THE PHOTOGRAPHER'S NOTEBOOK

Want to know more about the photos in this book? Here you'll find information about each image—including all available technical information, such as the camera model, focal length, shutter speed, and aperture.

You will also find a helpful glossary of photography terms on pp. 278–279.

MIKE BLACK — CONOWINGO, MARYLAND

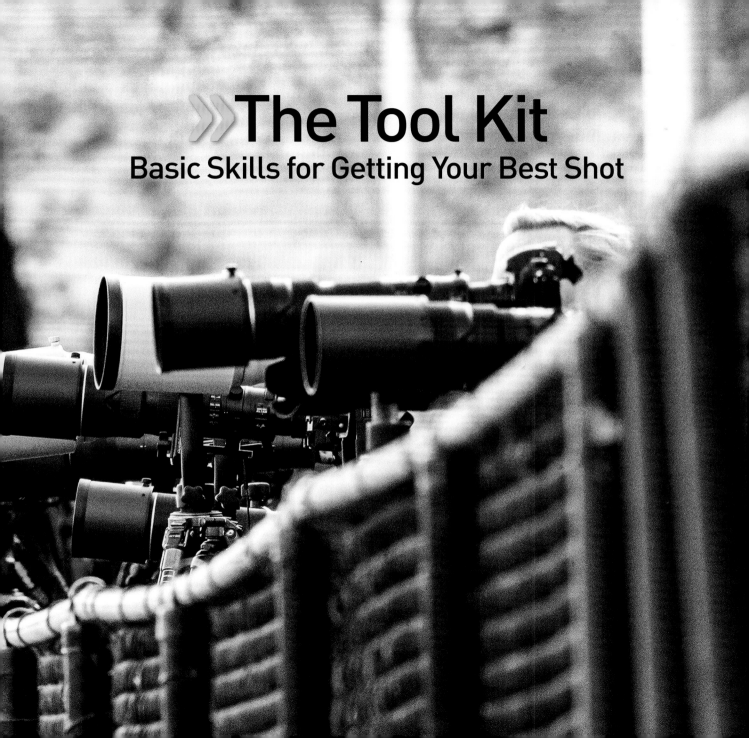

»The Tool Kit
Basic Skills for Getting Your Best Shot

GETTING STARTED

Whether you are using a camera to document rare birds, to capture your family's beach vacation, or to shoot the architecture of a beautiful building, photography is a powerful medium. It allows you to tell stories, to make memories, and to meet new communities.

To get the most out of your photos, you'll need a full set of tools, and that means more than lenses and memory cards. An understanding of the fundamentals of photography—from the basic structure of a camera to the strategies for telling a visual story—will provide you with a tool kit that you can draw upon every time you pick up your camera.

In this section you'll find information about different types of cameras and lenses, along with helpful tips on composition, technique, photo editing, and more. The goal is for you to become so familiar with your camera that you use it like you breathe. With practice, the camera becomes an extension of you rather than an obstacle.

So get out there and find subjects that capture your attention, no matter where they are—in your backyard, in the next town over, or on the other side of the world. Let your passion and unique point of view be your inspiration.

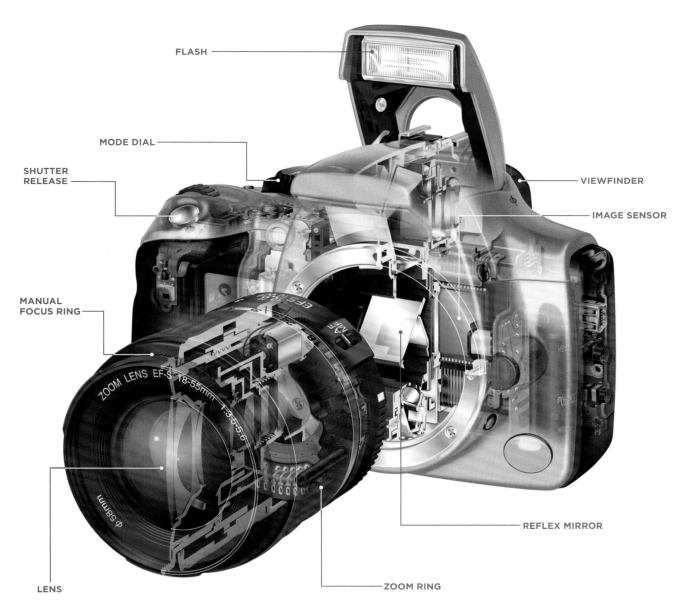

FLASH

MODE DIAL

SHUTTER
RELEASE

MANUAL
FOCUS RING

VIEWFINDER

IMAGE SENSOR

LENS

REFLEX MIRROR

ZOOM RING

Camera Basics

>> **With so many different cameras on the market, choosing the right one for you can be overwhelming. To narrow down your options, think about what kind of photographer you are or aspire to be. Do you want to take great pictures of your family and friends? Capture amazing wildlife scenes? Show off your latest vacation? This overview highlights the pros and cons of basic categories of digital cameras.**

Most point-and-shoot cameras have two downsides. One, they give you minimal manual control over your camera's settings. Two, they tend to have lower image quality than higher-end cameras, even though they may have a high megapixel count.

These days, the camera feature in many smartphones is comparable to a point-and-shoot camera in terms of image quality. Smartphone cameras have fewer customization options and very limited zoom capabilities, but they can be useful for taking pictures on the go.

POINT-AND-SHOOT

These small, lightweight cameras are inexpensive and perfect for everyday use. You can take quick snapshots or carry them around in a backpack or purse for everyday use. They are easy to use and inexpensive. Most point-and-shoot cameras have different modes that automatically set the camera to detect faces, fast-moving objects, close-up subjects, and more. Depending on what model of camera you use, modes range from traditional scenes (such as Portrait, Landscape, and Macro—for close-ups), to even more specialized modes (such as Party, Snow, Beach, Sports, and Kids), and more.

ADVANCED COMPACT

Also relatively lightweight and inexpensive, advanced-compact cameras offer more control and higher image quality than point-and-shoot cameras do. Automatic mode is still an option, but you have the flexibility to change more of your camera's settings, including flash, shutter speed, aperture, and ISO (which refers to how receptive your camera's sensor is to light).

Many of the specialty modes on point-and-shoots also are featured on advanced compacts, so you can preset your camera for shooting a basketball game or capturing a relaxing afternoon at the beach.

The built-in zoom capability of some compact cameras is comparable to that of a much heavier and more expensive telephoto lens for a DSLR camera. And the more powerful zoom means you don't have to tote around different lenses to capture a variety of images; for example, you could shift from shooting a wide forest landscape to taking a close-up of a ladybug without changing lenses.

DSLR

A digital single-lens reflex camera (DSLR) is the standard for professional photographers. Its image quality is much higher than that of compact cameras, and it allows as much or as little control over your photo as you like. The large sensors in DSLR cameras are better at capturing light than those of point-and-shoot or compact cameras, which means you'll end up with fewer grainy photos. They are also better at shooting in low light than other camera types.

It takes some time to get to know your DSLR camera. Try testing out different settings, such as exposure, shutter speed, and aperture, to see how they affect the final picture. While automatic mode can come in handy, learning how to control your camera manually will help you get your best shots. Once you get comfortable, you can shoot everything from professional-looking family portraits to extreme weather events.

The speed and quality of a DSLR help you capture details that other cameras would not be able to pick up. And with an endless array of lenses, flashes, and other accessories, you can put your camera to work in hundreds of different ways.

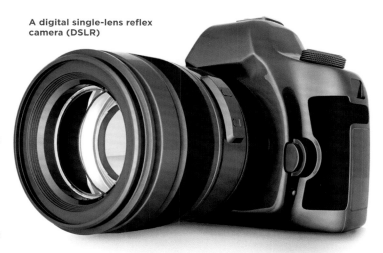

A digital single-lens reflex camera (DSLR)

CAMERA COMPARISONS: WHICH IS THE BEST CAMERA FOR YOU?				
TYPE	PRICE	RESOLUTION	SIZE	WEIGHT
Point-and-Shoot	$80–$300	10-16 megapixels	width: 3–5 inches; height: 2–3 inches	4–10 ounces
Advanced Compact	$150–$1,000	10-18 megapixels	width: 3–5 inches; height: 2–4 inches	0.5–2 pounds
DSLR	$350–$6,500	12-24 megapixels	width: 5–6 inches; height: 4–6 inches	1–3 pounds + additional weight of lens(es)

Choose the Correct Lens

Whether you want to shoot a tennis match or take a close-up of a butterfly, you will need the right lens for the job. The primary differentiators among lenses are focal length (the distance at which the lens begins to focus) and field of view (the area that is visible in the frame). This cheat sheet introduces you to the different kinds of lenses so that you can pick the one that best suits your needs.

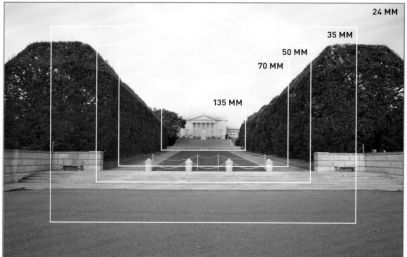

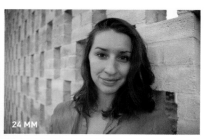

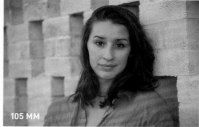

PATRICK BAGLEY — WASHINGTON, D.C.

FIXED

A fixed lens, also known as a prime lens, has a fixed focal length—35mm and 50mm are typical. Because they have no zoom capability, these lenses are straightforward to use, and they offer high image quality for a lower cost. A 35mm focal length is considered normal because it mimics what the human eye sees. Fixed lenses are useful for shooting portraits because they have wider maximum aperture and tend to produce higher-quality images than zoom lenses do.

ZOOM

A zoom lens can be adjusted to a range of focal lengths. Most DSLRs come bundled with a "kit zoom" that shoots at a range somewhere between 18mm and 200mm. Zoom lenses are bigger and heavier than fixed lenses are, and they tend to be

more expensive. They are convenient for travel, however, because one zoom lens can take the place of a bagful of different lenses.

● TELEPHOTO

One of the largest, heaviest, and most expensive options, a telephoto lens is a powerful magnifier. You can capture distant subjects as if they were in front of you. Ideal for shooting sporting events or wildlife, this lens makes it look like you were right in the middle of the action. With the help of a tripod, a long exposure time, and clear skies, a telephoto lens can even capture shots of the moon, the Milky Way, and other celestial objects.

● MACRO

This lens allows you to achieve clear focus when you are very close to your subject. It magnifies the smallest subjects, such as insects, blades of grass, and intricate patterns and textures. You can get macro effects with other lenses, but a dedicated macro lens allows for the sharpest images of tiny subjects. Macro lenses come in a range of magnification levels, from 1x (life-size) to 5x, that allow you to shoot everything from a butterfly to the colorful scales on its wings.

● WIDE-ANGLE

To capture an angle wider than the eye can see, such as the angle required for a landscape or several sides of a room, you will need a wide-angle lens. These lenses come in many sizes, but their distinguishing factor is a wider field of view than a normal lens. Some

image distortion will occur—lines that appear straight to your eye will look curved through the lens—but this can create an interesting, artistic perspective. Wide-angle lenses range in price from $200 to $2,000.

Fish-eye lenses are wide-angle lenses taken to the extreme. They capture the widest angle of view, causing a more dramatic curve, as if you are looking through a peephole.

● LENS ACCESSORIES

Special accessories like filters and lens hoods can enhance or alter the light entering your camera's lens. Filters cover the lens and come in many different varieties. Polarizing filters eliminate glare and reflection from reflective surfaces like windows and water, while gel filters add a layer of color over your scene.

A lens hood, fitted over the front end of your lens, blocks light and helps eliminate glare and lens flare—it's useful for bright conditions like midday sun on a light background.

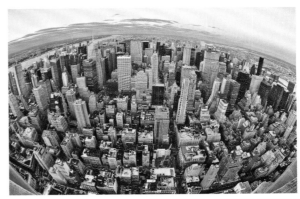

MOSHE DEMRI — NEW YORK, NEW YORK

Time to Gear Up

>> Let's face it, everyone loves gear! But beyond its irresistible luster, the right gear can also help you achieve your photography goals. Gear can help steady your camera, light your scenes, keep your camera dry, and open up new photo opportunities. Your interests and budget will, of course, determine which gear is worth your investment.

• STABILIZERS

Sometimes a camera in hand just isn't enough to get the perfect shot. If you're working with a long exposure, even the slightest movement can make your photo blurry. When you need a little extra support and there's no flat surface nearby, these stabilization tools will help keep your camera steady:

TRIPODS are three-legged stands that attach to the bottom of your camera. They steady the camera to capture extra-sharp images or hold the camera still for long-exposure shots.

MINI TRIPODS are smaller for when you need to pack light. You can stand them up on a table, and some even have flexible legs that you can secure around uneven

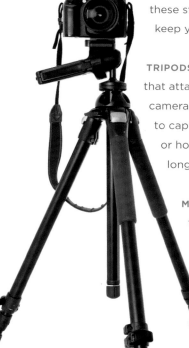

surfaces, such as branches or large rocks.

A **MONOPOD** is a pole that attaches to your camera for extra support but does not provide the total control of a tripod. A monopod can steady a long, heavy lens for sports photography or hold your camera still for a macro shot. You can even attach a "selfie stick" to your camera or smartphone when you want to take self-portraits.

• REMOTE SHUTTER RELEASE

This device syncs with your camera so you can trigger the shutter from a distance. This device allows you to take self-portraits without holding the camera at arm's length. For a long-exposure shot, a remote-release device gets rid of the slight movement of the camera's body caused by pushing the shutter button.

Cable-release triggers let you shoot from as far away as your cord can take you, while radio-remote

triggers are wireless and can work from up to 330 feet away.

UNDERWATER HOUSING

Specialized waterproof housing kits make it possible to take your camera underwater to shoot a scuba trip or to get a unique perspective on swim practice. Underwater housing comes in many varieties, from rugged polycarbonate cases designed for specific camera models to flexible covers that also work in snow, mud, rain, and sand. These housings are waterproof from 30 to 200 feet underwater. The deeper you want to go, the more expensive the gear will be.

Waterproof point-and-shoot and advanced-compact cameras can eliminate the need for underwater housing. They can withstand depths up to 49 feet. Some waterproof advanced compacts even have interchangeable lenses.

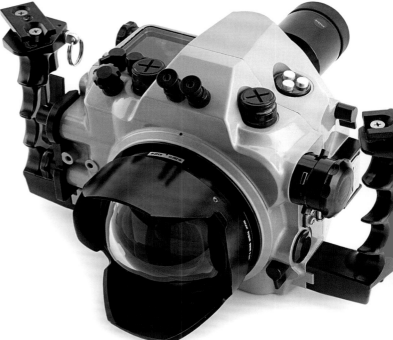

EXTERNAL LIGHTING

External flashes and additional lighting create a more customizable light source than a built-in flash. These lights can be synced with your camera to go off when the shutter is released, and they are often placed in bowl-shaped reflectors to evenly distribute

the light toward a focal point. Special waterproof strobes are sealed tight so that they can illuminate murky underwater shots.

MEMORY CARDS

Most digital cameras store images with either a secure digital (SD) or compact flash (CF) memory card. Figure out which type of card you need, and stock up on cards with high storage capacity. SD cards are smaller and less expensive, but they take longer to save photo data. The larger CF cards can save your images more quickly and often at higher quality, but they are more expensive.

Compose Your Shot

>> A strong composition brings together multiple elements to tell a compelling visual story. Making that magic happen involves skill, instinct, and luck. And you have to be willing to take *a lot* of not-so-great shots first. The following basic rules of composition are the foundation of good photography, but sometimes the best shots break all the rules. So above all else, trust your gut.

• FRAMING THE STORY

Just as you frame art for your walls, you can frame a subject within a photo by shooting through an opening such as a doorway, a window, or a cave entrance. Framing can add depth to a photo and draw attention to one particular element. The frame you choose for your subject provides context to the scene and adds a layer to the story that it tells.

To keep the attention on your subject and off the frame itself, it's best to set the frame off from your subject in some way—for instance, keep the frame

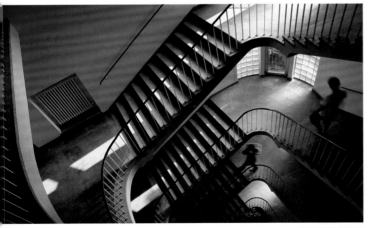

VERONIKA KOLEV

out of focus, or avoid showing the full expanse of the framing object. For example, the stairwell in this photo (below) creates a barrier on the left side, guiding the viewer's eye into the frame.

The edges of the photo are also important framing tools. Decide where you want your image to begin and end. Identify what you want to include, and keep extraneous elements out of frame or out of focus to guide the viewer's eye.

• LEADING WITH LINES

Leading lines are linear elements that draw the viewer's eye to a certain point and add a sense of depth and direction to your photo. While the camera sees in only two dimensions, a leading line can create the illusion of a third dimension—imagine a fence or a road getting smaller in the distance. In addition to adding visual interest, these lines have the power to draw your viewer into the world of the photograph.

Diagonal lines that cut across the frame add drama to a photo. Vertical lines—such as tree trunks in a redwood forest—can convey height and grandeur, and horizontal lines—common in landscape photography—often create a sense of comfort and calm. Once

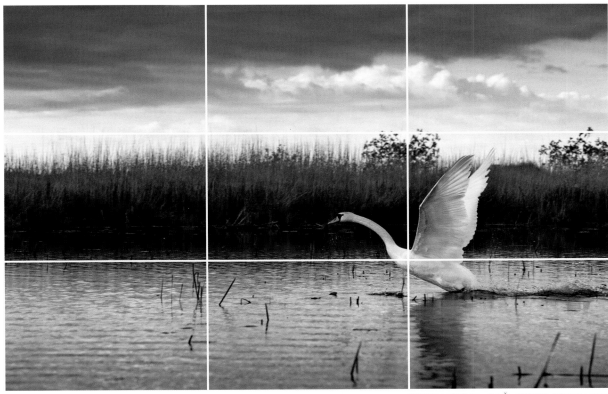

GASTON LACOMBE — PELČI, RUCAVAS NOVADS, LATVIA

you start looking for lines, you'll see them everywhere: birds flying in formation, a twisting mountain path, or the distant horizon.

THE RULE OF THIRDS

All good photos start with a focal point: the place that the viewer's eye travels to first. While the center of the frame seems like the natural focal point, it isn't always the most interesting position for your subject. Many photographers follow a simple guideline called the rule of thirds. Imagine that your photo is split into thirds, both vertically and horizontally. These grid lines divide your photo into nine parts. Placing your subject at the intersection of two grid lines helps guide the viewer's eye away from the center of the photograph. Many digital cameras have an option to place this grid on your viewfinder.

Balancing the main focal point with elements along the other grid lines often creates an image that tells a rich story. In this photo of a swan (above), the bird prepares to take flight against a backdrop of rain clouds. Even in a still image, you can imagine the bird continuing up and out of the frame, away from the coming storm.

Get Focused

>> Picture yourself standing in the field on the opposite page, looking at a beautiful old barn in the distance. Whether you want to zoom in on a single detail of the barn's architecture or take in the whole scene, you'll need to make decisions about your photo's aperture, depth of field, focus, and how these elements work together to craft a complete photograph.

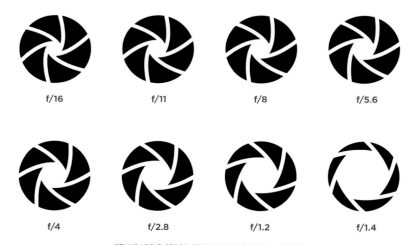

f/16 f/11 f/8 f/5.6

f/4 f/2.8 f/1.2 f/1.4

STANDARD F-STOPS, FROM SMALLEST TO LARGEST

• APERTURE

The aperture is the size of the opening in the camera lens. Like the iris of your eye, the wider the opening, the more light can reach the camera's sensor. Aperture is denoted in f-stops (see diagram above). F-stop numbers reflect the ratio of focal length to the size of the lens opening. It may seem counterintuitive, but the largest number refers to the smallest aperture, and the smallest number refers to the largest aperture.

Light conditions often govern which f-stop is optimal. In situations where the human eye might see just fine—for example, sitting around a campfire—a camera can have difficulty picking up on available light. A wide aperture, or opening—such as f/1.4—will let your camera collect as much light as possible in order to capture the scene.

When you have plenty of available light, a small aperture (such as f/16) works well for capturing

precise details, while a wide aperture allows you to capture the whole scene in sharp focus.

DEPTH OF FIELD

The depth of field (DOF) is a creative tool that allows you to emphasize important elements of the frame. DOF refers to the part of an image that appears in focus, as opposed to the part that is blurred. In images with shallow DOF, such as portraits and macro photographs, a small area of the photo is in sharp focus, while the rest fades into a blur. This blur, which is the camera's rendering of out-of-focus points of light, is called *bokeh*. A deep DOF allows the entire frame to be in sharp focus; it comes in handy for wide landscapes or busy scenes.

DOF is determined by the size of the aperture, the focal length of the lens, and the distance between you and your subject. As a general rule, a larger aperture or longer focal length creates a shallow DOF, while a smaller aperture or shorter focal length creates a deep DOF.

FOCAL POINT

The place that the viewer's eye travels to first is called the focal point. By controlling your photo's depth of field, you dictate which elements are in focus and where your focal point is. Think about how the focal point can contribute to the story you want to tell.

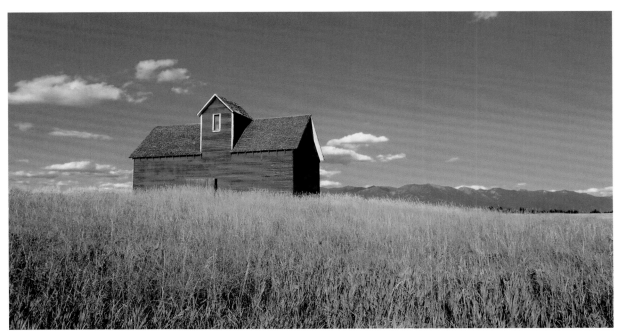

GLENN BARCLAY — PARKDALE, MONTANA

What's Your Point of View?

>> There are plenty of standard ways to shoot standard scenes, but identifying and curating your own point of view will make for more interesting and personal photos. A change from the norm can create a fun, unexpected take on a scene. Don't be afraid to look silly—stand on a chair, lie on the ground, stand in the waves, and take some risks to create a perspective that's all your own.

SHOOTING AT EYE LEVEL

Shooting at your eye level and using the "normal" focal length, 35mm, allow you to show exactly how the world looks to you at a given moment in time. Try focusing on whatever elements catch your eye in a particular scene.

You can also show the world from someone else's eye level, thus creating a point of view that's totally different from your own. When shooting children or animals, try getting down at the subjects' level to capture a scene through their eyes. You may find inspiration by lying or kneeling on the ground and noticing what details you see for the first time.

Creating a unique and interesting viewpoint from your eye level (or someone else's) means thinking critically about how you will show the subject. Can you capture movement by using a slower shutter speed? What elements other than your subject are present? Can they act as frames or layers that create a more dynamic photograph?

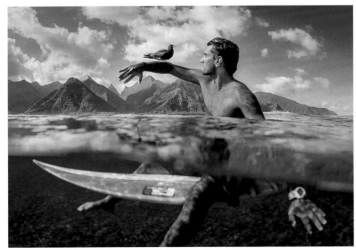

LEONARDO NEVES — TEAHUPOO, TAHITI

THE VIEW FROM BELOW

Looking up enhances the sense of scale in an image. Try capturing a skyscraper's dizzying height from the sidewalk below. Experiment by pointing your camera straight up while you lie on the ground. Capture the path of a plane as it flies overhead, or see how light from a chandelier transforms the ceiling above it.

For context, try including other recognizable objects in the frame. You can convey just how massive a glacier is if you show how it dwarfs a hiker climbing to the top.

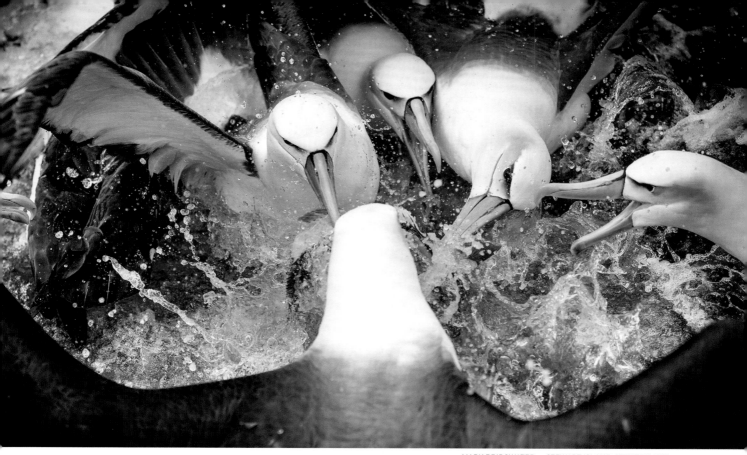

If you have a wide-angle lens, try looking from the ground up in a wooded area: Treetops will point up and away and form a curved frame for the sky above.

Getting low can also mean taking a dip. A partially submerged camera shows the line between land and sea, which can be an interesting angle in pictures of marine animals in their natural habitat or surfers paddling out to catch a wave (opposite page).

● SHOOTING FROM ON HIGH

You don't have to go skydiving or mountain climbing to get an interesting shot while looking down—though these activities do help. Whether you are peering out an airplane window at an ant-size city or standing on a chair to snap a photo of your dinner table, the view from above has the power to transform a scene. This overhead view of birds squabbling over a fresh catch (above) turns an everyday scene into an artistic, abstract image. Looking straight down can also transform your subject, so it looks almost two dimensional, like a drawing on paper. A unique angle can show what others might be unable to see.

See Beauty in Details

>> Envision the blue-green waters of the Caribbean against the white grains of sand on a beach; a yellow umbrella on a rainy, gray day; or the brilliant gold and red leaves of autumn. The colors, textures, and patterns in scenes like these make for beautiful photographs. Here are some tips for how to emphasize the most striking details in your scene.

● COLOR PALETTES

Color guides our emotional response to a photo. For example, blues and purples are cool and calm, while yellow is often associated with happiness. Different shades of the same color can change the emotion it conveys: Bright red conveys energy, love, and excitement, while dark reds are more often connected with anger or war. A lush green scene is peaceful and often reminds people of nature, while yellow-green is sometimes associated with illness.

Black and white can add a vintage feeling, or it can make the focus on your subject stronger by removing the element of color. Shadows and shapes are emphasized more in black and white, so pay attention to how they affect the composition of your photo when shooting.

The range of prominent colors in your photo is known as the color palette. How they all fit together helps guide the story your photo tells. A photo that captures a row of brightly colored houses (below, left) conveys an entirely different feeling from the muted white and tan of salt fields (below, right). By paying attention to the palettes that define your images, you will build your personal style as a photographer.

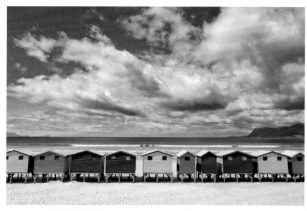

PJ VAN SCHALKWYK — MUIZENBERG, WESTERN CAPE, SOUTH AFRICA

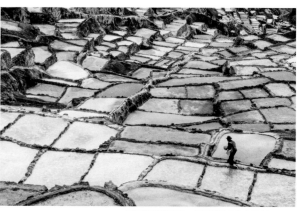

CEDRIC FAVERO — PICHINGOTO, CUSCO, PERU

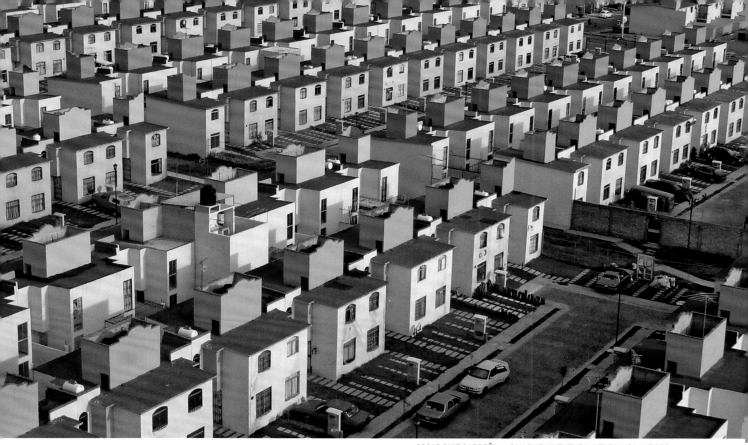

• PATTERNS

The human brain is wired to seek out symmetry and patterns. We notice whorls and ridges of a fingerprint; stark lines of tree trunks in winter; or rows of identical, brightly colored suburban houses (above). When you turn everyday experiences into abstract patterns, you use the photographer's power to make a unique statement.

Pattern-breaking elements are also common in good photos. Any contrasting object (in size, color, shape, or texture) draws the focus to itself. By interrupting your viewer's expectations, you can tell a richer story. An old house sandwiched between two skyscrapers or a puppy in a row of stuffed animals would add surprise and whimsy.

• TEXTURE

Capturing the texture of your subject or the backdrop against which it has been placed can create a tactile sensation in your photograph. When you show the roughness of a brick wall or the tickle of grass beneath your subject's feet, you transport the viewer into the world of the photograph.

Find the Right Exposure

>> Exposure results from a combination of settings that ultimately determine how much light reaches your camera's sensor for a particular photograph. Getting the right exposure depends on being aware of the light available, your desired effect, and a lot of repeat shots. Whether you're shooting the stars at night or a soccer game at noon, knowing how to expose a scene will lead to better photos.

• ISO

In digital photography, ISO refers to your camera's sensitivity to light, or how receptive its sensor is to the light source. To set the right ISO, assess the available light in your scene. There is a wide range of ISO settings, but here are some common options:

LOW/SLOW ISO (100) works best for sunny outdoor scenes.

MID-LEVEL ISO (400, 800) is ideal for shooting on cloudy days or taking indoor shots.

HIGH/FAST ISO (1600) maximizes light in a dim setting, whether you are snapping a photo of your favorite singer at a concert or watching the birthday girl blow out the candles on her cake.

Many digital cameras can automatically detect the light level and adjust the ISO for you, but manual adjustment allows you to get exactly the effect you are looking for.

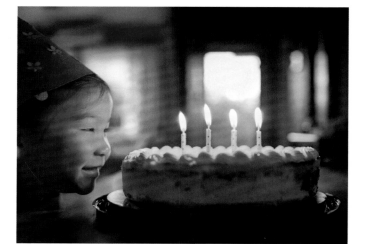

DAVID TAO / A HIGH ISO HELPS CAPTURE THE GLOW OF BIRTHDAY CANDLES — QUEANBEYAN, NEW SOUTH WALES, AUSTRALIA

• SHUTTER SPEED

Shutter speed determines how long your camera's shutter stays open during a shot, thus controlling the amount of light that reaches the sensor. The best shutter speed for a picture depends on what you are trying to capture. When shooting still objects, your shutter speed should be determined by the available light. In a dim scene, you will want a slow shutter speed to capture as much light as possible—and a tripod or steady surface to keep your camera stable while the shutter is open. Night photography requires a much longer opening period for your camera to

sense the light coming from the moon and the stars (see next page).

For action scenes, such as a speeding motorcycle or a sports game, a fast shutter speed paired with a good flash can freeze the action in place. Shooting movement with a slower shutter speed creates a blurring effect. When done correctly, it can enhance movement and showcase the speed of your subject. It is also particularly effective when shooting a waterfall or a rushing river.

Speed is denoted in seconds or fractions of a second:

- **Slow shutter speeds: 1/4, 1/8, 1/15, 1/30, or multiple seconds**
- **Average shutter speeds: 1/60, 1/125, 1/250**
- **Fast shutter speeds: 1/1000, 1/2000, 1/5000**

● LONG EXPOSURE

Long-exposure photography refers to using a *very* slow shutter speed—multiple seconds, or even minutes or hours—to capture faraway light or the movement of a light source over time. When shooting the night sky, your camera often requires up to an hour to take in all the light from a source that your eye can see immediately.

Other effects, such as capturing the flow of traffic or "painting" with light (when someone moves a light source, often a flashlight, to draw or write something) require that your shutter stays open for as long as the light source is moving. For these shots it's important to be prepared with a tripod or other steady surface to prevent your camera from moving while the shutter is open. Take along lots of patience as well.

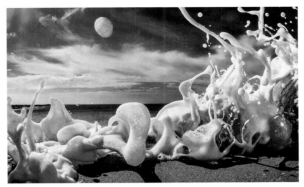

LARRY BEARD / FAST SHUTTER SPEED CAPTURES A CRASHING WAVE — NEWPORT BEACH, CALIFORNIA

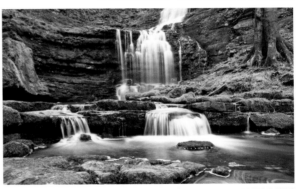

SOPHIE PORRITT / SLOW SHUTTER SPEED SHOWS FALLING WATER — AIRTON, ENGLAND, U.K.

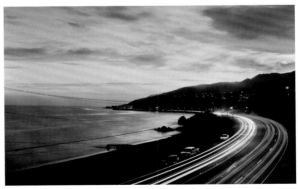

JR. MARQUINA / LONG EXPOSURE CAPTURES TRAFFIC MOVING — MALIBU, CALIFORNIA

Play With the Light

>> Light is what makes photography possible. Different qualities and colors of light can add depth and complexity to your photos. Try experimenting with light in a range of settings and at different times of day. You'll be amazed at the beautiful images you can take of a campfire, a cloudy day, or sunlight streaming through a kitchen window.

• THE QUALITY OF LIGHT

Hard lighting comes from a single light source: a lightbulb, a camera flash, or the sun. This bright, direct light has an easily identifiable direction and casts the scene into harsh contrast (below, left). Shadows are clearly defined. Shooting against hard light, like the midday sun, can produce strong silhouettes, but beware of lens flare—light that bounces around your lens before reaching the sensor, thus causing streaks of light in your photo.

Soft light, on the other hand, lacks direction and instead fills the scene with a dull glow. It produces a more subtle color palette. Soft light often results from cloud, fog, smoke, or some other diffusing agent (below, right). It creates a tranquil, sometimes mysterious effect. Take advantage of the reduced contrast

EMILIANO CAPOZOLI / A BEAM OF SUNLIGHT DRAWS THE VIEWER'S EYE TO THE BOY. — SÃO GABRIEL DA CACHOEIRA, AMAZONAS, BRAZIL

B. YEN / A CLOUDY DAY AT THE BEACH CREATES SOFT LIGHT — BACOLOD CITY, WESTERN VISAYAS, PHILIPPINES

to create a romantic, almost painterly effect in your photo. Soft lighting can create beautiful landscapes, but it's important to take your shot at several different levels of exposure to make sure you're capturing the details and the feeling that you want.

• NATURAL LIGHT

The color and temperature of light change throughout the day. At midday, natural light is relatively colorless. At dawn and dusk, it creates a golden hue that many photographers call the "magic hour" or the "golden hour." You may see the sky change from red to pink to orange, but the camera can't always read these subtle changes in color the way the human eye can. Your camera's digital sensor adjusts based on the temperature of the light that reaches it. The cool colors (purples, blues, and greens) have some of the highest temperatures, and the warm colors (reds, oranges, and yellows) have some of the lowest.

If the camera is set to auto color, it may neutralize the most beautiful and interesting colors in your scene. Knowing when to turn off automatic color settings is an important creative skill. Also try starting with a fast shutter speed, and then slow it down to see how your image changes.

THOMAS NORD / THE GLOW OF A LIGHTBULB IS BALANCED SO IT FEELS WARM AND INVITING. — BIRMINGHAM, ALABAMA

• ARTIFICIAL LIGHT

The camera and the human eye read artificial light sources differently. This is another scenario in which your brain can "autocorrect" what your camera can't. Different light sources bring different tones to a photograph. Standard household lightbulbs emit low-temperature light that can give your photographs an orange-yellow tone. Fluorescent and halogen lights are hotter, but they still cast an off-color tone (toward the blue end of the spectrum) compared to sunlight. To counteract any undesirable tones in artificial lighting, try adding a colored filter or adjusting the exposure and the white balance.

Postproduction Pointers

>> For many photographers, a photo is only half done after the shutter closes. Photo-editing software has become an indispensable tool of the trade, making it possible to edit and refine digital photos. Here we introduce some of the most common file formats and editing tools, but the best way to learn is to experiment. Just be sure to save your original image before you start editing it.

• FILE FORMATS

The file format you use dictates how many photos you can fit on a memory card. A compressed file format, such as a JPEG, takes the best reading of your photo and saves it, leaving room for many more pictures. A raw file format saves unprocessed photos but takes two to three times more memory space than compressed files do.

Raw files can be worth the extra space because they retain information about your photo, including shutter speed, aperture settings, ISO, color temperature, file size, and more. In addition, working with the raw file allows you to make precise adjustments to the photo's colors, highlights, shadows, and other features.

Other file formats, such as PNG and TIFF, are best for specific purposes. TIFF is best for maintaining quality in printed photos, while PNG works well for posting photos to the Internet.

• PHOTO EDITING

Photoshop, iPhoto, and other photo-editing programs give you many tools to improve your digital images. The following common tools are just a few of the options at your fingertips:

CROP lets you adjust the frame to improve the composition.

ROTATION allows you to rotate your photo in small increments or to flip a photo upside down or sideways.

RED-EYE REMOVAL takes the red-eye out of your portraits. (Red-eye can happen when you use a flash in low-light settings.)

• BALANCING COLOR

Many editing programs have auto-enhance options, which apply a standard set of color filters to photos. You can also adjust the color manually using the tools below (and others). The terminology for these tools can vary depending on which program you use, but all photo-editing programs come with similar functions.

EXPOSURE allows you to adjust the overall brightness of an image. Adjustments correspond to f-stop values: A +1 exposure in editing is equivalent to widening your aperture by a single stop, making the photo slightly brighter.

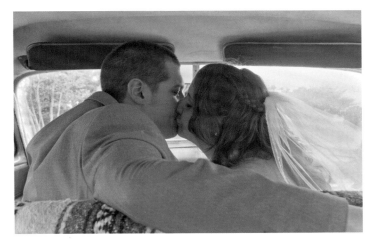
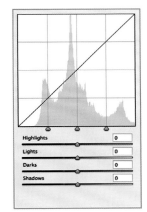

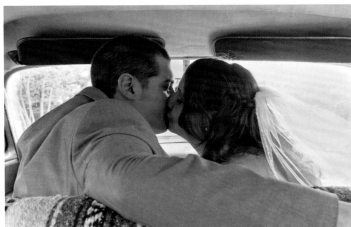
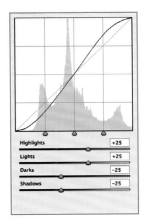

PATRICK BAGLEY — BALTIMORE, MARYLAND

LEVELS lets you alter shadows, mid-tones, and highlights in relation to each other. A slider tool allows you to change the intensity of different tones, based on how prominent they are in the image.

CURVES offers the most precision by letting you adjust bright and dark tones independently of each other in an image.

GRAY SCALE converts color images to black and white. Playing with the saturation and contrast after a photo is in gray scale helps find the right balance.

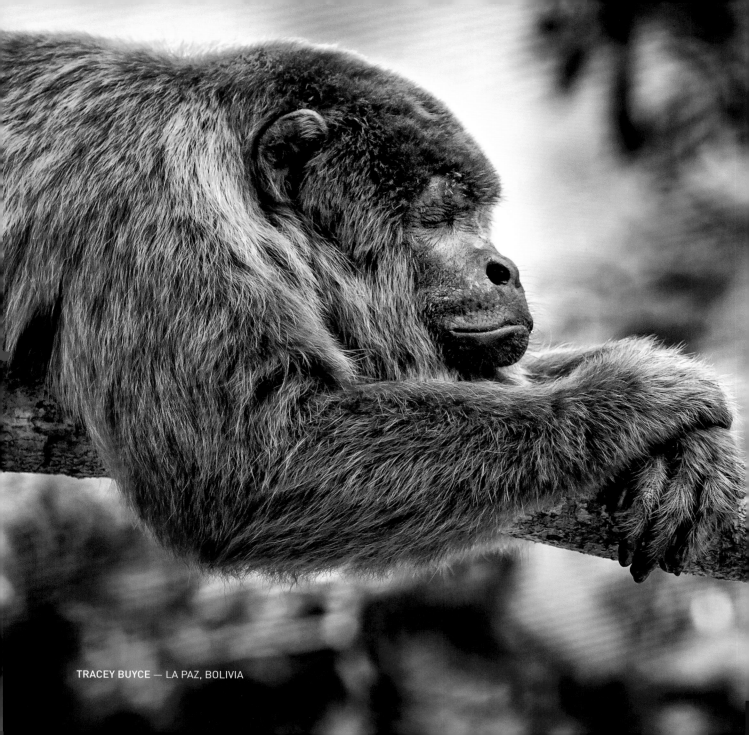

»The Assignments

Get out in the field with help from the pros

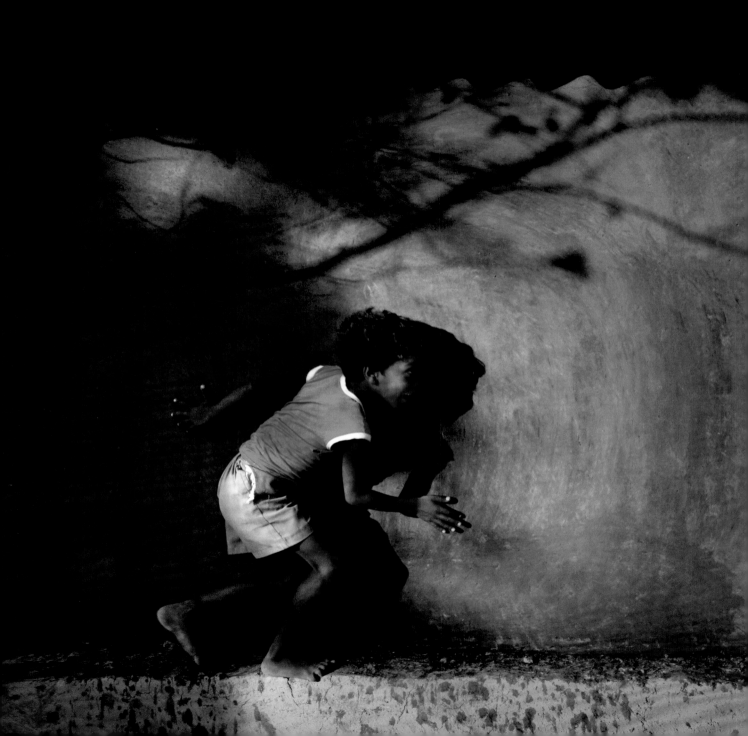

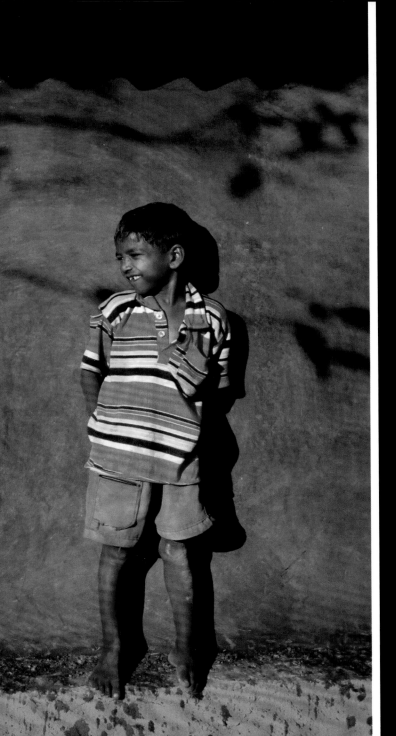

CATCH
THE LIGHT

BY ALEXA KEEFE

ILLUMINATING IDEAS

Fleeting or steady, capricious or intentional, light is the fundamental element of photography. It transforms a scene from mundane to magical. Illuminated edges reveal shapes and textures. Shadows and reflections create impressions that may exist only for a moment. The ordinary becomes extraordinary, infused with mystery and mood.

I invite you to speak the language of light. Spend time in one place and take note of how the changing light affects the mood and tone of what you're seeing. Observe the way light might fall on someone's face, cast a shadow across a surface, or play with color in a scene. Experiment with light sources in interior spaces, or get creative with light painting.

To catch the light, photographers must be watchful, still enough to notice our surroundings yet ready to press the shutter when something unexpected comes into view. We can even use our cameras to catch light beyond what our eyes see, like the frenzy of hovering fireflies frozen in flight or the light of distant stars.

As you look at the frames you have made for this assignment, ask these questions: Is the light you have captured what makes your photograph sing? Is light the element that binds moment, composition, and technique? Does it make you want to say, "Nice light"?

To be a photographer is to be a master of light—to be fluent in the interplay of composition, shape, and color exactly as it exists in any given moment. The story told by a particular scene transforms depending on time of day, weather, angle of light, or position of your subject. A quiet forest floor may hum with life in the twilight, or a brief ray of light may illuminate grains of sand blown by the wind. You are there, watchful and ready, to catch the light.

ABOUT THE ASSIGNMENT EDITOR

Alexa Keefe, NATIONAL GEOGRAPHIC DIGITAL

As photography editor and producer for nationalgeographic.com and editor of National Geographic's "Photo of the Day," Keefe uses her artful eye to bring the beauty of National Geographic photography to the digital medium. Check out some of her favorites here: *photography.nationalgeographic.com/photography/photo-of-the-day*

HIMAL REECE — BRIDGETOWN, SAINT MICHAEL, BARBADOS

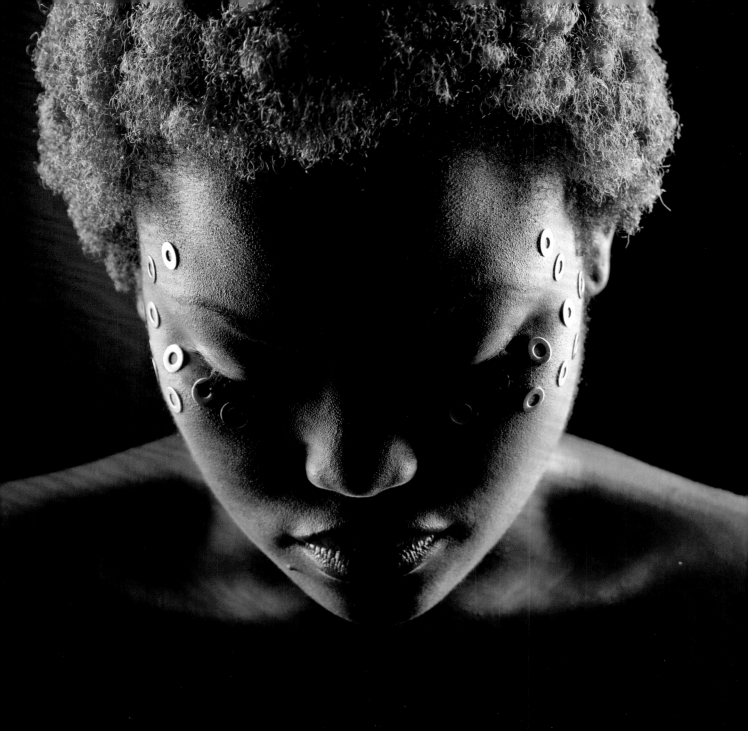

»SAND DUNE

Light is the star of this photograph. It animates the blowing sand and gives dimension to the dunes. With no horizon line or other objects to provide a sense of scale, the drama of this fleeting moment takes center stage. The color of the sand creates a feeling of warmth that is almost palpable. Don't be afraid to try out your camera's manual mode to get the most out of extreme light situations like these. Underexposing the scene will allow you to capture the color of the surrounding elements and enhance the contrast of the light ray without blowing it out. You might get lucky shooting in automatic mode, but your camera might not pick up on all of the nuances you see with the naked eye.

THE PHOTOGRAPHER'S STORY

"The Namib Desert must be one of the most fascinating places on Earth. Walking into the low light, you can see the shadows and the shapes of the dunes changing every minute. This is a simple shot of the light highlighting the windblown sand between two large dunes. It all vanished in mere seconds." —Ken Dyball

WALVIS BAY, ERONGO, NAMIBIA

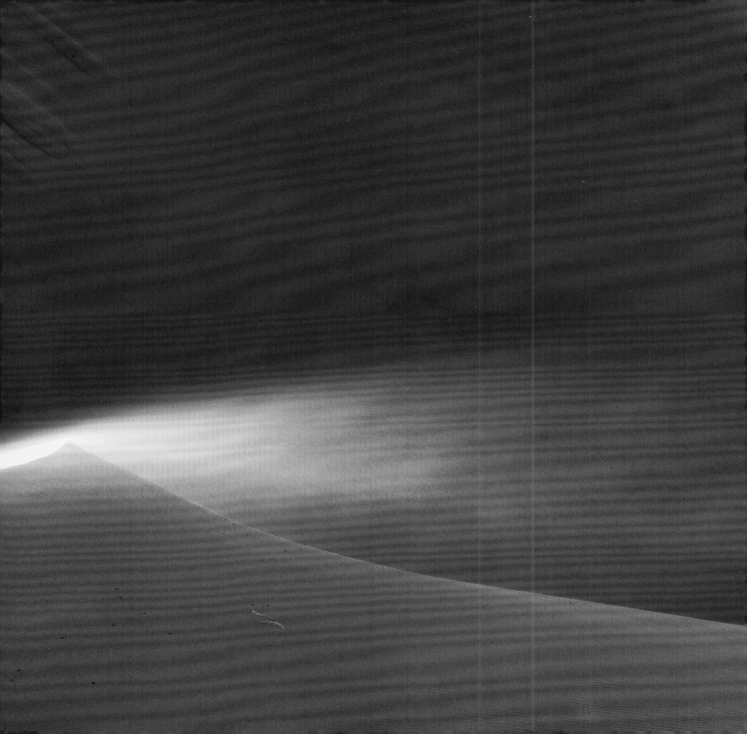

»INTO THE SUN

Bright light can sometimes be exactly what you don't want. It can create harsh shadows and obliterate details. In this case, however, bright light is precisely what transforms a humble geranium into a work of art. Photographing the soft purple petals so they are backlit by the sun creates a luminous gem and accents the fragile veins of the flower. The flower is also a surface unto itself, catching the curled shadow of the flower stamen. You need not travel to a far-off locale to find something special. If you look around you, everyday objects can be just as rich.

HOW TO WORK WITH BRIGHT LIGHT

- **You can't control the sun,** but you can make it work for you. Harsh sunshine helps illuminate the pattern on the flower petals in a way that diffused light does not.

- **Bright light can lead to harsh shadows.** Using a flash in a bright environment can help fill in those shadows so you don't lose the details.

- **Take your time.** This flower is not in a rush to get anywhere. Spend some time with your subject, and experiment with shooting from different angles.

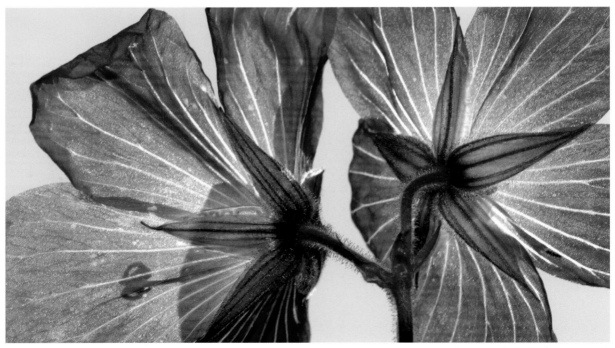

CAROL WORRELL — MOUNT VERNON, WASHINGTON

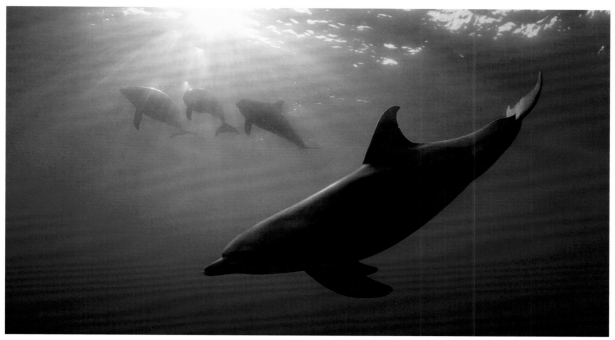

NATALIA PRYANISHNIKOVA — AL GHARDAQAH, AL BAHR AL AHMAR, EGYPT

»TAKE THE PLUNGE

The interplay between the light and layered composition takes this photograph beyond others of its kind. The eye travels first to the light gilding the outline of the dolphin in the foreground, and then to the rays beaming down from the surface. Illumination gives this underwater scene dimension and depth, and invites the viewer to linger a moment. I love the trio in the background, swimming up and out of the frame as they continue their journey. Captured minutes later, this photograph would have looked completely different.

HOW TO CAPTURE LIGHT UNDERWATER

- **Light can't penetrate deep underwater.** To maximize sunlight, shoot when the sun is brightest and stay relatively close to the surface.

- **Water reduces light.** Using a higher ISO will increase your shutter speed, so you won't miss the amazing creature that swims by in a flash.

- **Shooting with your subject between you and the sun** can create a dramatic effect. Here, the backlighting emphasizes the natural curves of the dolphin in the foreground.

- **Avoid using auto white balance,** which will neutralize the blue of the water.

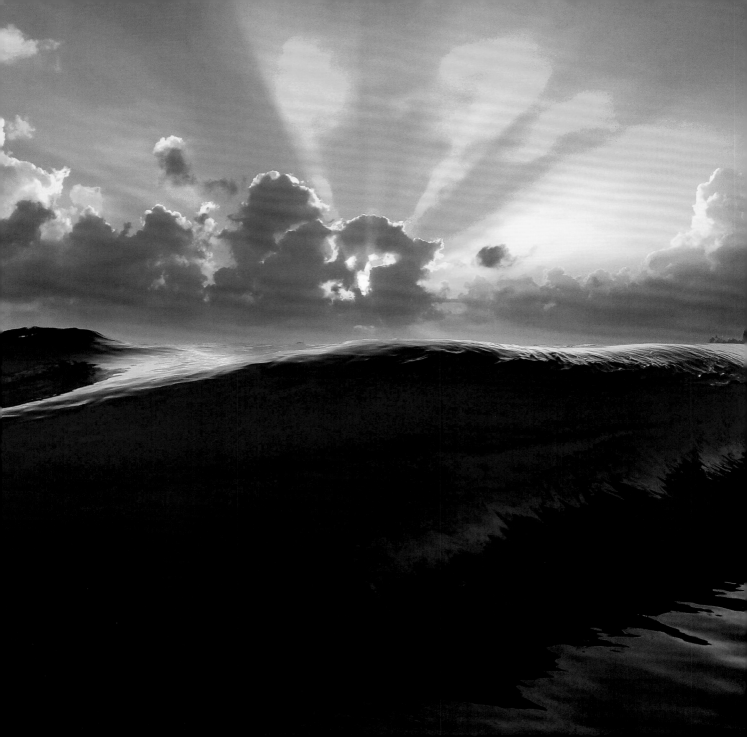

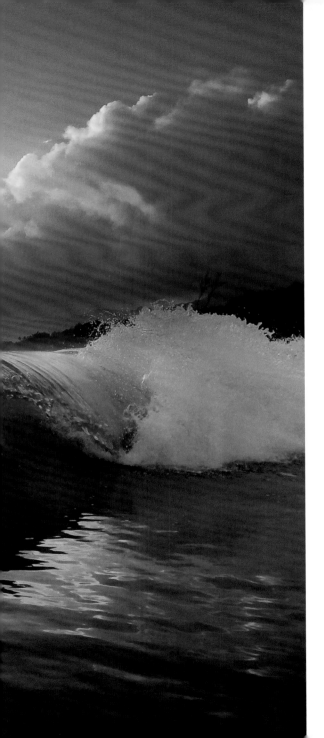

»SUNRISE, SUNSET

Perhaps you already have an idea of the kind of shot you want—just the wave curling across the horizon and the sun bursting out of the clouds above. Simple. Except you can't get that from standing on the beach. Sometimes you have to immerse yourself in the scene, literally, to get the shot you want. Beyond finding the right perspective, photographing at sunrise and sunset poses unique challenges. The light changes from one minute to the next and reveals patterns, shapes, and reflections that you can't anticipate. Be aware of elements you want to highlight, and let that dictate your exposure. Timeliness is of the essence, as is a ready finger on the shutter. Start shooting before you think you should, and keep going.

THE PHOTOGRAPHER'S STORY

"I'm standing in knee-deep water, trying to get my camera just above the lip line to catch the sunrise. The light is stunning. I'm taller than the wave, so I basically got chopped in the chest while capturing this. This image taught me that my ego is not my amigo, and I should never pass up the little things in life." —Freddy Booth

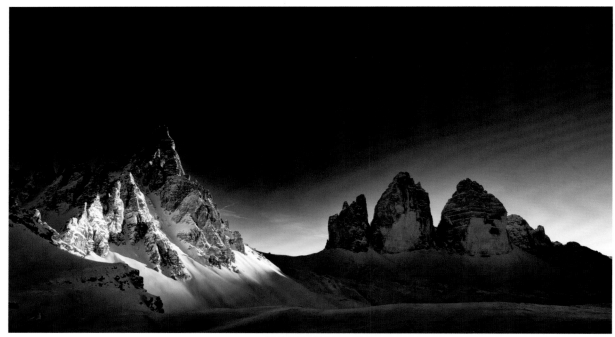

»SHADES **OF GRAY**

Black and white is a timeless choice for landscape photography, for good reason. Without the distraction of color, the eye is free to focus on the basics of light and composition, form and texture. In this dramatic scene, hard light illuminates the craggy rock face, casting the valley in dramatic shadow. A cloudless sky makes the mountains pop. The photographer made an artful decision to focus on the peaks rather than trying to fit the whole landscape into the frame. Here, showing less is clearly more.

HOW TO CREATE CONTRAST

- **Try to visualize** the landscapes in black and white before you start shooting. Which elements do you want to appear in light and shadow?

- **Expose for the highlights** to create deeper shadows. In situations with a lot of natural contrast, the challenges are maintaining detail in both the light and the shadows, and capturing the shades of gray in between.

- **Go back to the same spot** at different times of day to see how the light changes.

»MIRROR **IMAGE**

W hat are we looking at in this geometric interplay of shadows and reflections? When presented with clues, the mind naturally wants to fill in the blanks, which is what makes this photograph so intriguing. The empty table and chair set the scene, but the real subjects are the shadows— subversive elements that suggest rather than reveal. They are sharp enough that we can make out the number on the door and the curve of the man's head, but where is the man exactly? All of this comes together to create a photograph that resembles a photo-realist painting, artfully and meticulously composed.

HOW TO SHOOT SHADOWS

- **If you photograph your own shadow,** be intentional about using it as a creative element.

- **Don't shy away** from a shadowy scene. A shadow can actually become the focal point of your photo.

- **If an object creates an interesting reflection** capture the reflection rather than the object.

- **When photographing** highly reflective surfaces, make sure that flares from your flash or the sun do not appear in the frame.

»A FIREFLY SUPERHIGHWAY

The woods are alive! Fireflies are magic in and of themselves, but a view of them en masse, emerging from the blue of the twilit trees, makes this photograph sing. The photographer takes creative advantage of the fact that fireflies are the only light source here. A long exposure time transforms the flies' blinking into zigzagging light trails, heightening the sense of energy. With the contrast of the forest, this scene is a study in movement and stillness. The eye-level perspective brings immediacy to the experience, as if the viewer were about to be overrun by this swarm of sprites.

HOW TO CONTROL LIGHT

- **Creating a scene** like this requires a long exposure time to coax ambient light from the dark forest.

- **A steady camera is paramount** to capturing this scene without blurring, so a tripod or other means of stabilization is a must.

- **When framing your scene,** be aware of extraneous elements that take the magic out of the moment. Imagine if there had been another source of light, such as a streetlight, in this photograph.

SPENCER BLACK / BLUE GHOST FIREFLIES — BREVARD, NORTH CAROLINA

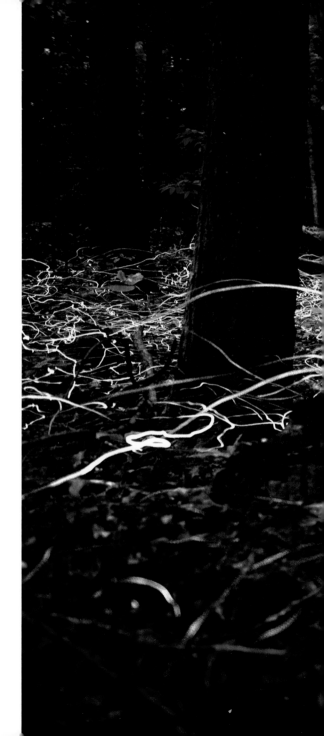

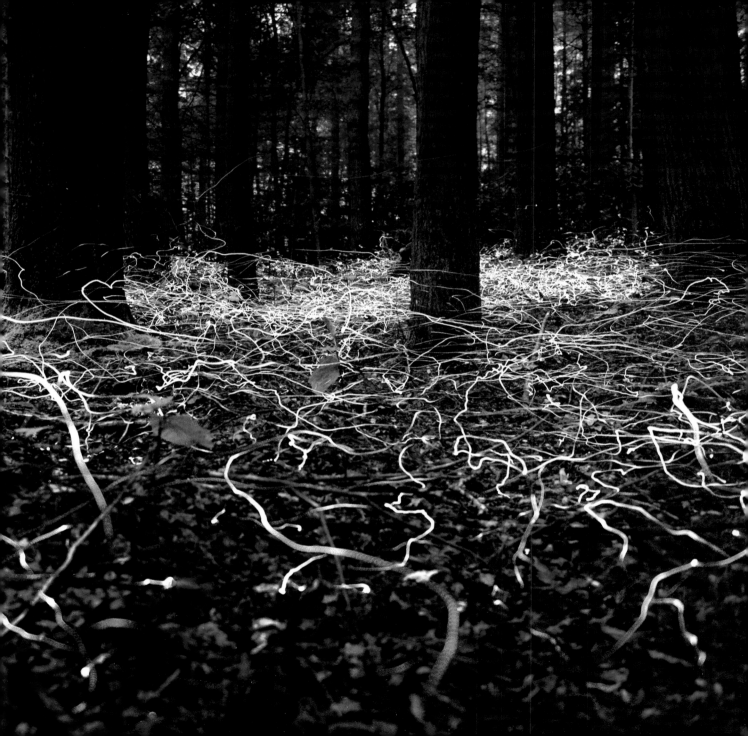

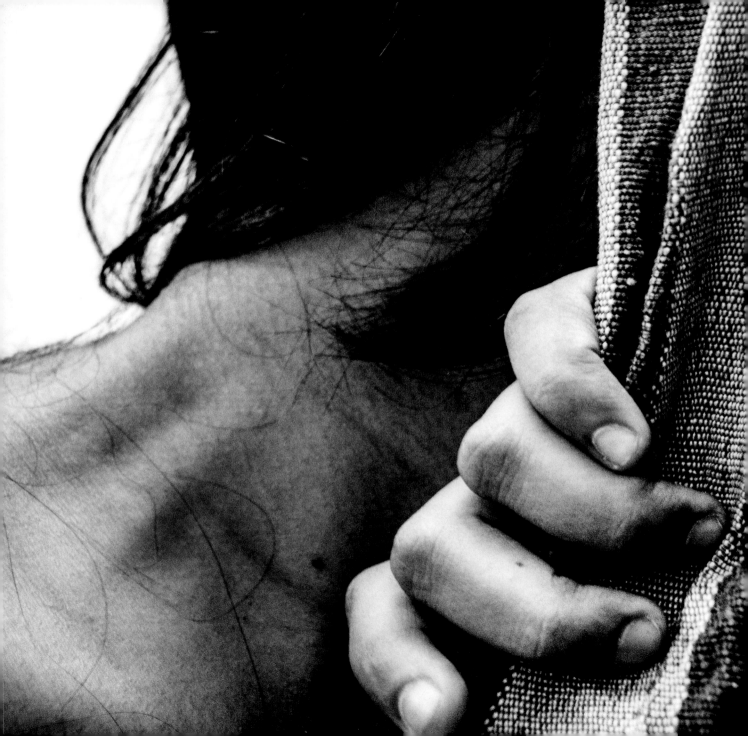

SELF-PORTRAIT

BY BECKY HALE AND MARK THIESSEN

EXPRESS YOUR SELF

We all have a self-identity that includes how we see ourselves and how we want others to see us. Here's your chance to show the world something about yourself.

As photographers, we are accustomed to using other people as our subjects. Turning the camera on yourself can be uncomfortable and counterintuitive. But self-portraits do have benefits. When you are your own subject, you control the strings. There's no subject impatiently looking at her watch while you set up the shot. Take as much time as you want to explore the possibilities. You are literally crafting your own image.

Think creatively, and push yourself beyond the traditional selfie, shot at arm's reach. Start by shooting your reflection in a mirror or window. (Remember to avoid covering your face with the camera or getting the camera in the shot.)

Once you feel more comfortable, think about what story you want to tell. Maybe you want to portray your joy for life or express your feelings. You don't have to include your entire form; perhaps just a portion of you or your shadow is enough. Some self-portraits draw on symbolism to emphasize poignant aspects of the photographer's life. You can also play with the lighting to create different moods, or try to compose an environmental portrait that provides more context.

If you get stuck, it can help to previsualize your self-portrait by writing the caption first. What words would you use to describe yourself? How will the viewer know what matters to you? An image may grow out of the caption you craft. Most important, keep experimenting, and don't stop shooting.

ABOUT THE ASSIGNMENT EDITORS

Becky Hale and Mark Thiessen, NATIONAL GEOGRAPHIC PHOTOGRAPHERS

Hale (left) is a studio photographer with *National Geographic* magazine. Her work includes portraiture and images illustrating complex scientific and cultural stories. Fieldwork has taken her to Istanbul, Rome, and Cairo. She has shot Stonehenge at daybreak and aerials of whooping cranes from an ultralight.

Thiessen (right) is a staff photographer with National Geographic and is recognized for his work on science stories and wildfires. He was also the expedition photographer chronicling filmmaker James Cameron's dive to the bottom of the Mariana Trench in *Deepsea Challenge*.

ESTEFANÍA HERNÁNDEZ — PUERTO VALLARTA, MEXICO

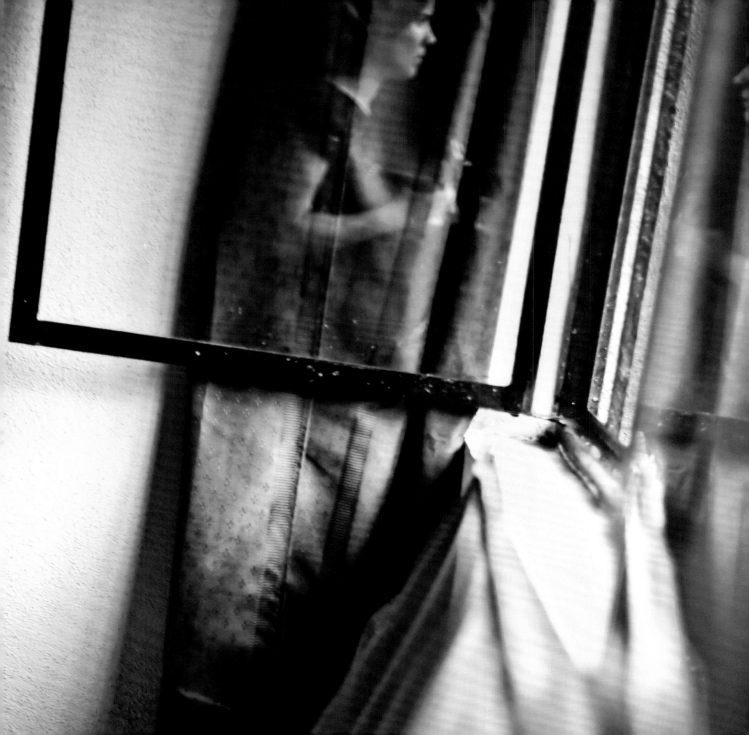

»SLEEPLESS **IN CHINA**

We love images that at first glance look like something else and then require a second look to figure them out. The broken mirror crops the photographer's face so his expression becomes even more intense. We see no forehead, hair, or other distractions. His eyes draw you in. This is a tricky shot because you have to balance the exposure of the foreground with the background. The different qualities of light falling on the mirror and the background play a key role in creating this striking image. The photographer lit his face while ensuring that the background didn't become too light or too dark.

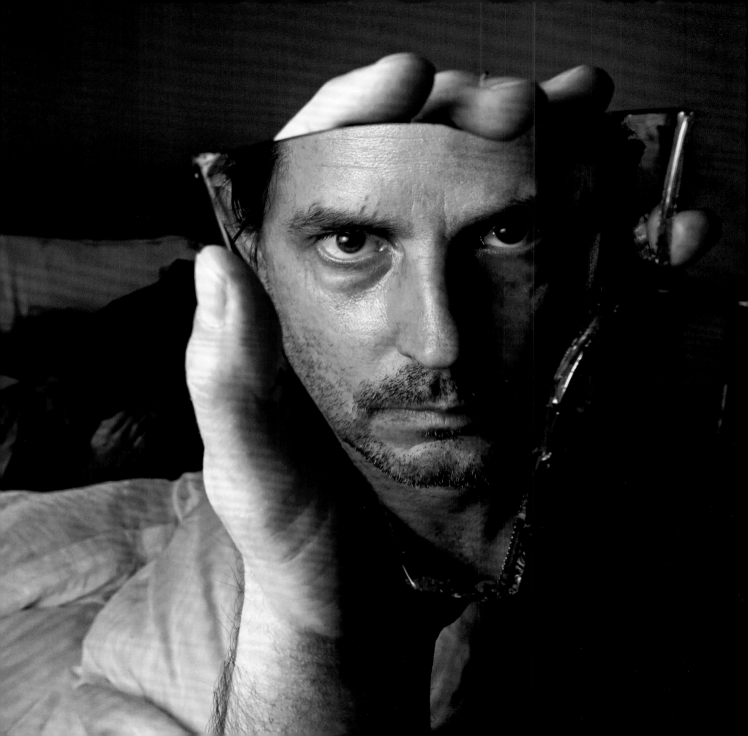

»BEHIND THE GLASS

This is such a mysterious and abstract self-portrait. The out-of-focus face, the hair that seems to defy gravity, and the moody light make this a strong image. We love the soft swirl of hair obscuring her face against the aquamarine background. The hair is interesting in and of itself. In this image, the photographer placed her nose on a flatbed scanner. This technique makes an image with a unique look you can't get any other way. The light on her face falls off so quickly. A scanner has a sensor with an attached light that moves along under the glass. The light is so close to the glass that anything on the glass is properly exposed and anything farther away gets darker.

HOW TO TAKE UNCONVENTIONAL PHOTOS

- **Experiment by pointing your camera** through anything that might make an interesting distorted image.

- **Leverage digital photography's immediacy** by reviewing your image, making adjustments, and shooting again. Rinse and repeat.

- **Try this technique to magnify an image:** Remove your camera lens and hold a loupe (from the film days) against your camera in place of the lens.

HELENE BARBE — JAN JUC, VICTORIA, AUSTRALIA

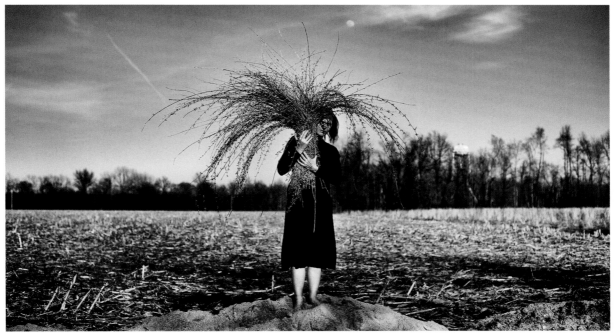

»FIELD **OF DREAMS**

This intriguing self-portrait made me stop and linger. It feels jarring yet familiar, vintage yet contemporary. The long tendrils of weeping willow seem to be the subject of the photo, yet they simultaneously obscure the human subject. Who is the woman hidden by the branches? By choosing to make this image black and white, the photographer creates a strong distinction between the field and the distant tree line. The photographer's white shins and bare feet contrast sharply with her black dress and guide the viewer's eye to the center of the frame. Quietly present in the background, the moon adds further mystery to this enchanting scene.

HOW TO CREATE COOL PHOTOS AT HOME

• **Try converting an image** to black and white to simplify its graphic elements.

• **Don't take your existing environment** for granted. You can make interesting images anywhere.

• **When shooting outside,** consider using a tripod or setting your camera on a steady surface.

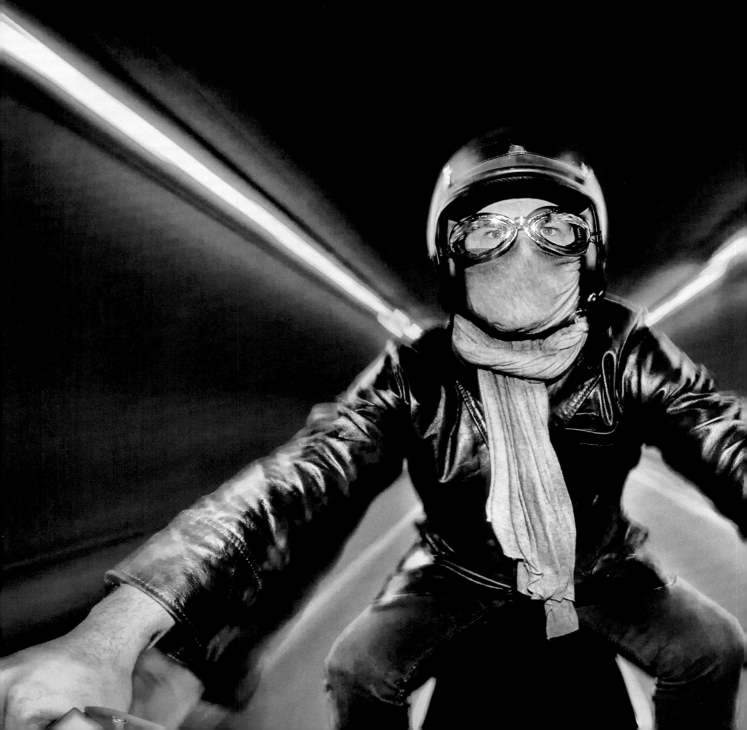

»THE NEED **FOR SPEED**

There's no ambiguity about this self-portrait, as the photographer puts himself smack in the middle of the frame. The bright tunnel lights create bold leading lines and a strong composition. The photographer uses a slow shutter speed to capture the streaming overhead lights, while an on-camera flash freezes his shape and keeps it crisp. He does a great job of incorporating lights that he can control (the flash) and those he cannot control (the tunnel lights). The camera is mounted on the scooter itself, which is an innovative way to capture a clean image at this speed. Clamping your camera down and playing with light and motion can be a great way to turn an ordinary moment into a dynamic photo.

THE PHOTOGRAPHER'S STORY

"I use my scooter for the commute to and from my work. It allows me to stop everywhere I want to take a picture. So a self-portrait should include my scooter. I taped a tripod to the front and mounted my Nikon D7000 with a Samyang 8mm fish-eye. I used the flash on manual to freeze my face and a long exposure to create the speed. This picture was taken in a small tunnel so I could use the tunnel lights to create these lines." —Lex Schulte

EWINKEL, NORTH BRABANT, NETHERLANDS

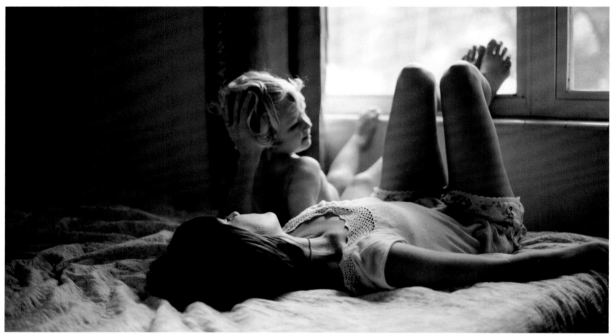

AMANDA DAWN O'DONOUGHUE — GAINESVILLE, FLORIDA

»MOTHER **AND CHILD**

This is such a lovely, simple image. I saw this frame and felt like I was witnessing an ordinary and poignant moment between a mother and her child. Many details make this shot compelling: the soft quality of the light, her hand on his head, his toes on the edge of the windowsill as he tries to mimic her pose. The photographer chose a very shallow depth of field, giving this image a gauzy, dreamlike feel. Very few elements of the frame are actually in focus, except for part of the photographer herself. Sometimes nothing is more resonant than a real moment.

HOW TO CAPTURE A QUIET MOMENT

- **Turn your camera's** sound effects off (or way down) to minimize the distracting shutter sound.

- **Shoot a lot of photos** as you let the moment play out. Keep shooting past the point when you think you've "got it."

- **Make sure you have** lots of room on your memory card for hundreds of images. There's nothing worse than missing a moment because your card is full.

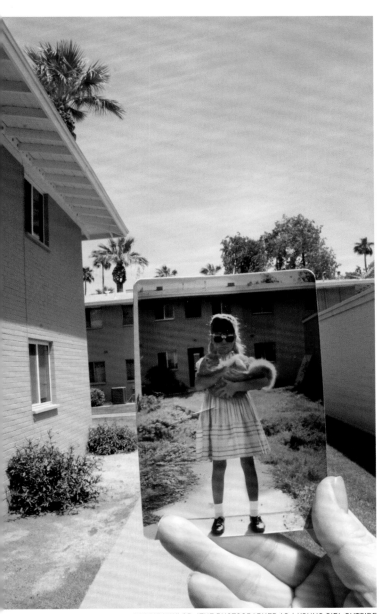

DARCIE NAYLOR / THE PHOTOGRAPHER AS A YOUNG GIRL OUTSIDE
HER HOME — PHOENIX, ARIZONA

»LOST IN TIME

This picture is like a time machine. I love the idea of bridging two periods of time to make a self-portrait that tells a story. The present-day background has a timeless look, which adds to the sense of disorientation. The photographer uses a frame within a frame to draw attention to what matters. She stopped down to an exposure of f/22, adding to the depth of field and bringing both the snapshot and the background into focus.

To shoot this kind of photo, try to achieve the same time of day and weather conditions in both the past and the present-day scenes. Shoot lots of pictures to make sure your alignment is dead-on. The final result will be worth the extra effort.

HOW TO CREATE A FRAME WITHIN A FRAME

- **Windows, doorways, and even tree branches** can be used to create a frame within a photo.

- **This framing technique** adds context to your image, because you are looking through the frame into something else.

- **Keep an eye out for frames** in different settings. Once you start looking for them, you will see them all around you.

» THE SELF **REFLECTED**

Cameras are central to a photographer's identity. But using one as a prop in a self-portrait can be a heavy-handed, dated cliché. This photographer avoids the usual traps in an inventive self-portrait that puts her camera front and center. My eye goes immediately to her shape reflected in the lens. Rather than focusing on herself, the photographer chose to make her lens as sharp as a tack and to let everything else go soft. As a result, the repeating silhouettes complement each other rather than competing for attention. The clean background behind the photographer also simplifies an image that could otherwise be overly busy. By letting her "self" take a backseat, the photographer creates a more powerful and surprising image.

HOW TO SET UP A SELF-PORTRAIT

- **Set your exposure first** so your settings are locked down and you can focus on making the image.

- **Use your tripod** and carefully frame the shot before inserting yourself.

- **To release the shutter,** use a long cable release that can be hidden from view easily.

- **Use the self-timer** on your camera to shoot automatically in time increments of your choosing.

MARGARET SMITH — ENGLAND, U.K.

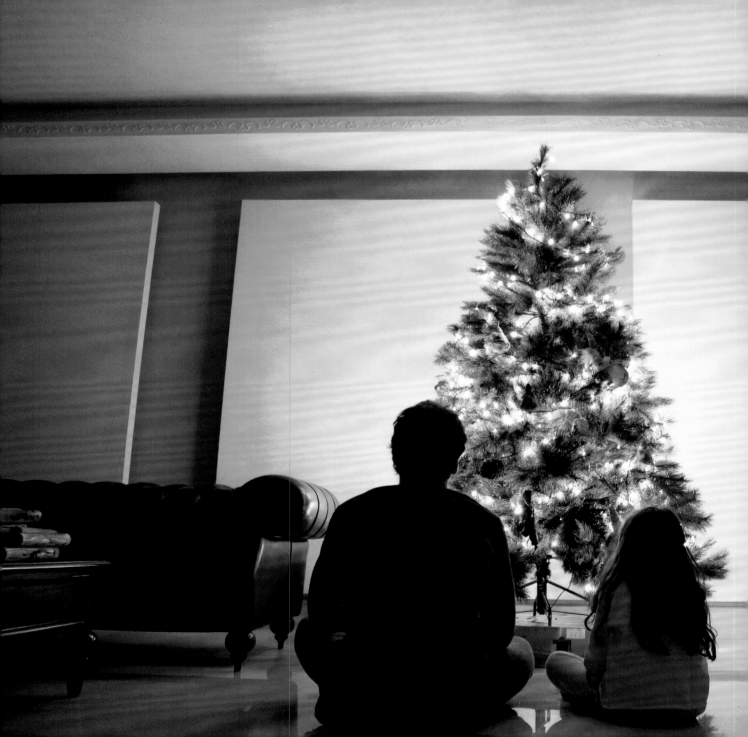

HOME

CARL YARED — DBAYEH, MONT-LIBAN, LEBANON

BY SUSAN WELCHMAN

WHERE THE HEART IS

've called many places home, and I continue to establish new homes. Not all of them are places I have stayed for a long time, and some of them don't even have roofs. When you set out to create your individual expression of home, think broadly and creatively. Home can be anything from a small room to the entire universe. It can include moments of sheer joy or desperation. It can be an extremely intimate place or a public space.

Often what constitutes a home is not where you are, but whom you are with. You could photograph the home you currently have or the home you hope to have someday. You can also shoot the home of someone or something else.

Strive not only to document but also to reveal. Your images can be abstract or realistic, but ideally they will convey a thought or emotion. Try to avoid shooting the obvious. Instead, search for the meaning of this assignment with your heart as well as with your camera. As always, there is no specific formula for success, except that all great photos need a little luck or magic.

ABOUT THE ASSIGNMENT EDITOR

Susan Welchman, *NATIONAL GEOGRAPHIC* MAGAZINE

An award-winning photographer and photo editor, Welchman retired as a senior photo editor for *National Geographic* magazine after 35 years. Earlier in her career, she worked as a photographer at the *Philadelphia Daily News* and a photo editor at the *New York Post*.

LARRY DEEMER — CHÉTICAMP, NOVA SCOTIA, CANADA

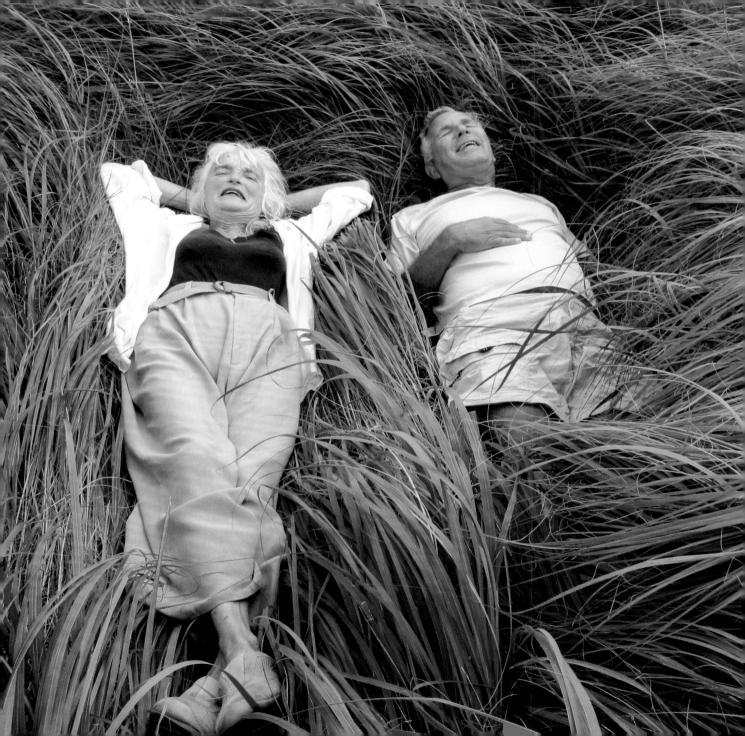

»THE BEDROOM **WINDOW**

My favorite thing about this image is that there's nothing extra in the frame at all. The curtain blows in the breeze in contrast to the strong geometric lines of the house. The photographer snapped this shot at the very moment the wind lifted the curtain at just the right angle. While the scene is somewhat stark, the curtain hints at the warmth and humanity inside. This image could have been shot in color, but it never would have given us the same delight as this black-and-white, perfectly framed image. The window on the right balances perfectly with the chimney on the left. And the asymmetry in the negative space—created by the lines of the house against the sky—adds visual interest. This image is minimalism at its finest.

HOW TO MAKE A LITTLE SAY A LOT

- **Show movement** in your photos to bring them to life.

- **To convey weather conditions** in your photo, look for a curtain blowing in the breeze, condensation on a window, a trickle of sweat, or another visual cue.

- **Stay very still.** It will help you concentrate on capturing movement in the subject.

RUI CARIA — PRAIA DA VITÓRIA, AZORES, PORTUGAL

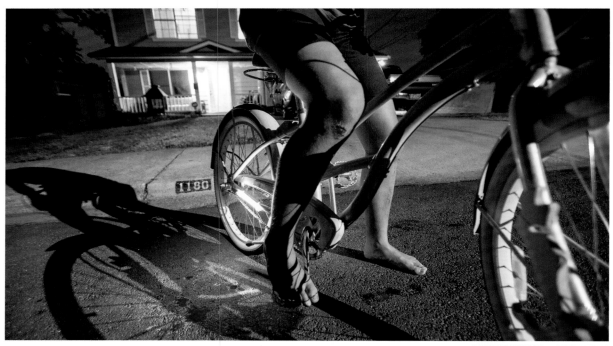

»A CHILDHOOD **MEMORY**

Bike, shadow, purple light, and home—a flashback to childhood and summer nights riding through the neighborhood in bare feet. The house number connects the rider to the home, yet the rider is anonymous. You connect with the freshly injured knee, the shadow, and the activity, but not to the type of person.

The image is direct in its simplicity. The roofline of the house is cropped, and your head is locked in position with no options. The unexplained green line seen through the bars of the bike makes you wonder what it could be. All of the ingredients in the photo surround the knee wound. You can almost hear the rider saying, "It was worth it."

HOW TO DISCOVER YOUR ANGLE

- **If subjects initially turn you down,** tell them you can make them anonymous by disguising their identity. Show them the image, and gain their permission to keep it.

- **Take photos from all perspectives.** Get down on the ground or on top of something high.

- **Shoot on the edge** of the light. Even if you can't see, make your camera do the work by using a higher ISO in the dark.

»THE WAR **AT HOME**

Seeing a child alone in these surroundings reminds us how precious and fleeting safety can be. She, with henna in her hair, fingers in her mouth, and a dress that is far too big for her—she is at home. This girl lives in a small Afghan village close to where the picture was taken. She has spent her whole childhood living among the trappings of war. So small and vulnerable juxtaposed against the massive military truck, she is the only burst of color and humanity in a harsh and unforgiving terrain. This is not a picture of comfort. This image makes us feel desperate to do something.

HOW TO WORK PEOPLE INTO LANDSCAPES

- **Explore depth of field.** Opening your aperture will help fuzz out your background so it doesn't compete with your foreground.

- **Shoot in all kinds of weather and light** just to explore the effects of wind, dust, and rain. Be careful to keep your lens clean and dry.

- **Don't hesitate.** Shoot first, and ask your subject for permission later.

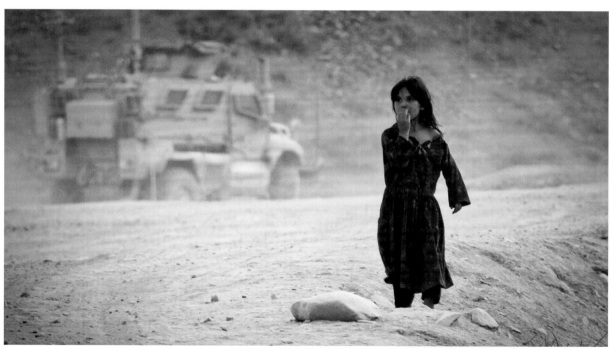

JUSTIN A. MOELLER — GARDĒZ, PAKTIA, AFGHANISTAN

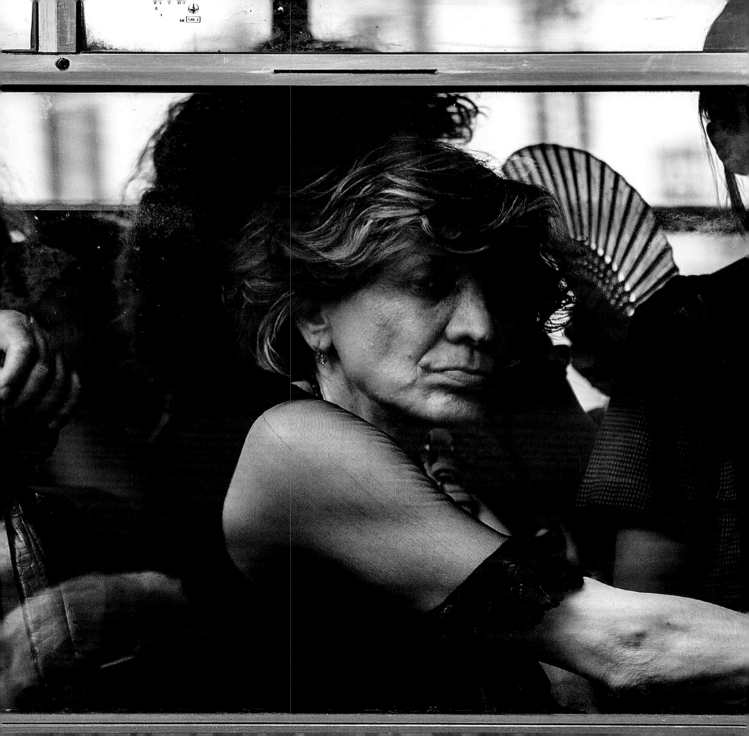

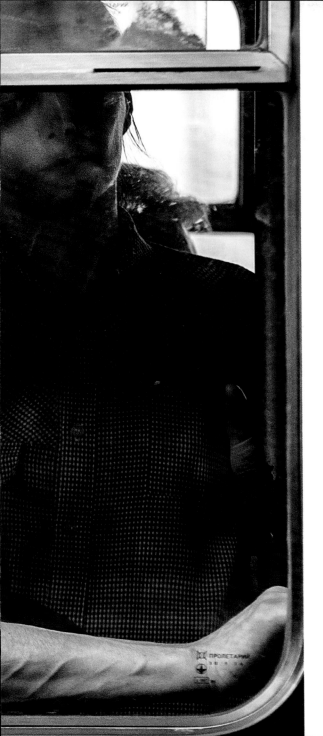

»A FACE **IN THE CROWD**

Riders on a city bus might not make you think of home, but the riders are often in the familiar surroundings of their hometown. Every inch of this frame is worthy of our attention. The lead character gazes unflinchingly at the photographer. Her confident, disdainful expression and unlikely daytime attire make her look at once defiant and defeated. The woman's hand pushes into the corner of the window while the waves of her hair flow in the opposite direction. At the lower left, the reflection of a face with sunglasses contrasts with the unhappily contorted face at the upper right. The fan is almost playful amid so much disillusionment. You can only wonder what the fanning woman looks like.

THE PHOTOGRAPHER'S STORY

"When I was waiting for my bus, I noticed this woman! I had the impression that she was gazing at me, but I could tell she essentially belonged to a different reality. I don't know what time or space she was in at that moment, but the view was beautiful and, at the same time, dolorous."
—Levan Adikashvili

TBILISI, REPUBLIC OF GEORGIA

SOTIA DOUKA — ROTTERDAM, NETHERLANDS

»A MINIATURE **WORLD**

This image poses as many questions as it answers. The dollhouse is displayed next to life-size lamps, yet the lamps appear to be the same vintage as the house. If only the lamps could fit inside. Similarly, it looks as if the occupants of the house could drive away the cars at any moment. Is the gold curtain backdrop hiding the real-life home of someone behind it? The doors and tiles provide extra framing around the image and help us understand the reality of the picture—that it's on a street. This scene is likely meant to delight viewers, and it succeeds.

HOW TO SHOOT A WINDOW DISPLAY

- **Still lifes won't run away.** Take your time and make a good exposure. Go back if the subject is right; the light could change in your favor.

- **Captions can illuminate.** Try to gather information before leaving a scene. It might change the whole meaning of your image.

- **Avoid reflections** unless you can give them an unusual spin. They tend to be cliché.

»WAITING **TO LEAVE**

The photographer's vantage point for this image makes the child look insignificant. The scene is unpleasant. She and we are waiting and wanting to get out of it. The disorganization and decrepitude remind us that homes vary greatly from tents to mansions. Small attempts at comfort, such as the curtain and the dangling Christmas lights, only make the scene worse and seemingly more desperate. The child is so relaxed that you wonder about her relationship to the photographer. You want to say or do something! Make it better! The viewer marvels that a shot could be so perfectly composed, seemingly on the fly.

HOW TO SHOOT REAL LIFE

• **If you want to document truth,** then change nothing in the scene.

• **Listen to your subjects** while you are shooting. They might be on the verge of doing something greater than they are doing now.

• **Scenes evolve.** Follow your subject until you are out of time or your subject is out of patience. Then go one step more.

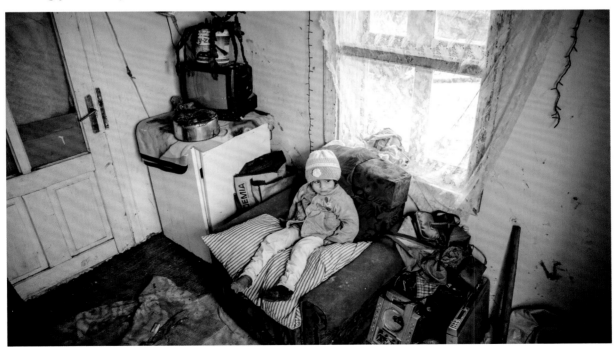

URDOI CATALIN — ROMANIA

»THE WELL-DRESSED **MAN**

This photo is a beauty. At first I thought it was a vintage image, but the gas price, modern cars, and 2014 newspaper headline take us right back to today. When this paper-selling man stops for a moment with his hand on the car's roof, he displays the checks of his perfectly pressed suit jacket and gives everything else a supporting role. The newspapers, the BP gas sign, and the smiling woman in the white truck divide up the sky's negative spaces. The man's arm is bent back, creating movement in the frame. You know there's no posing going on here. The photographer has succeeded in documenting a true moment in life.

THE PHOTOGRAPHER'S STORY

"Detroit is a city of flash and panache. I feel at home when I see a sharp-dressed man at a stoplight in the middle of the street with a bag of lollipops and a stack of newspapers. I roll down my window: 'May I take a picture?' There's something very old-school about this image, and about many of the photos I've taken in Detroit. It's a forgotten culture—that's what I love about it." —Amy Sacka

DETROIT, MICHIGAN

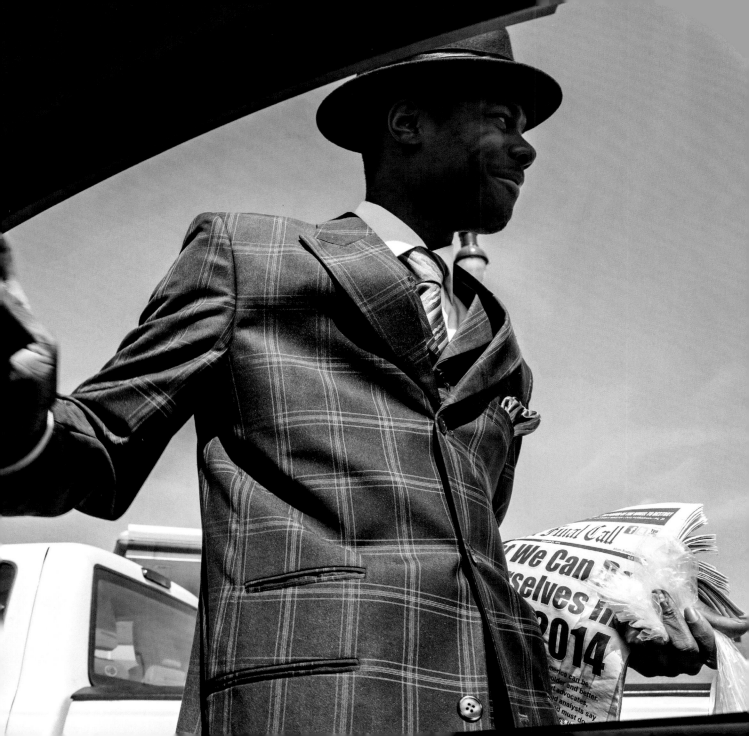

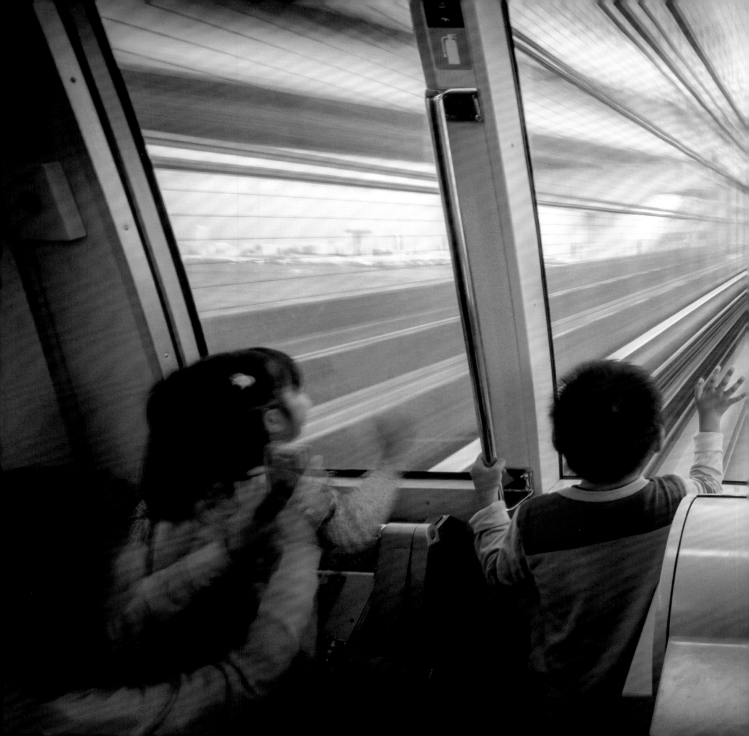

SPONTANEOUS ADVENTURE

BY JOHN BURCHAM

GET UP AND GO!

Has it been way too long since you went on an unplanned adventure? If so, I invite you to forget your cell phone and email, to turn off your reminders, and to throw out your itinerary. This assignment is all about spontaneity.

For me, the unplanned adventure always turns out to be the most memorable. You don't have to go far to have a spontaneous adventure; you just have to go. So the next time you get an impulse to go out and do something, follow that impulse right out the door—and take your camera with you!

Your assignment is to take photos that showcase unexpected and exciting imagery from an unplanned escape. Shoot an idea you have had for a while, take a fresh look at a place you have been before, or go somewhere you have always been meaning to visit.

Don't forget that emotion can create some of the most dramatic action shots. An image can have solid composition and beautiful scenery but still lack connection with the viewer. Instead of just photographing the places you go on your road trip or the mountain you just climbed, capture the experience of *being* there.

Being spontaneous is not the same as being unprepared. You don't want to miss the perfect shot because you forgot your favorite lens or that extra battery. Create a checklist of items you might need for your adventure. Keep a packed bag in your car or closet for easy access when you need it.

If you keep up the philosophy of spontaneity, you will never stop growing and learning as a photographer. Continue to go out there on your own personal assignments, take those risks, and force yourself out of your comfort zone. It's worth it in the end.

ABOUT THE ASSIGNMENT EDITOR

John Burcham, NATIONAL GEOGRAPHIC PHOTOGRAPHER

Burcham feels most at home when climbing up the sandstone spires of Sedona, Arizona. He has been adventuring and photographing since college. His work has appeared in *National Geographic* magazine and the *New York Times*, as well as on the History Channel.

DOUGLAS GIMESY — TORRES DEL PAINE NATIONAL PARK, MAGALLANES, CHILE

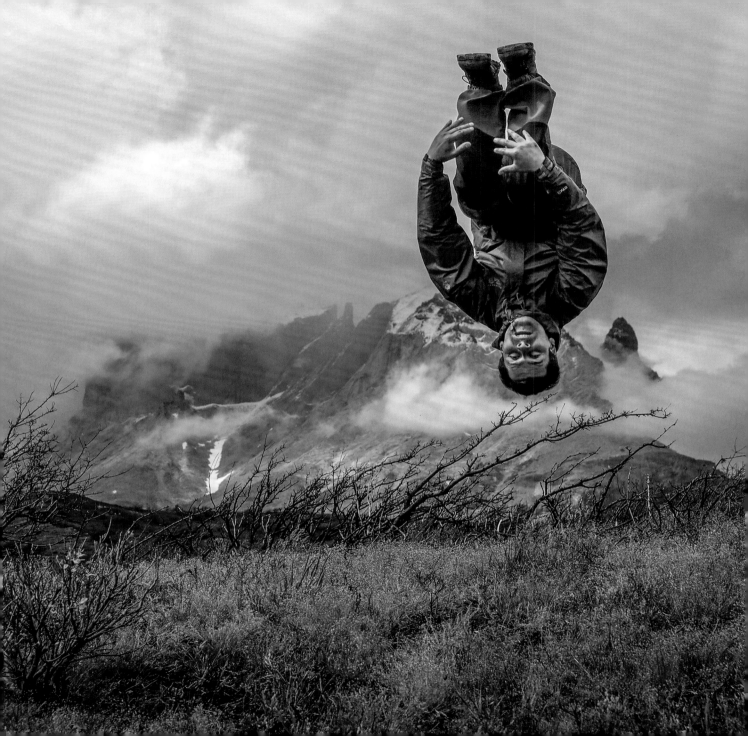

»LOVE IN THE WILD

Sometimes one small gesture is all you need to transform an image from good to amazing. The composition of this photo is perfect. Your eye goes directly to the young elephant in the center of the frame. You see the other elephants, but there is only one face in the crowd. The connection is instantaneous. The way the elephant drapes its trunk gently over the other elephant, presumably its mother, creates a powerful and touching image. You can sense the young elephant's need to hold on and desire for security. By capturing this moment, the photographer has created an affectionate story as well as a great photo.

HOW TO GET A CLOSE-UP AT A DISTANCE

- **To capture this tight view,** the photographer shot at a focal length of 80mm. Telephoto lenses can help you get that close-up when you are far away from the action.

- **Shooting wildlife is unpredictable.** Stay in position to shoot, because you never know when the action is going to happen.

- **Don't be afraid** to crop an image to improve its composition.

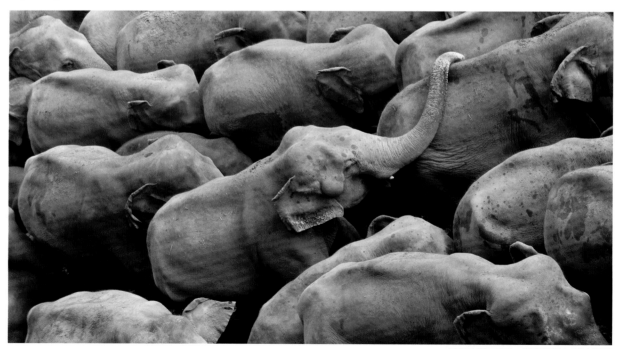

YASHA SHANTHA — PINNAWALA, SRI LANKA

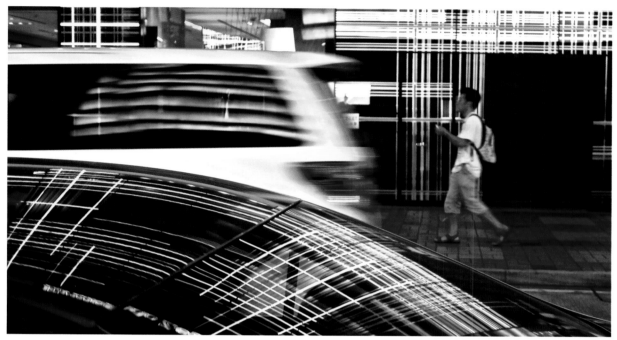

»BRIGHT LIGHTS, BIG CITY

This image is graphically stunning. Its many shapes and colors could overwhelm us, but a perfect composition ties all of the elements together. The photo has a symmetrical, balanced feel. The bisecting lines in the background and the reflecting lines in the foreground echo each other and draw us in. All of the components are in just the right position, and the pedestrian fills the space exactly where he is needed. It's amazing how the photographer was able to make all of these moving parts work together in one frame. This is a truly spontaneous moment.

HOW TO FIND BEAUTY IN BUSY SCENES

- **At night cities come alive** with contrasting colors. Look for bright colors as a focal point, and let them draw you into the photo.

- **Sometimes a scene** may seem too busy, but you see a way that it might work. Take the photo anyway. You never know when something exciting and unexpected will enter your frame.

- **You don't have to go far** to get a great photo. Keep an eye out for graphic elements that surround you every day.

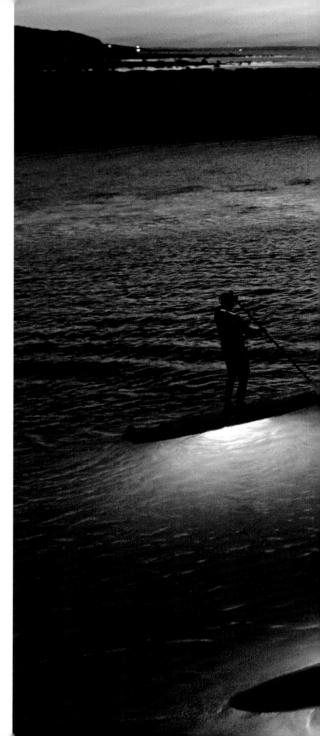

»ADRIFT AT SEA

What an adventure it would be to go out on the ocean at night with an illuminated paddleboard. Imagine the thrill of gazing down and looking into that dark unknown below your feet. These nighttime explorers are setting out on their ocean adventure, and we want to partake of this journey with them.

Each board is illuminated so perfectly, giving off just enough light to silhouette the paddlers as they drift with the soft current. The lighting from the background warms everything up, but not too much.

The most magical photos often happen after sunset. Twilight can illuminate clouds beautifully and give off different intensities of light and subtle colors. If this shot had been taken any earlier in the evening, the boards may not have been lit up in the same way. The natural light on the horizon and the unnatural light under the boards complement each other and make this photo a beautiful, spontaneous adventure into the unknown.

THE PHOTOGRAPHER'S STORY

"What I love so much about stand-up paddleboarding is its ability to transport me, surrounded by nature, to a quiet, meditative state. On a perfect late-September evening, with no wind and a full moon, I got to photograph the nighttime version of this experience. Waterproof LED lights are attached to the bottom of the boards, illuminating the water below, which meant the paddlers could see fish passing by. I photographed this from a jetty at a harbor near my house and was stunned by the beauty of it all."
—Julia Cumes

DENNIS, MASSACHUSETTS

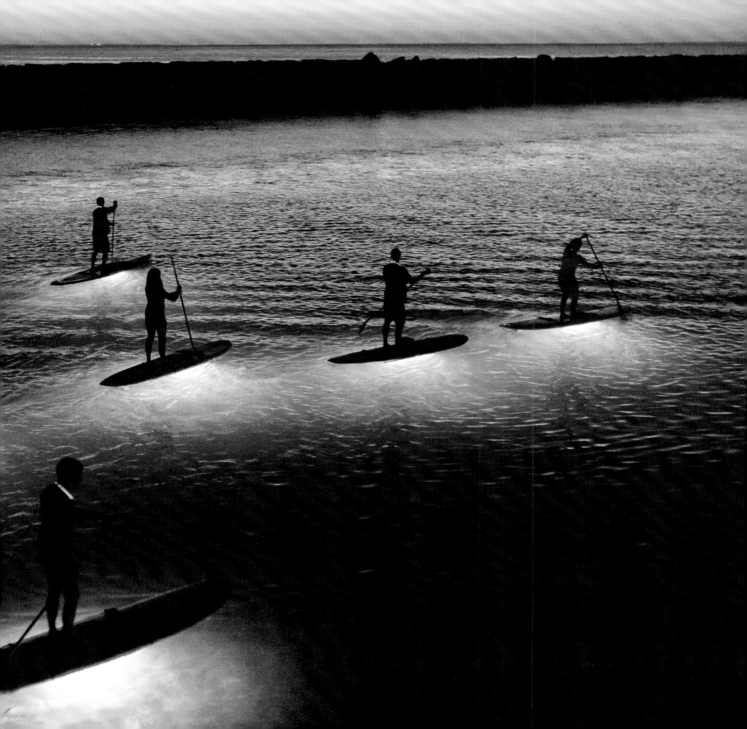

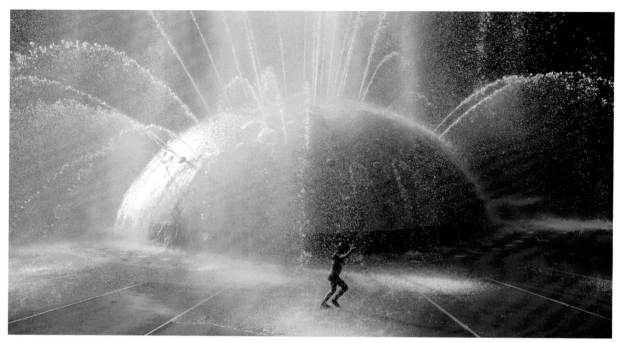

»FOUNTAIN **OF YOUTH**

The dreamlike quality of this image stirs up memories of those summer days of childhood, when we ran gleefully through backyard sprinklers. The photo has a futuristic feel, but it also makes the viewer wish to be young again. The water fountain, with its soft, luminous shades of blue, would have made a spectacular photo on its own. But with the little girl frolicking in the spray, the photo is no longer about the fountain or the girl; it's about a feeling. It becomes a beautiful representation of nostalgia.

HOW TO SHOOT A MOMENT

- **If you want to "freeze"** moving water, prevent blurring by keeping your camera on the highest possible shutter speed.

- **Don't stop shooting.** Ironically, it often takes a long time to capture a spontaneous moment like this one. Waiting for that perfect moment takes patience.

- **Set your image quality** to raw rather than JPEG, if you have the option. This will give you more control in post-processing. You can warm up the color or, in this case, cool it down.

SERGE BOUVET — PRALOGNAN-LA-VANOISE, RHÔNE-ALPES, FRANCE

»A NATURAL HIGH

Spontaneous adventure is about getting out, experiencing an amazing place, and having fun with it. This ultimate selfie expresses the joy of adventure. The mountain range in the back is awe inspiring and massive, and the photographer puts himself right smack in the middle of it all. It can be difficult to capture the feelings that you are experiencing at a given moment, but the photographer does this quite well. The look on his face says that he's enjoying this moment to the fullest. What makes this image so much fun is that he is a part of his own photographic journey.

- **Try using a wide-angle lens** to capture the surroundings. But be careful not to go too wide, or the photo could get distorted.

- **Be daring.** A beautiful landscape makes a pleasant photo, but don't be afraid to try something different and have a little fun.

- **Human emotion** goes a long way in spicing up a photo.

»ALONE IN A CROWD

This stunning photograph creates a mystery. Who is this woman? Is she lost in thought or just waiting for someone? The woman and the direction of her gaze become the focal points of this photo. We follow her gaze and wonder.

You can feel the thickness of the air. The crowds on top of the train add to the story by creating a feeling of chaos and crowding in the background. Despite the hustle and bustle, the woman in the foreground remains as still as the eye of a hurricane.

The contrasting colors and subject matter give this image an almost palpable strength. The photographer shot into the sun, which backlights everything beautifully and creates mellowness and tranquility. The photographer saw this moment and captured it perfectly.

THE PHOTOGRAPHER'S STORY

"A newlywed bride waits for her husband to board the special train in Kamalapur Railway Station in Dhaka, Bangladesh. The mehendi *(henna) on her hand is still showing as the light seeps through the roof and onto the people 'seated' on top for the journey. This is a pilgrimage home to enjoy the Eid festival with family." —Shahnewaz Karim*

»JOURNEY INTO SPACE

The universe is vast and endless. Our planet makes up only a tiny portion of the cosmos. Looking at this image, you grasp the reality that humanity is just a tiny blip in time and space. Paradoxically, the photo is also a testament to human ingenuity. To get this shot, a couple of guys sent a GoPro camera into space on a weather balloon. Their crazy idea worked! The results were amazing images of Earth.

This photo is embedded with so many contrasts. Humans are big yet small, helpless yet powerful. Our planet sometimes seems chaotic, but it is beautiful and peaceful from a distance. Mostly, we see how far we can go with very little.

HOW TO TAKE YOUR DREAM SHOT

- **Follow through.** We all have ideas, but they don't mean anything until you put them into action. If you think a project is worth doing, write down step-by-step what it would take to get from point A to point B. Set a date and make it happen.

- **GoPros can inspire creativity.** You can attach these small, lightweight video cameras to just about anything, so they can go places where you and your DSLR cannot.

- **Don't be afraid of failure.** Crazy ideas work sometimes.

JAY MANTRI — EARTH'S STRATOSPHERE (ABOVE SOUTHERN CALIFORNIA)

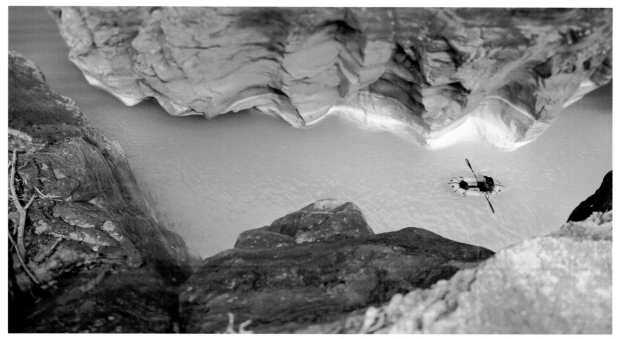

»ROLLING ON THE RIVER

The rich colors in this scene appear to bleed into each other like those of an oil painting. The orange hues of the rock contrast nicely with the aqua blue river. The small yellow raft provides perspective on the incredible steepness of the canyon walls. The rafters create a sense of direction as they paddle into the scene from the right. Although the environment is harsh, the soft, even lighting brings out the beauty of the landscape. This place feels isolated, but the bright colors and lighting evoke the pure joy of adventure.

HOW TO SHOOT IN ROUGH TERRAIN

● **Look for the perspective** that best tells the story. Sometimes getting lower or higher can change the whole photo.

● **Cloudy days** often make for better shooting conditions than sunny days, which can create harsh lighting.

● **When shooting in extreme or vertical conditions,** make sure you have a high-quality camera strap. It could be worth every penny. A reliable strap is much cheaper than a replacement for a dropped camera.

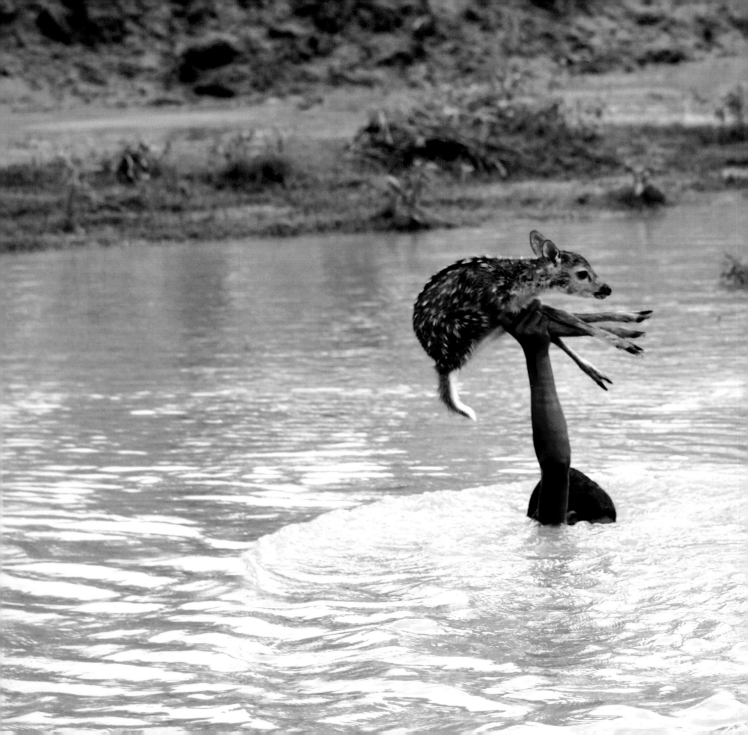

THE ANIMALS
WE LOVE

BY ROBIN SCHWARTZ

A WALK ON THE WILD SIDE

Animals have been my passion for my entire life. They are my joy and my family. They give me support and make my life better. If you identify with any of these statements, then this assignment is for you. I challenge you to follow your passion for animals and photograph from the heart.

You might create an intimate portrait that communicates an animal's distinct personality, or you may decide to photograph an animal within a landscape, on the street, or in a park or zoo. Just remember to be respectful and safe at all times. Be aware of cultural mores and institutional rules. Asking permission to take pictures of someone's pet may open up a dialogue and allow you to create a more intimate photograph.

There is no formula for shooting the perfect animal photograph, but the most powerful images strike a universal chord. Some generate poignancy and empathy; others capture similar qualities in humans and animals. Finally, including context, such as an informative background, can help tell the animal's story and make it relatable.

As you shoot, keep an eye out for any arms or legs that are awkwardly chopped off in the frame. And when you are editing your photos, be aware that there is a fine line between poignant and cloyingly cute.

That said, photograph what you care about and don't worry about making a perfect composition. Get the shot first and edit yourself later. Some of the photos in this chapter are not technically perfect, but they get to our hearts and minds—and that is a successful photograph. Trust that the value you place on a photograph might come through in your capture.

If you truly love animals, and if photographing animals gives you pleasure, then do not let any criticism impede your photographic pursuits—unless it involves safety or stalking! Follow your instincts, and photograph what you love.

ABOUT THE ASSIGNMENT EDITOR

Robin Schwartz, FINE ART/EDITORIAL PHOTOGRAPHER

With photographs in collections at the Metropolitan Museum of Art, the Museum of Modern Art, and the Smithsonian, Schwartz has also been published in four monographs, as well as the *New York Times*, *TIME LightBox*, and *Aperture* and *O, the Oprah* magazine. She teaches at William Paterson University in New Jersey.

JUAN TORRES — GUAYAVILLA, PUERTO RICO

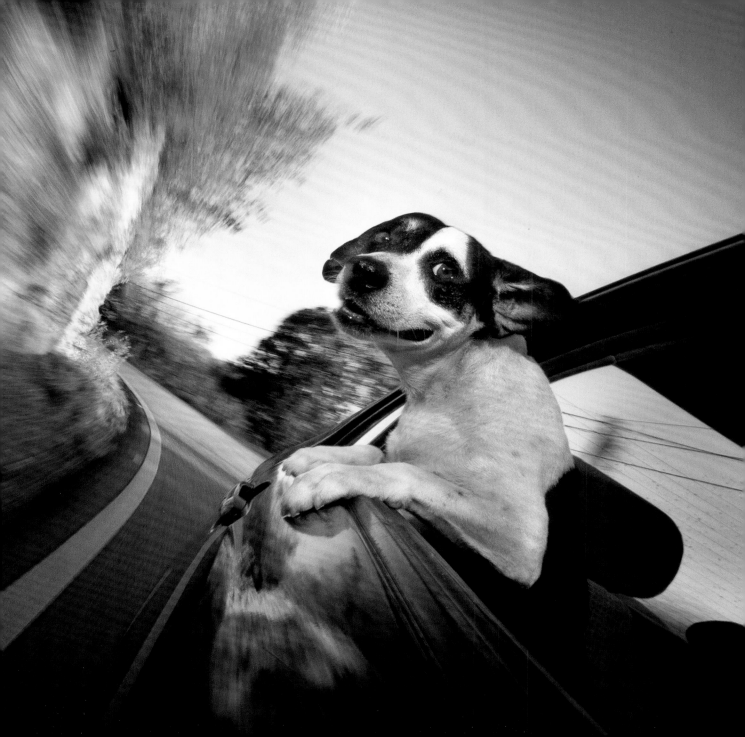

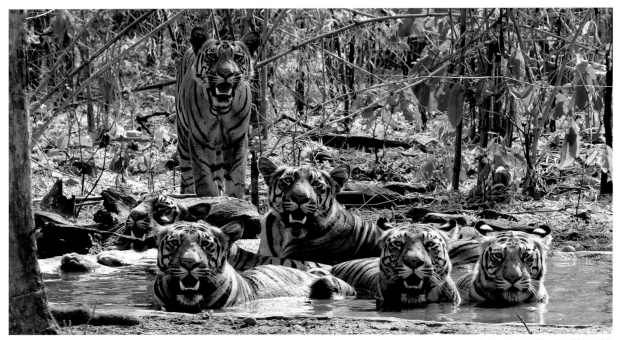

»LAND **OF THE TIGER**

This is the shot of a lifetime. A photograph of six large tigers immersed in a small stream, as if they were at a spa, is almost unfathomable. Remarkably, five out of six animals are looking directly at the camera. I relate to this photo as a universal family portrait of the almost-adult kids and parents together before everyone grows up and leaves home.

The photographer, Nirmalya Chakraborty, knows these tigers as a family of parents and four subadults. Chakraborty writes: "This is a rare capture after much patience that at last bore sweet fruit."

HOW TO PHOTOGRAPH WILDLIFE

- **Know your subject's behavior,** both for your own protection and to help you get better shots.

- **This photograph requires** a long lens to capture the image without getting too close.

- **When photographing animals,** extreme patience is required. Attempt to take the photograph you want many, many times.

- **If photographing animals is your passion,** connect with people or organizations that can help you learn. Contribute financially, invest your time, and volunteer. This may give you the opportunity to access the animals you are passionate about.

»IMAGINARY FRIEND

laughed out loud when I saw this sheep head-butting a screen door. This photograph speaks the universal language of humor. Let's face it, we have all walked into a sliding door at some point in our lives. The mirrored reflection reads as a metaphor of the sheep knocking her head against the wall and getting nowhere—definitely not inside.

Showing a sense of humor in your photographs is a wonderful way to engage the viewer. Your approach can be intentional or serendipitous. It is a gift to make people smile or laugh. Some of the funniest shots highlight behavior that humans and animals have in common.

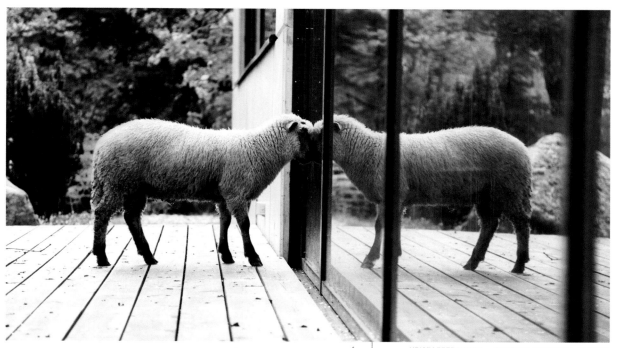

KRISTOFFER VAIKLA — SUURUPI, HARJUMAA, ESTONIA

103

»SHELTER **IN THE STORM**

Photographers have taken many wonderful shots of snow macaques in Japan's hot springs. But this image is particularly poignant in that it creates a universal portrait of a mother-child relationship. The mother's expression of awe and awareness of the weather, as evidenced by her open mouth and upward gaze toward the falling snow, are entirely unexpected. Secure in her embrace and perhaps ready to drift off to sleep, the baby looks off into the distance. An animal's surroundings can be a powerful factor in a photograph, as context helps the viewer understand the story about the animal's life.

HOW TO CONVEY A MOOD

- **Be careful of shooting *too* much** and missing the moment. The downside of using a digital camera is that you might click so much you miss the "decisive moment."

- **Be empathic and sensitive** to your subject—in this case, universal mother-baby love.

- **Choose your depth of field carefully.** This long lens set at f/5.6 rendered the lovely, soft focus around the monkeys.

TAKESHI MARUMOTO / A JAPANESE MACAQUE HOLDS HER BABY — TOKYO, JAPAN

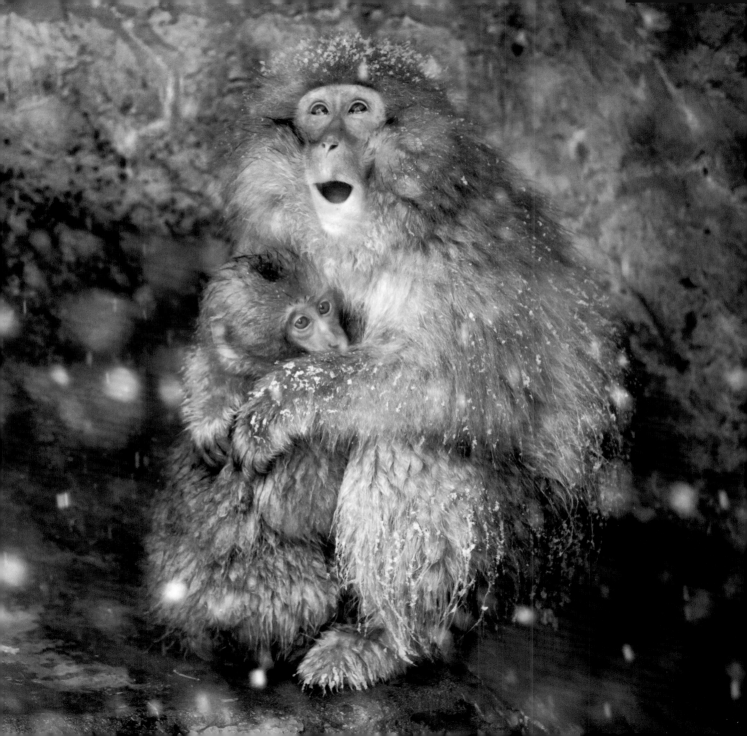

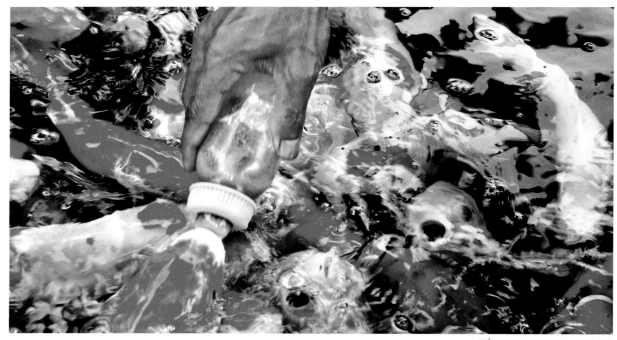

»FEEDING FRENZY

This image captures a popular attraction in Thailand, but it transcends any generic, touristy photo. A bright orange koi stretches its head out of the water to suck on a baby bottle held by a human hand. A cluster of open-mouthed fish desperately want to latch on to the bottle. Motion is everywhere, and the slow shutter speed amplifies the frenzy. The overexcited fish create a chaotic rippling in the water. Meanwhile, the oddly colored pink-and-brown bottle clashes with the orange fish. Weird! But weird is good. The surreal quality of the scene makes it that much more intriguing.

| HOW TO | KEEP AN OPEN MIND |

- **Take a chance and shoot.** You have nothing to lose.

- **Consider the happy accident** when reviewing your photos. Photos may have technical glitches but still create an interesting or quirky scene like this one does.

- **Show your images to others** to see their reactions. Listen first. They may love an image that you have overlooked. But after considering all feedback, go with your gut.

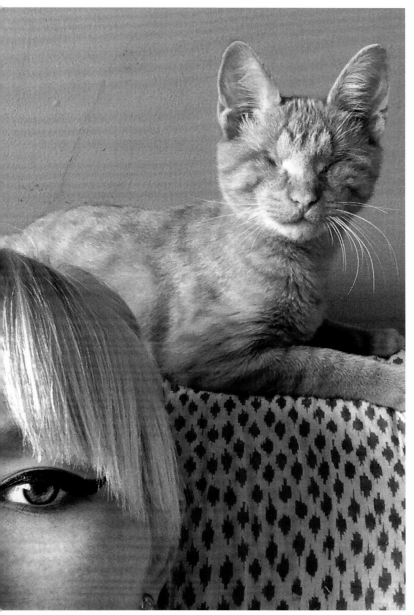

HANNAH HARVEY — MASSACHUSETTS

»A PERFECT PAIR

The photograph is a staged self-portrait taken with a smartphone, but the photographer managed to compose a successful shot, even with minimal control over the camera's settings. The approach is deliberate, confrontational, and challenging. This composition is edgy, with an extreme crop of the face that begins at the corner of an eye staring directly into the camera. The eye, dramatically accentuated with makeup, is juxtaposed against the eyeless cat. The two are linked visually by the similar colors of the woman's hair and the cat's fur. Dillon is a blind rescue cat, but the photographer says that Dillon rescued her right back.

HOW TO BE CREATIVE WITH A SMARTPHONE

• **Do not put off photographing** because you think you do not have the right equipment. As this photo shows, it's possible to create a powerful photo with the most basic of cameras.

• **Photograph** the people and things you love.

• **Consider using your camera** to create a visual diary.

• **Plan your color palette.** The harmonious colors in this photo greatly increase its impact.

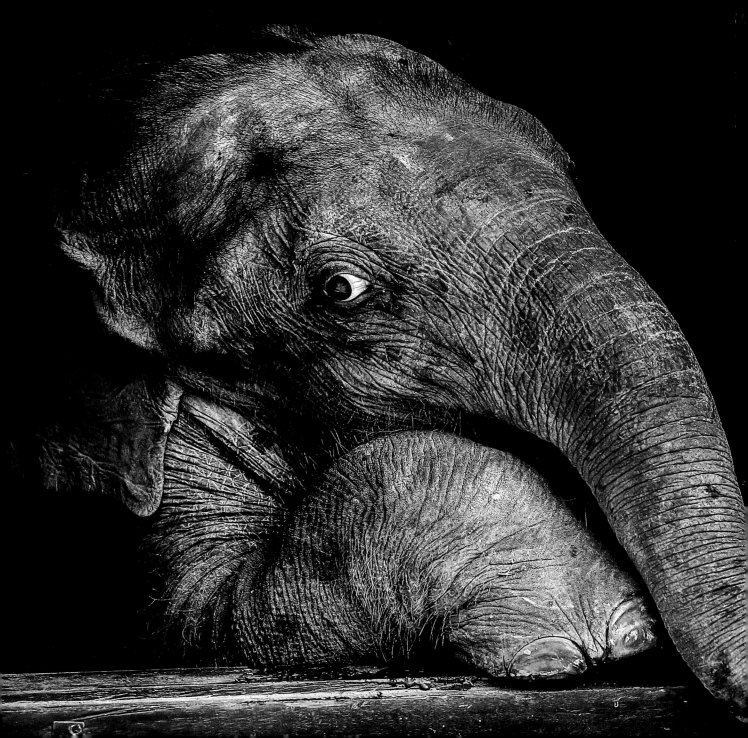

»ORPHAN ELEPHANT

This photograph is a strikingly compelling portrait with uncomplicated but dramatically effective composition. Structurally the baby elephant is literally in the window frame, which functions as a frame within a frame. The elephant has surprisingly negotiated this barrier to see the photographer one last time. As viewers, we first make eye contact with the elephant and then follow his trunk to his front foot, which lightly circles the bar of the window frame and connects to his other foot. His wide-eyed, beseeching look is so compelling, especially because we see the whites of his eyes—an interesting element in photographs of animals. This image is at once endearing and haunting.

THE PHOTOGRAPHER'S STORY

"I met this baby elephant while documenting an elephant rehabilitation and release program. He had lost his mother in a flood. I spent a lot of time with him and became quite attached. When I finally had to leave, I turned around one more time to look at the building that housed him and saw that he had gotten up on his hind legs and was looking out the window at me. His expression was so strikingly human in that moment, and I saw in his eyes something universal and profoundly expressive." —Julia Cumes

KĀZIRANGA, ASSAM, INDIA

»ONE MINUTE OLD

This newborn piglet, with its umbilical cord still attached, seems to smile right at the camera. The arms create a frame around the piglet and tell the story of passing along this sweet bundle. The color palette is mellow, and the pale pink color of the pig pops against the blue background. The focus and drama of the photo lie in the piglet's black markings and its eye, which looks directly at the camera. This adorable piglet's eyes and expression create a humanlike quality, which is one of the most tried-and-true ways of creating connection in a photo of an animal.

HOW TO SPOT A SHOT

• **Eye contact** can draw a viewer in, but it is not a foolproof formula. Experiment with shooting portraits that do and do not include direct eye contact with the animal.

• **When photographing animals,** look for the same qualities you would want to capture in a photograph of a person—in this case, the eye contact and the smile of the new baby.

• **Choose your subject deliberately.** This piglet may have stood out because of her eye markings.

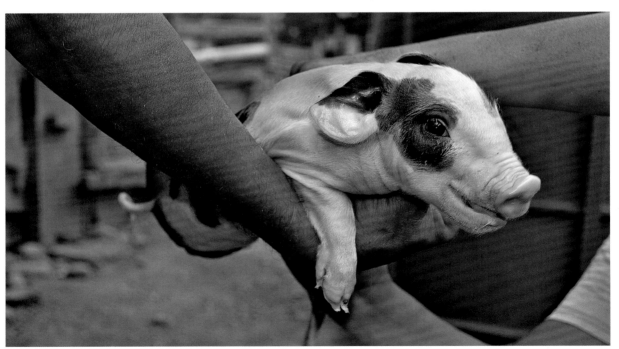

JOSE A. SAN LUIS — KALINGA, CAGAYAN VALLEY, PHILIPPINES

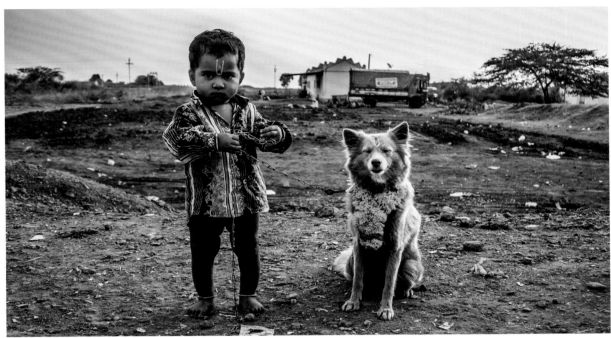

»CHAINED **LOVE**

A sense of equality emanates from this boy-dog pair. They are close in size, as the child is young and the dog is petite. They are linked companions, literally, as the child holds the dog's chain-link leash with two hands. The dog's eyes are closed, as if in a gesture of supreme patience with his too-young master. The foreheads of both the child and the dog are adorned with religious symbols. The dog is clearly identified as a participating family member with festive marigold flowers, which add to the charm of this unusual capture.

HOW TO TELL AN ANIMAL'S STORY

- **Show the relationships** between the animals and the people in your photographs by looking for expressions of love, interdependence, and gratitude. Capture the connection.

- **Seize opportunities** to create context for your photos. The background of this photo speaks volumes about the boy-dog pair.

- **Be aware** of cultural or religious symbols displayed by the subjects of your photos. They can help tell a more complete story.

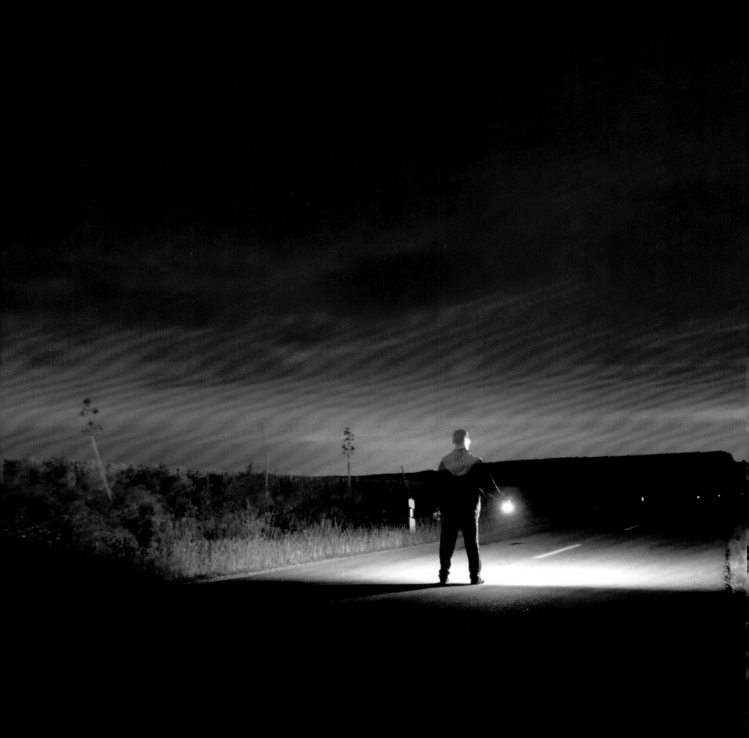

AFTER MIDNIGHT

BY DIANE COOK AND LEN JENSHEL

A SHOT IN THE DARK

As inspiration for this assignment, we are using the lyrics from J. J. Cale's song "After Midnight,"—famously covered by Eric Clapton in the 1970s. The lyrics begin, "After midnight, we're gonna let it all hang out."

So how are you gonna let it all hang out? We've spent many a midnight hour making pictures. In fact, the night is an amazing time to photograph: It's magical, mysterious, and metaphorical, whether by moonlight, ambient city light, or any light you find yourself in after the clock strikes midnight.

Those of you way up in the Northern Hemisphere may have the midnight sun to work with. And for those of you way down south, who knows, maybe an amazing display of the aurora australis? For everyone else, use your imagination to show what "after midnight" means to you.

What do we love most about photographing after midnight? We've learned to embrace the unknown, the darkness, and the strangeness. The night is mysterious, magical, and often surreal, but mostly dark. You simply can't see everything out there, and you have to take a leap of faith and to trust your intuition and instinct. Especially in the dark, the camera can "see" what the human eye cannot.

When we shoot for *National Geographic* magazine, the conditions aren't always ideal, the weather doesn't always cooperate, and the light is never what we envisioned—but on a professional assignment, we still need to come home with the goods. Wherever you find yourself—even if you are inside—you'll have lots of interesting nocturnal potential.

Pay careful attention to your exposure, and beware of overprocessing. You don't want your nighttime shots to look as if they were taken during the day. The last question you need to ask after you have made your best frame is this: "Now, how can I make this picture even better?"

ABOUT THE ASSIGNMENT EDITORS

Diane Cook and Len Jenshel, NATIONAL GEOGRAPHIC PHOTOGRAPHERS

Two of the foremost landscape photographers in the United States, Cook and Jenshel make award-winning images that explore issues of beauty, boundary, culture, and control over nature. Their work has been published in many books and magazines, including *National Geographic*.

JUAN OSORIO — NEW YORK, NEW YORK

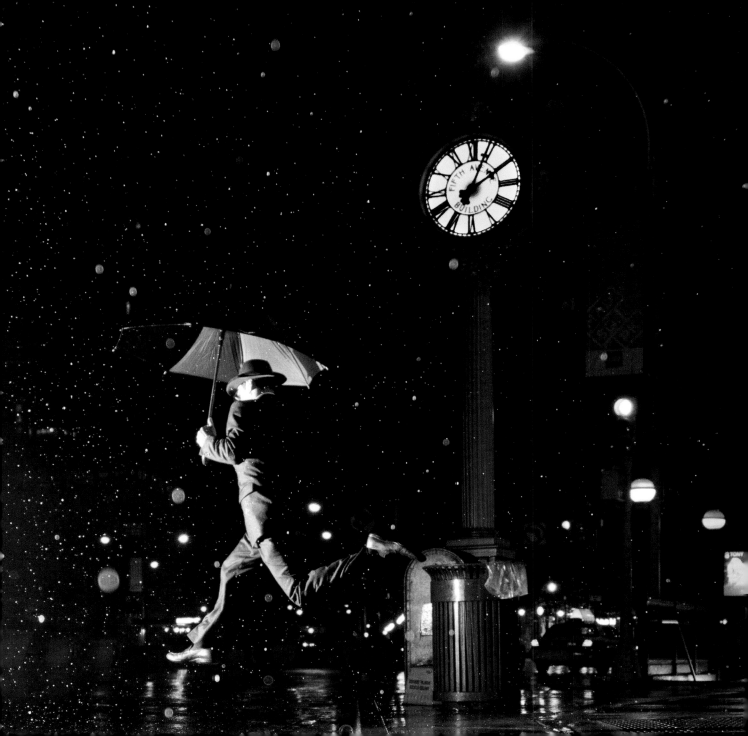

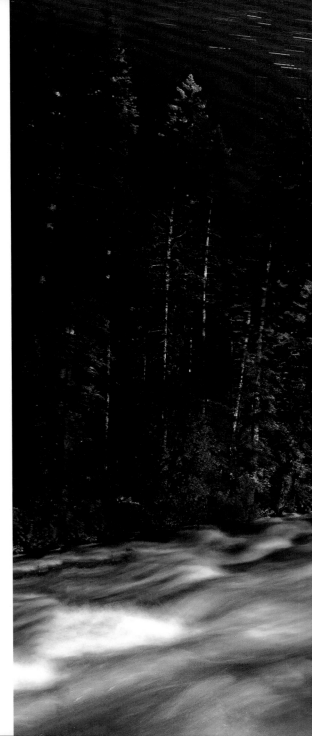

»NIGHT ON THE RIVER

There is something magical about this nocturnal landscape. The incredible sweep of stars and sky pulls us into the image and rushes alongside the wonderful blur of the fast-moving river. The still forest, a perfect counterpoint to this motion, makes for an arresting image.

Capturing a nighttime scene like this, with little or no illumination, requires one of two methods. You can bump up your ISO to 3200 or higher, in order to get enough exposure for the image. Or you can opt for a longer exposure, which results in a blurring of elements in motion.

This photograph was created with a technique called light painting, in which the photographer uses light to illuminate or "color" the scene. The exposure for this image was approximately five minutes, which gave the photographer time to use a high-powered flashlight to light up the trees and the river. The result? The dazzling effect of simulated moonlight.

HOW TO "PAINT" WITH LIGHT

• **To create an image using light painting,** shine a light source onto various sections of the scene for different amounts of time.

• **Flashlights and headlamps** are essential for working in the dark.

• **Be sure to move** the light source around to achieve a softer edge. Holding the light in just one area will create hot spots.

JOHN WARNER — BOULDER RIVER, MONTANA

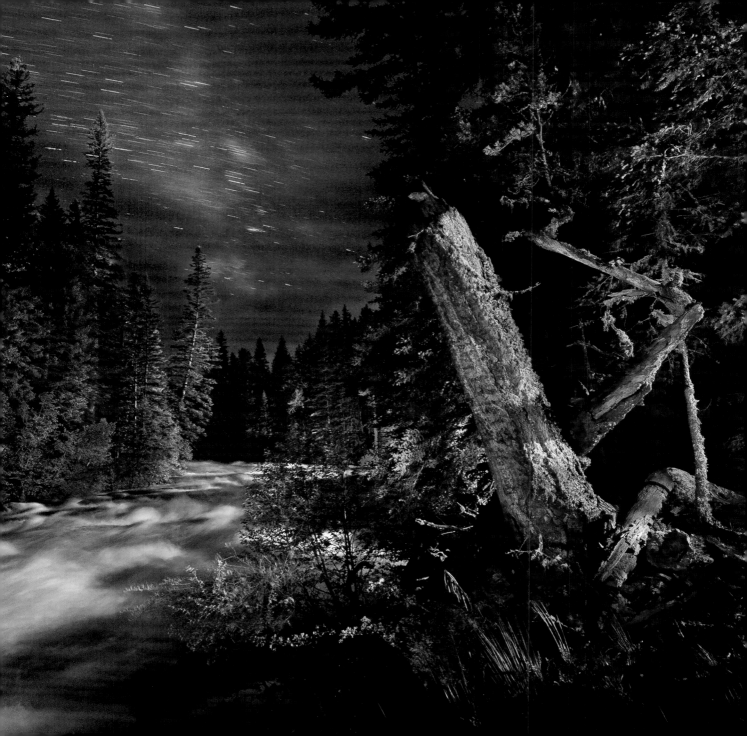

»STREETS **OF NEW YORK**

n this photograph, many layers add up to a complex nocturnal narrative. The homeless man with his arm sprawled out is beautifully juxtaposed against the bus shelter's poster, in which the man's arm is also outstretched. The words in the poster—"We're still here" and "the leftovers"— add another poignant layer of meaning to this image. In addition, the homeless man is bathed in an ethereal light while sleeping next to a pile of garbage bags—a contrast that completes the irony and the narrative beautifully.

The photographer paid close attention to framing, vantage point, details, and lighting. This is a complicated and meaningful photograph.

HOW TO LIGHT THE NIGHT

● **A lens hood is helpful** at night (especially in urban settings), as it will prevent unnecessary light from entering the lens and creating unwanted lens flare.

● **Mixed lighting—** whether flashlight, flash, or ambient light—vastly improves the final image.

● **If you find yourself uncertain** about whether to use color or black and white, shoot the image in color and convert to black and white in postproduction.

MICHAEL WAGNER — ALBANY, NEW YORK

»A FLIRTY SKIRT

The conventional way to photograph a person would be to avoid cutting off the subject's head. This image throws convention aside and takes a more lyrical and whimsical approach to photographing people. The low vantage point is unusual and daring. The figure blocking the main light source creates an intriguing shadow, an interesting silhouette effect, and a beautiful backlighting effect on the skirt.

From this photograph we may not know this woman's exact identity, but the details of how this image is captured reveal an aspect of her personality. In photography, ambiguity is an asset—less is often more. The strong complementary colors of orange and blue create a dramatic backdrop to this unconventional and charming portrait.

HOW TO WORK WITH YOUR LOCATION

- **If you are taking pictures** that cannot be repeated, scout out the location beforehand, and be prepared for anything.

- **At night, and especially indoors,** check your white balance setting. "Auto" doesn't always get it right, so tweak the settings to get the effect you are after for each picture.

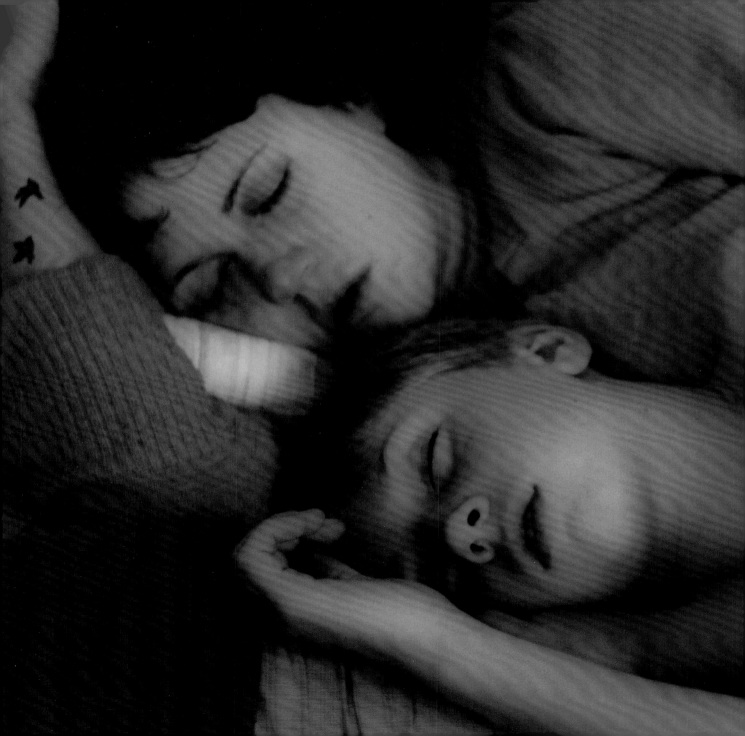

»SLEEPING BEAUTIES

You don't have to travel far from home to find suitable or intriguing subject matter. Photographing someone you know well often leads to new discoveries—and successful pictures. This image reminds us of the work of Gertrude Käsebier, a pioneer of photography who often shot personal themes, such as motherhood, in the late 1800s. The composition and lighting are excellent, but what stands out is the idea of photographing people asleep. This picture is soft, peaceful, dreamy, and suffused with tenderness and love. The sepia tone not only lends itself to a look of antiquity, but also contributes to the romantic quality of the image.

THE PHOTOGRAPHER'S STORY

"It's a Friday night, and we don't really go out with kids at home. While watching a movie these two fell asleep on the couch. My older son laughed as I set up the tripod and started taking photos of them. It's 2 a.m., and I'm trying out black and white with a sepia tone. You'll notice the bird tattoos on her arm. Two years ago we decided we needed more excitement in our lives, so I bought a Harley and she got tattoos. Life is for living." —Adrian Miller

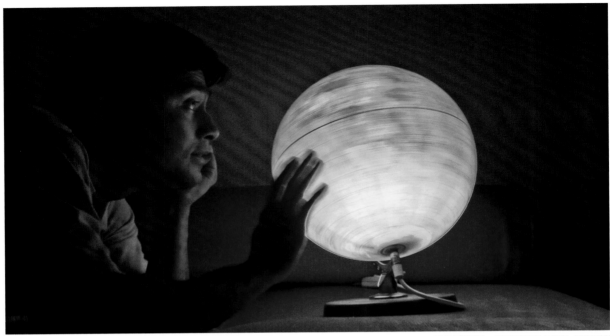

JOYDEEP DAM — DARMSTADT, HESSE, GERMANY

»AS THE **WORLD TURNS**

Photography can be literal, documenting a scene as it exists, or conceptual, which involves communicating a preconceived idea. This spinning, illuminated globe is a journey of the mind, with the spirit of discovery on the next horizon. We love that "dreaming" becomes the subject of a photograph. Our eyes go first to the spinning globe and its twirl of seductive colors. Next, we discover the warm glow that brings the man out of all that darkness. He has a dreamy glint in his eye, and his mind spins with thoughts of future travels and adventures. This photograph contains a well-executed conceptual narrative.

HOW TO CONTROL YOUR EXPOSURE

• **Your eyes adjust to darkness,** so what appears to be a good exposure on your LCD screen will actually be underexposed. If you have a DSLR camera, adjust your LCD brightness to the "–1" setting.

• **Learn to use the histogram feature** on your DSLR camera to check exposure.

• **A combination of stillness and blur** in the same frame can be an effective tool. Experiment with different shutter speeds and ISO settings in order to get the desired effect.

»SOLSTICE SUNSET

One of the first things we learn in photography is to keep the light source behind the camera. This photographer, however, bucked the rules and created a beautiful image. By shooting into the setting midnight sun, he creates a starburst effect and makes the glowing rays on the horizon even more dramatic.

He cleverly used a secondary light source on the woman and dog. Had he not done so, shooting into the sun would have rendered them as dark silhouettes with no detail at all. In the end, he created a powerful photograph that transports the viewer into this private yet majestic scene.

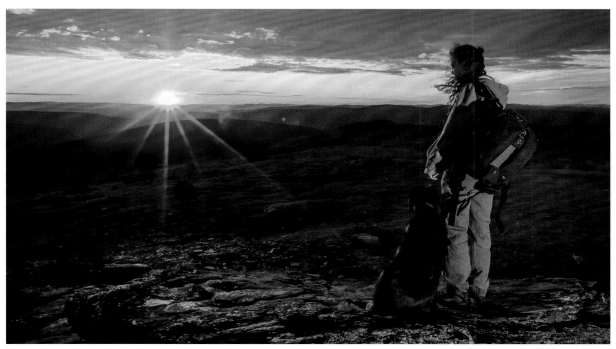

RONN MURRAY — FAIRBANKS, ALASKA

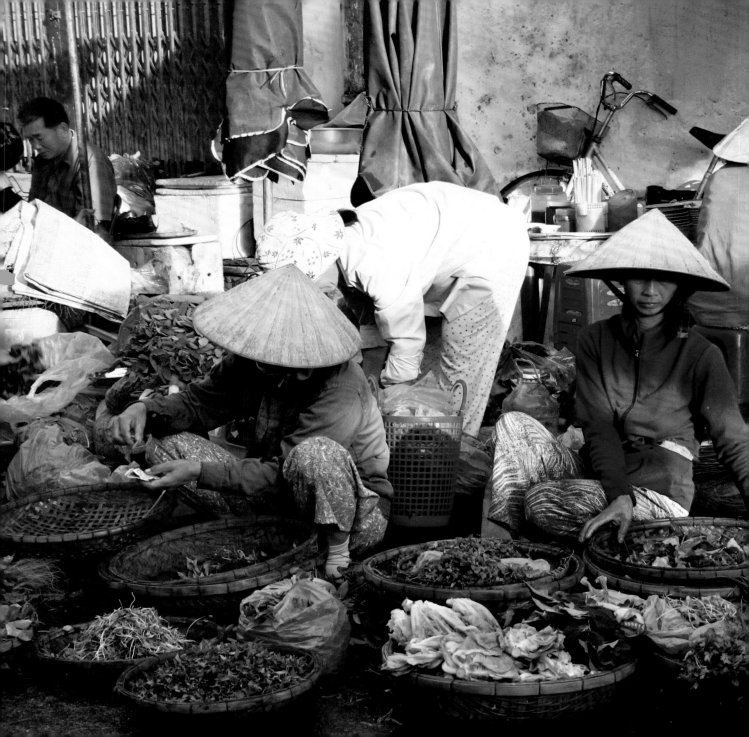

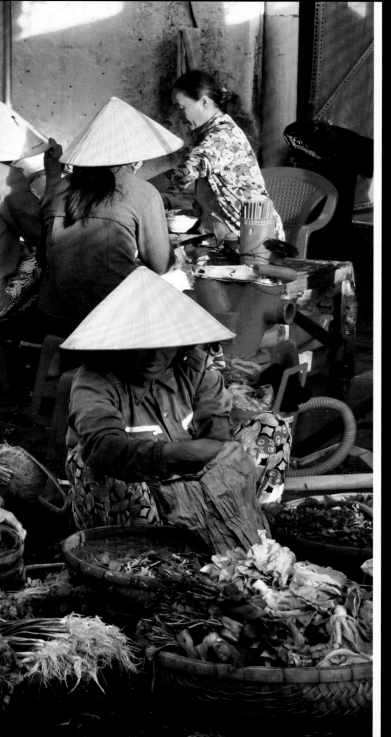

FOODSCAPES

BY PENNY DE LOS SANTOS
AN INVITATION TO DINNER

Photography has always been my way into the lives of people, whether they are a family sharing a meal in the Mediterranean, a group of farmers harvesting grapes in northern California, or the elder ladies of a Sicilian village drinking wine and cooking. Food and the moments that surround it are incredible ways to dive into a community and to discover stories and real human moments.

In this assignment, try to capture what you see at the crossroads of food and culture. Foodscapes are about so much more than showing what's on the plate. They tell the story of the landscape of food from table to farm and beyond. They are about everything that surrounds food, especially the connections that happen before, during, and after a meal.

Two things come to mind when I think about shooting great foodscapes. First, I want to be where the action is. I want to stand wherever the energy in a scene is most intense. And when I'm there, I wait with my camera to my eye. I am waiting for a moment. Maybe it's fast-moving cooks, slinging pans and yelling out orders in the kitchen. Or maybe I'm on a step stool so I can hover above a crowded table and capture hands grabbing for bowls and plates. My point is, put yourself where the action is—not ten feet away from it, but right in front of it.

The second thing I think about is how the scene feels. Is it chaotic, empty, lonely, or happy? As a photographer you should aim to capture that feeling. Think about the creative devices you can use to create mood in a photograph: lighting, motion, details, and so on.

What I love most about photographing food culture is its powerful storytelling ability. Food can tell us so much about history, culture, and ourselves. Next time you sit at a table in another culture or community, think about the story behind what is on your plate—who made it, who grew it, why it matters. Think about those moments, then grab your camera, and go.

ABOUT THE ASSIGNMENT EDITOR

Penny De Los Santos, FOOD AND TRAVEL PHOTOGRAPHER

An American born in Europe, with a family history tied to the Texas-Mexico border, De Los Santos began photographing as a way to explore her diverse cultural background. She has traveled on assignment to over 30 countries.

SOMA CHAKRABORTY DEBNATH — WEST BENGAL, INDIA

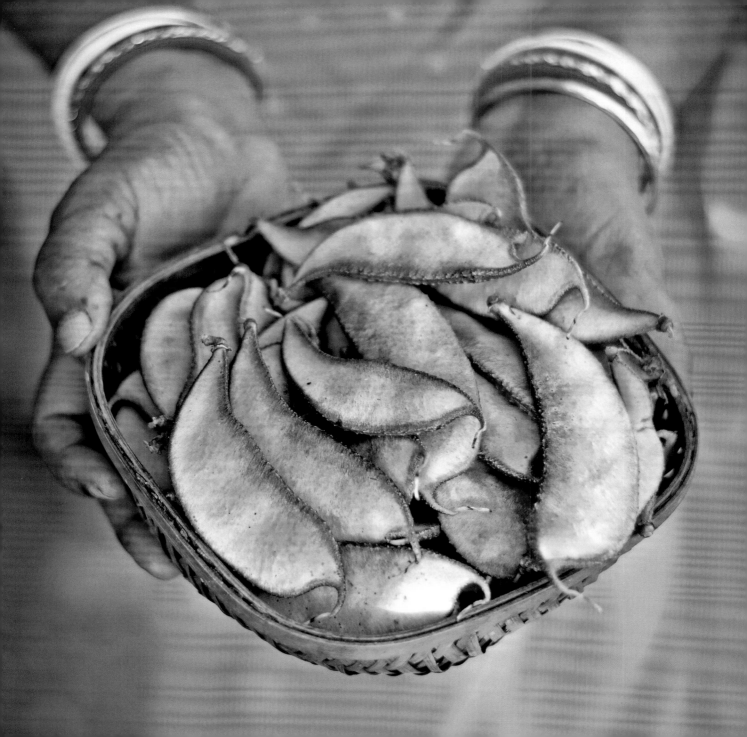

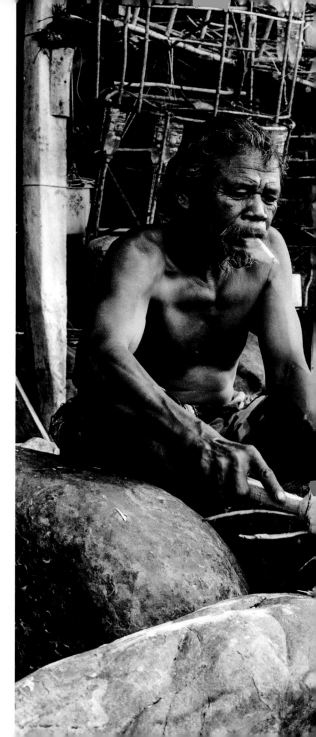

»SEA GYPSIES

When I am shooting a story about food in a foreign country, or even in my own backyard, I love to head straight to where the cooking is happening. That's what is so great about this image: It takes me immediately into these men's world. The fishermen are shirtless as they cook their meal. They are surrounded by boulders and hanging fishing cages. The exposure allows the viewer to see everything, from the veins in the men's bare arms to the smoke rising from the obscured fire. This image grabbed my attention and made me want to know more. It tells a story, informs the viewer, and beckons us to ask questions.

HOW TO CAPTURE FOOD AS CULTURE

- **Look for unusual people** or interesting jobs. Then spend time cultivating trust so you can gain the access you need.

- **Follow your subjects** throughout their day and search for unique moments.

- **Where there's smoke** there's fire, and a great shot. Follow the flames to find the action.

KÁRI JÓHANNSSON — KRABI, THAILAND

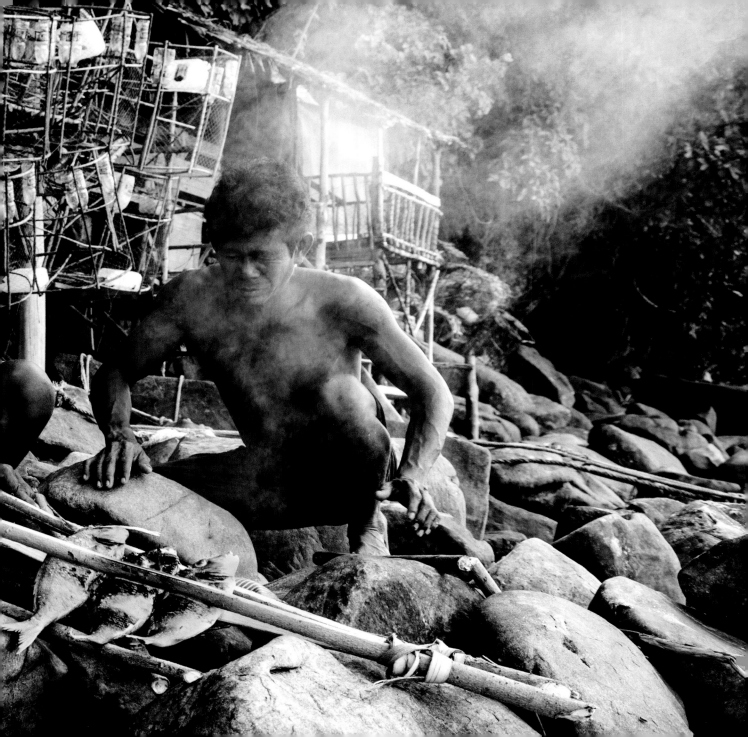

»FEAST **FOR THE EYES**

From any other angle this moment would be straight-forward and expected, but shooting from overhead created a graphic composition that celebrates the background and the bright colors of the food. As observers, we feel privileged to be allowed inside a scene we might not normally experience. This image feels almost voyeuristic. From above you can also appreciate the texture of the ground and the beautiful arrangement on the platter. The person wears colorful and uniquely formal attire, which serves as a backdrop to the food. This is a photograph of ingredients, but the unusual perspective in this image heightens the experience.

HOW TO CAPTURE A UNIQUE VIEW

- **Walk around** the food subject 360 degrees before shooting.

- **Look at the food from overhead,** from a three-quarter view, and from a side view and decide which way the food looks the most appealing.

- **Capture unusual details** around food, such as: condensation, color, textures, weathered hands, beaten-up knives, old cutting boards with dark patinas, etc.

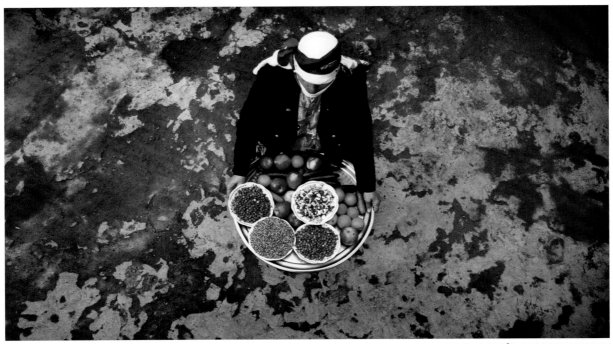

ALI HAMED HAGHDOUST — LEQALÂN, EAST AZERBAIJAN, IRAN

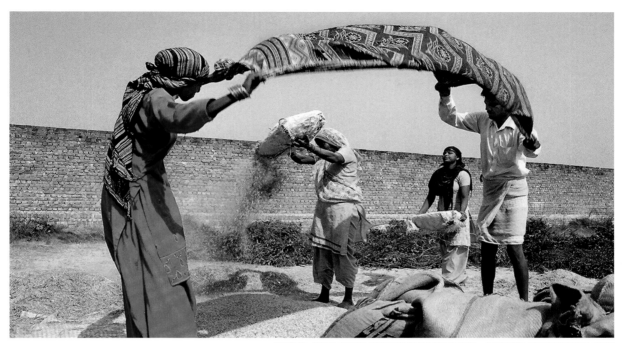

»IT TAKES A VILLAGE

Looking at this photo is like watching a dance with every character in place and helping to tell the story. There is so much movement and energy in this frame. The bright red color of the woman's dress draws us in to the action.

To make a great storytelling photograph, look for a rare scene, and then elevate the moment by anticipating and thinking about your composition. Try to include elements that create a backstory for the action. In this case, the photographer used framing and layering to create context and visual interest.

HOW TO TELL A VISUAL STORY

- **Try to think ten steps ahead** of where the subject might go at all times.

- **Capture the food** before it's on the plate. Show the harvest, the cooking, and the preparation.

- **If possible, layer images** with movement in the background. This will add weight and interest to your composition.

- **Get down low** to convey intimacy and perspective.

- **Use your subjects** as a way to frame the action.

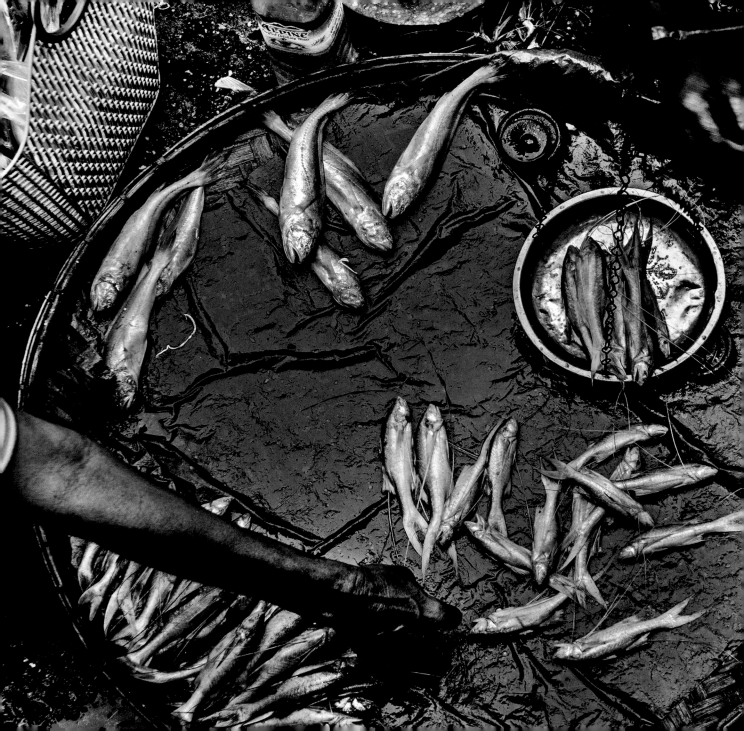

»FISH **FOR SALE**

The power of this image lies in its details: the thin white fish, the wet surface, the dark arms, the hands in motion, the primitive scale, and the bare dirt floor as a backdrop. These elements give tremendous emotion and tension to the frame. The photographer's use of perspective—photographing the image from overhead—makes for a graphic and clean image. The black-and-white palette strengthens the image by allowing the shapes and tones to set the mood.

Shooting in black and white can transform a so-so image into something entirely different. Black-and-white photography is much more forgiving than color and allows the photographer to focus on composition, light, and tone—a liberating practice.

THE PHOTOGRAPHER'S STORY

"Among the shouting of the fish and vegetable sellers, in this chaotic riverside market, I found solitude and beauty in these simple circles. A few tiny fish provide an affordable protein. This is likely this family's one daily meal of fish curry, spooned over a hearty portion of rice."
—Joshua Van Lare

YANGON, MYANMAR

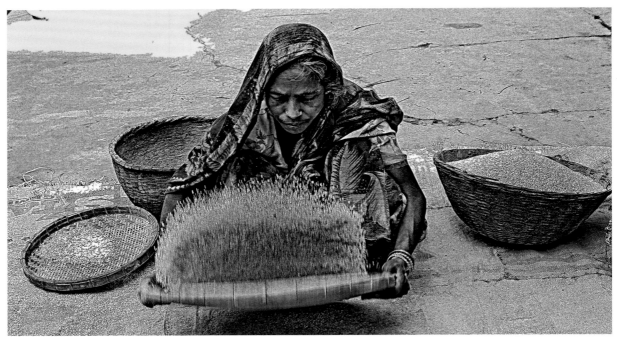

SRIMANTA RAY / A TRADITIONAL METHOD OF CLEANING RICE — KAILĀSHAHAR, TRIPURA, INDIA

»THE RITUAL **OF RICE**

Every image has a decisive moment. Some, like this one, are more obvious—the photographer captured the exact millisecond when grains of rice were perfectly suspended in midair. Other moments are harder to anticipate. When you come across a scene, step back and really think about when the decisive moment will happen. Remember that the moment can be quiet and soft, or it may hit you over the head. The image can have several layers and a complicated composition, or, in this case, it can be quite simple. The idea is to hone your ability to know when to wait for it and when to try a different approach.

HOW TO MAKE SIMPLE PHOTOS SAY A LOT

- **Think about** what you are trying to say in a photograph. What is your point of view?

- **If your subject is doing something** while preparing food, stick with it and look for pauses or breaks in the routine. Try to anticipate the photograph.

- **Don't be afraid** to shoot simple, quiet photographs. Sometimes they speak the loudest.

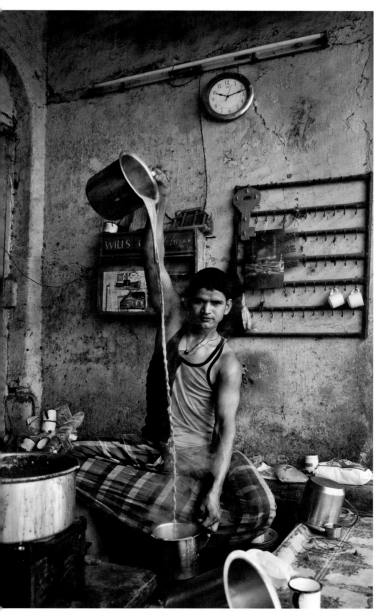

MITUL SHAH — AHMEDABAD, GUJARAT, INDIA

»THE TEA **MAKER**

The colors and details in this scene tell such a compelling story. I love how the teal background, the yellow shirt, and the hints of red make this image jump. This *chai wallah,* or tea maker, is in his own environment, and you can feel it in all the details—the cups on the table, the turned-over kettle, and the clutter of his work surrounding him. The photographer has captured the subject's mood so well. Even if the wall weren't such a vivid color, the subject would still stand out because of the intense expression on his face. This young man clearly takes great pride in his ability to perform this feat and to do his job well.

HOW TO MASTER FOOD PORTRAITS

- **Identify someone** who is interacting with the food and has striking features or an interesting expression.

- **Take time to study the person.** Contemplate how you will make a portrait of your chosen subject and what role the food will play in the photo.

- **Try to use all the elements** of composition, color, light, and moment to make a portrait that is expressive, moving, and evocative. Portraiture is a hard skill to master, but with practice you can get there.

»HOT FOOD **ON A COLD DAY**

This image invites me to travel to a different place, to learn something new, and to see something in a unique way. It is evocative and thought provoking, and it makes me ask so many questions. This portrait captures a true moment in a market scene where visual elements are constantly shifting. In this case, the setup of the food, the steam, and the woman's clothing and gear come together to tell this woman's story. The woman's body language is non-emotive, but the intensity in her eyes speaks volumes. The use of color and light create mood for this image. It takes time and hard work to recognize moments like this, but when you find them, it is worth all the waiting and searching.

"Even in the below-freezing temperatures of wintertime, there are always food vendors doing business outside in Harbin, China. That's because Chinese people take meals and eating very seriously. No one misses a meal no matter where they are—or, for that matter, how cold it is."
—Wesley Thomas Wong

HARBIN, HEILONGJIANG, CHINA

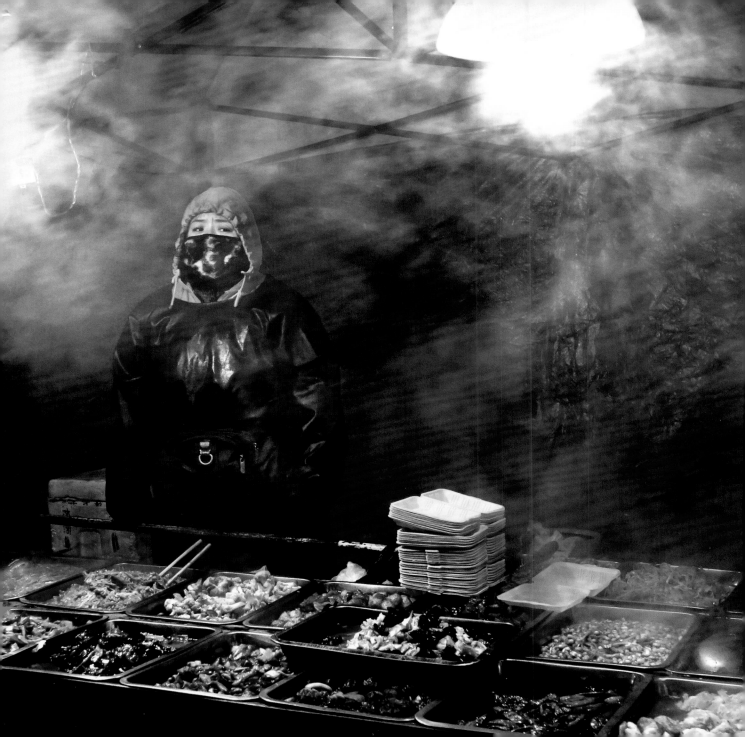

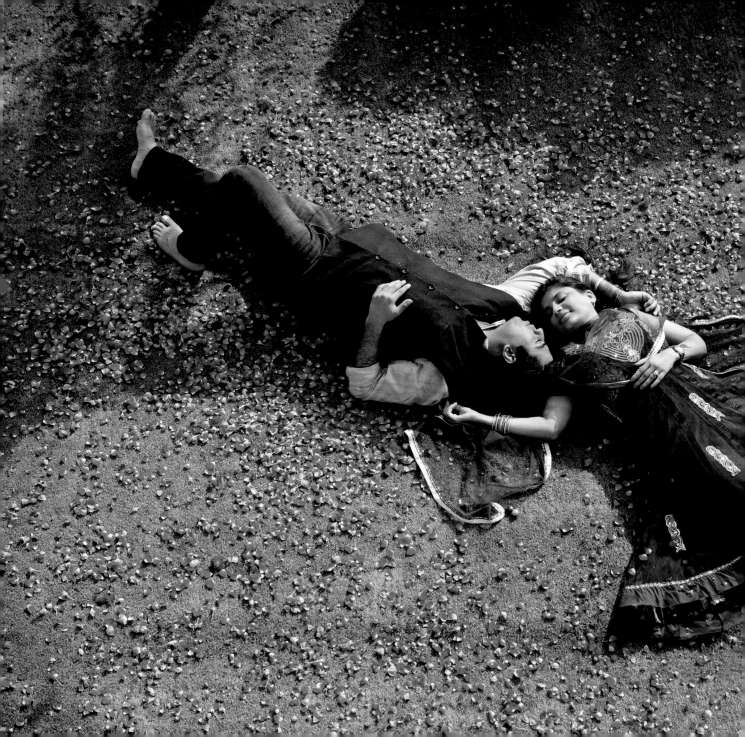

LOVE SNAP

BY LYNN JOHNSON, ELIZABETH KRIST & MAGGIE STEBER

SHOT THROUGH THE HEART

Love. We often use this powerful word so casually. Stop for a moment and consider what love actually means to you. Now is the time to turn words into images. Who or what makes your heart sing?

Photography is a powerful voice for all things, physical and metaphorical. How can the people and things you love be expressed with light, movement, and color? Stop and close your eyes. Conjure up the situations that bring out your deepest feelings for your chosen subject. Is it when your husband cooks you breakfast or your wife tucks your daughter into bed? When your mother practices the cello? Or when your dog runs through the woods? What time of day is it? What is the light like?

We live in a Hallmark world, filled with candy-coated images of love. These are not the images that make great photographs. A great photograph is timeless, purposeful, balanced, energized.

Pretend you need to make one new frame of someone you love, to bring with you on a long journey. But you are absolutely forbidden from making the classic snapshot—no standing at eye level and shooting a head-and-shoulders frame straight on. Try catching your beloved in motion, or shoot from different angles.

We want to goad you into a deeper originality, a raw authenticity going beyond the slick, idealized ads promising love in impossible ways. Don't settle for anyone else's ideas. Only you can create your own true vision of love.

ABOUT THE ASSIGNMENT EDITORS

Lynn Johnson, NATIONAL GEOGRAPHIC PHOTOGRAPHER, **Elizabeth Krist,** *NATIONAL GEOGRAPHIC* MAGAZINE, **Maggie Steber,** NATIONAL GEOGRAPHIC PHOTOGRAPHER

Featured in the introduction to this book, Johnson (left) has been photographing the human condition for 35 years. A National Geographic photography fellow and a "Woman of Vision," she is a regular contributor to the magazine.

A senior photo editor, Krist (right) curated Women of Vision, a traveling exhibition at National Geographic. She also judges competitions, teaches workshops, and reviews portfolios at photography festivals.

Also named a Woman of Vision by National Geographic, Steber (left) is an award-winning documentary photographer who has worked in 65 countries and has been a contributor to *National Geographic* magazine since 1988.

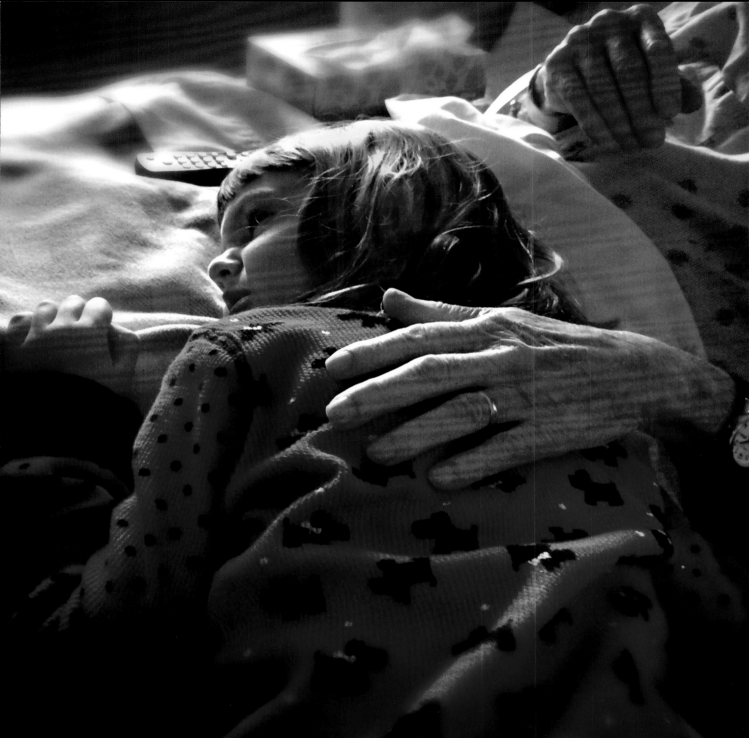

»ARTISAN'S BALL

On fields and patches of grass all over the world, children play soccer for the love of the game. It is a completely democratic sport, open to everyone. Economics has nothing to do with it. Children who can't afford real soccer balls make them from anything they have—a rag, a sock, or a tire. Sometimes they are made of plastic or even bark, which can be weaved into a ball. As long as the ball rolls, it's perfect.

You can feel the love and care the boy has put into this ball. It represents initiative, planning, pride, and problem-solving skills. Each ball is a unique signature of the person who made it. This simple photograph tells a big story.

THE PHOTOGRAPHER'S STORY

"Timamo, my 15-year-old neighbor, rushes home, completes his chores as quickly as possible, then begins constructing his soccer ball. Every child has his or her theory/process on making the best ball possible. This is Timamo's." —Rafael Hernandez

PEMBA, CABO DELGADO, MOZAMBIQUE

»PLAYING **HOOPS**

Children love their toys, even if the toys don't always cooperate. These boys skillfully guide old bike tires as hoops. It's a joyful battle for control over the tire. This photo has so many things going for it: the composition, the frozen action, and, most important, the story. Children in developing nations play with whatever is available. Running hoops down the road is a common game in many cultures—one of those universal experiences that transcends borders and cultural boundaries. These kids may have limited choices, but the joy they feel while playing is limitless.

HOW TO EVOKE FEELING

- **Create mood** by using different tonal ranges with digital files—from saturated color to sepia—as this photographer did. The sepia tone alludes to a memory and evokes a feeling of nostalgia.

- **Look for interesting ways** to frame your shots. This photographer captured the exact moment when one boy was framed by the other's hoop.

»A CUB IN HIS DEN

Which is more popular, pictures of cute animals or pictures of cute kids dressed up as animals? I chuckle each time I see this photograph. This little baby, all dressed up in his bear outfit, is smiling at his mother, who is out of the frame. He is joyful at seeing her, and she is, no doubt, smiling back at him. The warm lighting sets the mood for this photograph. We can see by the baby's face that he and his mother love each other deeply. We dress up babies because it piques our own imaginations and our hopes for our children. This little bear sitting in his pen, with the world on the wall at his back, is a story in the making.

LORI COUPEZ — CHICO, CALIFORNIA

HOW TO | CREATE EVEN LIGHT

• **The lighting** in this scene is called high-key lighting, which creates a joyful or playful mood. One way to achieve this effect is to raise the ISO so you can hold the camera by hand.

• **Choose your frame and compose it.** The composition and framing in this photo makes the photo informative and even funnier.

»LEAVING THE NEST

've liberated or tended to small birds and baby owls in various places. Once I bought a sea turtle and returned it to the sea. Releasing these animals gave me the most indescribable feeling. I had freed something to go back to its happy life in the sky or sea. This photograph of a father and son helping an injured hummingbird is about the love of freedom and the honor of holding something wild for a fleeting moment. It also shows a tender, unforgettable moment between a boy and his father.

THE PHOTOGRAPHER'S STORY

"This picture was taken on a picnic day. We found a wounded hummingbird that flew and crashed on a window, and my husband picked it up and I started taking pictures. When my husband was showing it to our son, the bird opened its wings and the moment was captured."
—*Karla Maria Sotelo*

ARTEAGA, COAHUILA, MEXICO

»A SPIRIT SONG

This young man is singing his heart out and seems to be transported to a more spiritual place. Love appears to pour out of him, with his voice and body dedicated to the power of his emotion. In the shadows we see the rest of the choir, creating a backdrop that makes the image even stronger. Shot at the peak of the boy's song, the photograph's tone is moody and serious, yet joyful. The composition also works to isolate the subject while keeping important information (the choir) in view. This photograph tells a deep story that's as old and universal as time.

HOW TO SPOTLIGHT YOUR SUBJECT

- **A telephoto lens** gets you closer to the action and stacks up things in the frame for a layering affect.

- **Expose for the light** hitting your subject while being mindful of the background.

- **Try bracketing your shot**—testing several different exposures to capture the desired lighting and the elements you wish to include in the frame.

BRANDY METZGER — SHREVEPORT, LOUISIANA

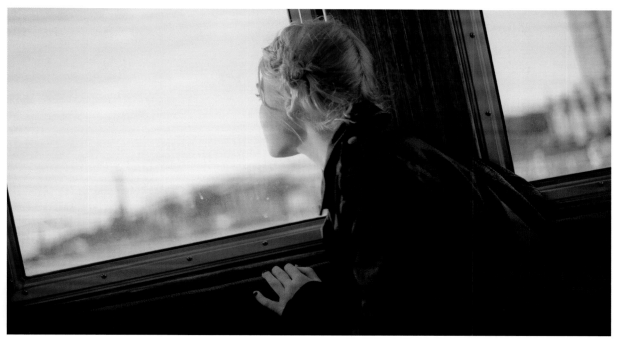

»ON THE LOOKOUT

We are witnessing a memory in the making in this photo. This image reminds me of being young more than any other photograph in this collection. It is about youthful curiosity and the love of new experiences. Lyrical and soft, the young woman in this image seems to be longing for something or someone. Or perhaps she is seeing a new view of the world for the first time. The power of the image lies in its simplicity. The lighting and composition tell the whole story without ever showing the subject's face. It's all in her body language—a spontaneous, happy, carefree moment of discovery.

HOW TO CREATE DREAMY PHOTOS

- **Not everything has to be sharp.** Shooting with a wider aperture allows for creamy light and a dreamy background. Meter for the subject, and let any other light blow out to create a moody seascape.

- **Where you focus** determines the subject of the photograph. The focus is on the girl, not what's outside the window.

»THE FIRST **KISS**

There is only one first kiss after a couple marries. We fall in love if we are lucky. Many of us see ourselves walking hand in hand toward our lives together, on a road laid out before us. Sometimes it works out, sometimes not, but there are always love and hope at the beginning. For this couple, it is an intimate moment, shielded by her veil and made dreamy by light coming from behind. We see their faces and enjoy both the shelter and the mystery behind that veil. The toning colors are both warm and cool, and the soft focus on the couple adds to the mood of the photograph. This photograph is a great example of the wedding fantasy because it's about love and romance and the sense of possibility.

HOW TO GET GREAT WEDDING PHOTOS

- **Avoid posed photos** of the guests at the reception. Take candid shots that make the viewer feel like part of the action.

- **Take some risks.** This photo is backlit and shot through the veil, but it's very moody and romantic. These are the photos that you and the couple will cherish.

- **Weddings are fun and joyful.** Stretch beyond portraits and capture the mood with lighthearted or zany photos.

PETER FRANK

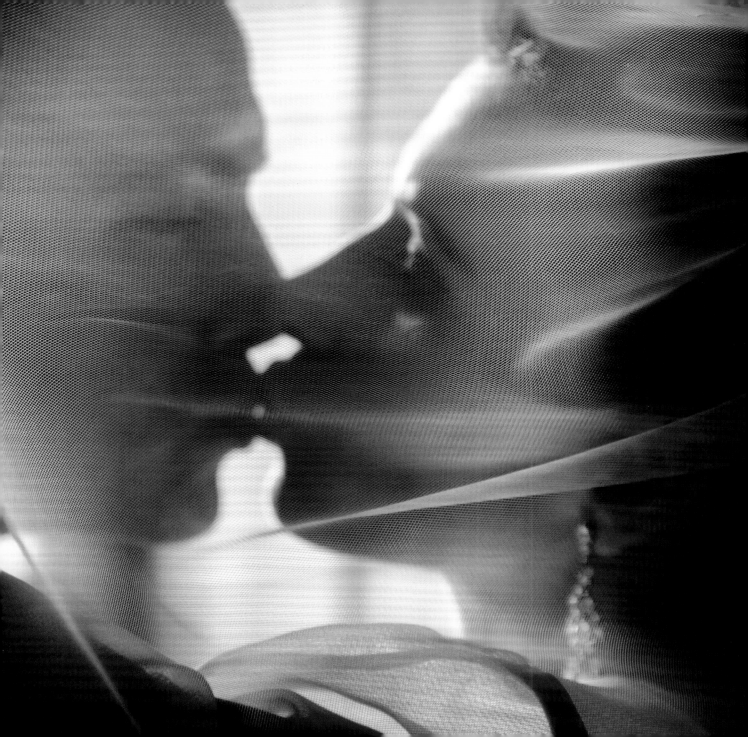

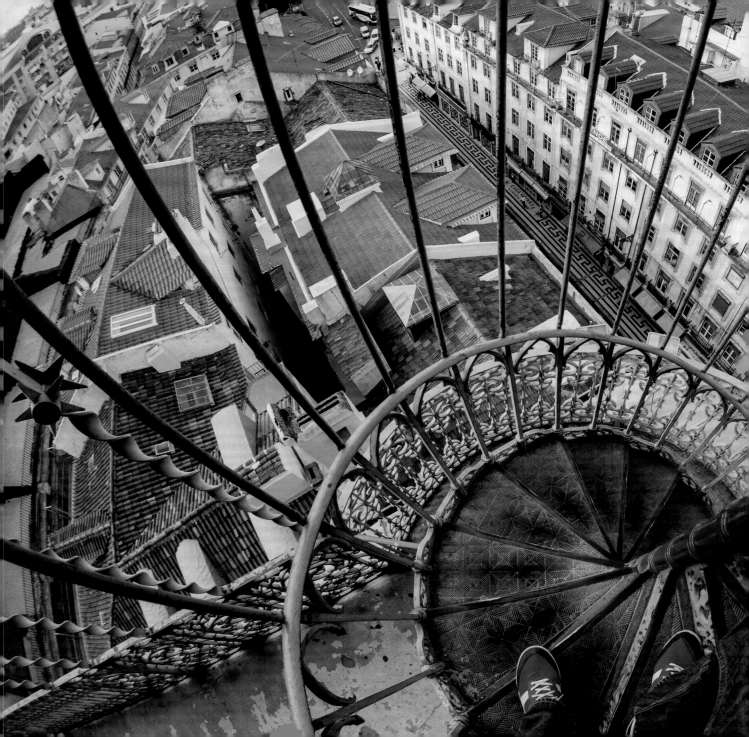

I HEART MY CITY

BY SARAH POLGER

AN URBAN LOVE AFFAIR

"You're going where? Don't even think about leaving without seeing . . ."

In our favorite cities, we all have cherished corners, hidden gems, and secret standbys. Whether it's your hometown or your home away from home, there's a place in the world that comforts, challenges, and excites you.

But how do you capture the essence of your city? What makes it different from any other place in the world? How do you show those moments when the day slips away and, for a second, the soul of the city seems alive in the scene before you? The way the light falls on the buildings just so, the way locals greet each other in the street, the aromas carried on the breeze . . .

At National Geographic we like to explore new destinations and to rediscover the classics. And with hundreds of thousands of cities in the world, there's always something new to learn. That's why we started the feature I Heart My City on our travel website *(travel.nationalgeo graphic.com)*, where locals share insider intelligence about the places they know and love best.

Cities are, in many ways, living organisms. Stunning architecture, breathtaking gardens, busy traffic, and bright lights make for strong photographs of cities, but the people are the true life force. Without people, cities would sit still, glistening with the promise of adventure never fully achieved. Take photographs that highlight the personalities and people that make the city come alive.

The experience of visiting a city can be difficult to capture. So bypass the standard tourist photos and take your camera down that narrow cobblestone alley or to the best restaurant in town. Show your city how you see it, whether you're shooting the well-worn path, the local haunts, or the coolest music festival in town. When you show your photos to friends and family members back home, you want them see what made you fall in love with this city and why it still makes your heart skip a beat.

ABOUT THE ASSIGNMENT EDITOR

Sarah Polger, NATIONAL GEOGRAPHIC TRAVEL

With more than 12 years of experience in visual storytelling, focusing on multimedia and digital platforms, Polger has a passion for crafting engaging stories in real time and helping us explore and understand our world.

KARL DUNCAN — AMSTERDAM, NETHERLANDS

»TURKISH **COFFEE**

No one is looking at the camera in this scene. All of the patrons and workers are in their own worlds, and the viewer feels a bit like an interloper, or perhaps a tourist, in a coffee shop in a foreign city. The shop's geographic location emerges from the details—the design of the tile floor, the server, and the style of the coffee being served. The viewer may guess that this photo was taken in Istanbul. The angle and height—created by the vantage point of a staircase—allow us to see more of the environment and the patron interactions than if the image had been shot on the main floor. The resulting shot captures an authentic moment in this East European city.

THE PHOTOGRAPHER'S STORY

"This is a tiny hole-in-the-wall coffee shop on the Asian side of Istanbul. It has existed for years. I am passionate about their product, their service, and their history. Does it get better than this? It's real. It's nongeneric. It's nonhipster. The coffeehouse was a gem of a discovery, and the photo even more so. I discovered this angle for the shot when heading up the tiny stairs to the restroom!"
—Philippa Dresner

ISTANBUL, TURKEY

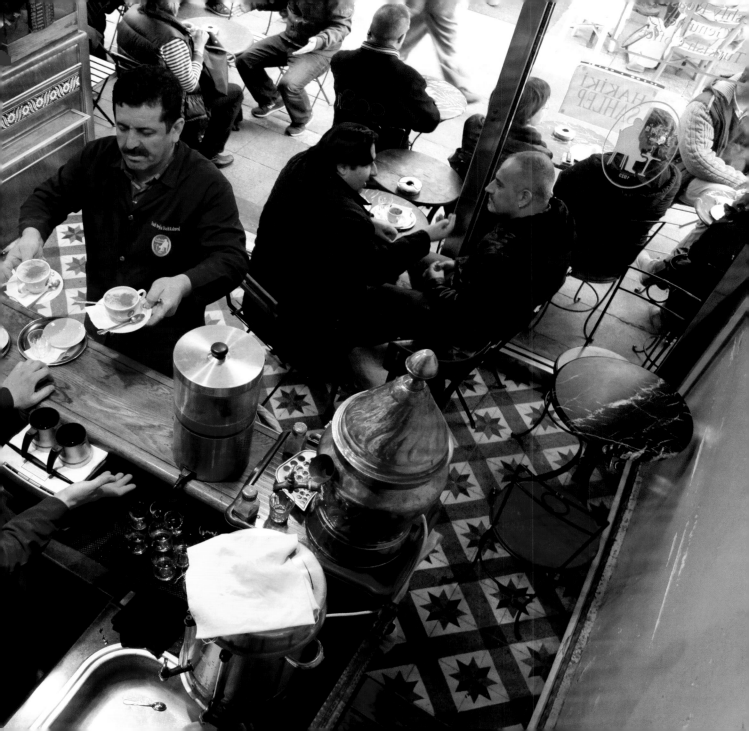

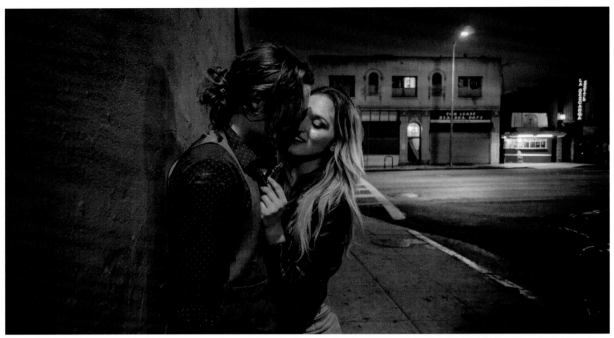

ANDREA JAKO GIACOMINI — LOS ANGELES, CALIFORNIA

»LOVERS' LANE

You can feel the grit of the street, the sweat of the night, and the sensuality of this couple. The way that the pair is framed against the barren street and the lone street lamp creates a sense of time—likely very late at night—and immerses viewers in the intimacy of the moment. Brash, contrasting colors dance throughout the picture. The couple is bathed in green light, suggesting both envy and lust. And the woman's lipstick red skirt pops from the bottom of the picture. Hair hides the man's face and creates a space for a private kiss soon to come. The viewer is left to guess how the night began and how it might end.

HOW TO SHOOT WIDE

● **This is a scene** where you crank up your ISO, open your aperture, and keep your hands very, very steady.

● **The photographer** used a wide-angle lens. The wide aperture helped achieve the necessary exposure and allowed for the wall on the left and the street lamp on the right to fit into one picture.

● **Think about color,** texture, and mood. These elements are not arbitrary in a well-thought-out image.

»SHANGHAI NIGHT

Using a long exposure to capture cars rushing by on the highway is a common photographic technique, but the photographer elevated this city scene, literally and figuratively. The headlights draw the viewer into the scene and create an alluring blood flow through the raised highway. The warm magenta hues, which seem to seep into the roadway, create an electric and vibrant mood. We can almost feel the thump of the city's heart, the whir of cars racing by, and the excitement of people dashing to their nights out. The photographer actually had to shoot this scene from a distant perch, but he puts the viewer right inside the action.

- **Night photography** almost always requires longer exposures. Here the photographer left the shutter open, allowing the city's ambient lights to bleed into the night sky.

- **Use the graphic elements** in your frame to lead the viewer's eye. Here the roadway and lights weave into the night and create the sense of being drawn into the scene.

- **Do you want your scene** to be bright? Dark and moody? Adjust your aperture and ISO to meet your goals. To ensure streaming lights, use a shutter speed of 1/15th of a second or slower.

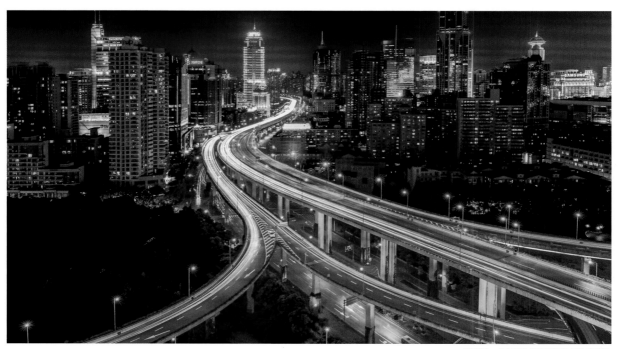

BIN YU — LUWAN, SHANGHAI SHI, CHINA

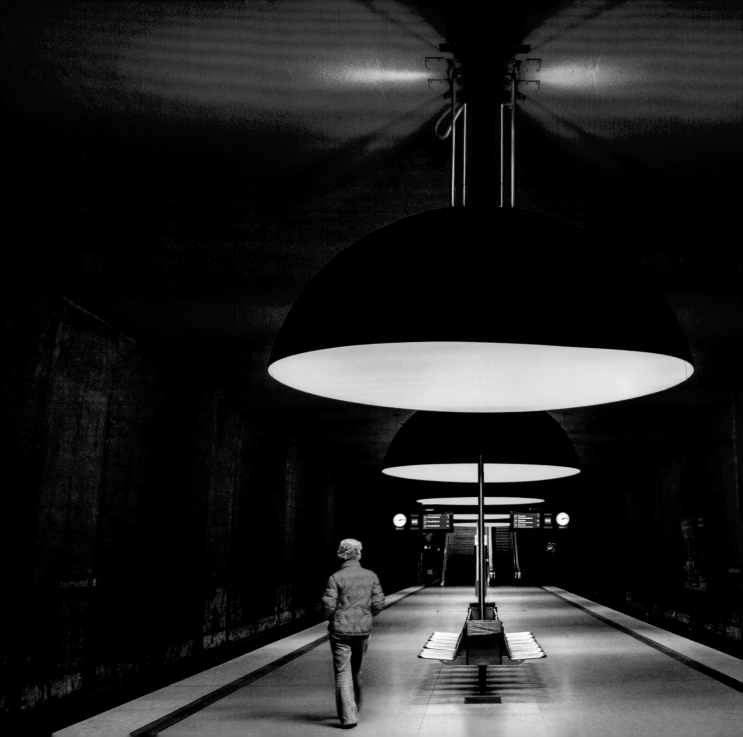

»SURREAL SUBWAY

Munich's subway system is full of uniquely designed elements, creating a vibrant and photo-ready transit system. The subway is a popular subject for tourist photographs, but this photographer spied a unique scene and made it entirely his own. He waited for a lone figure to hover, waiting on the platform for the next train. The giant orbital lights cast a yellow haze over the person and create a scene that is at once lonely and playful. Is this person alone, or is she a character in a sci-fi movie with a UFO ready to beam her up?

HOW TO GET GREAT TRAVEL SHOTS

- **Don't be afraid** to open a tripod in public. Set up where you need to, and take your time until your moment arrives.

- **Tourists often** take photos they are "supposed to" take but forget to document the real-life elements of their visit. When you travel, immerse yourself in the city and capture mundane moments—such as subway rides—and you'll have more honest pictures when you return home.

TONY RAMOS — MUNICH, BAVARIA, GERMANY

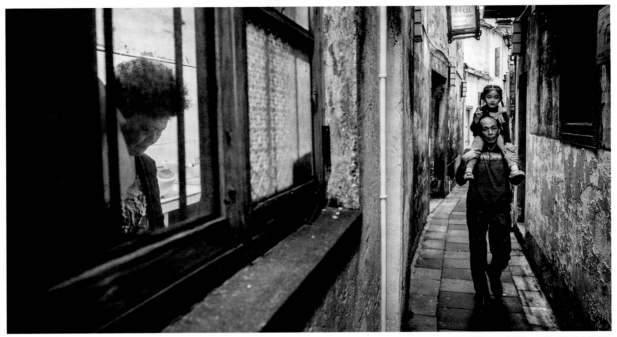

»WHEN PATHS CROSS

When exploring a city, wander off the main street and you'll often find the city's most authentic parts. That's what this photographer did before stumbling into this scene. He relied on a wide-angle lens to capture both the woman in the window and the man walking with the girl on his shoulders. While the man and girl stare directly at the photographer, the viewer is left to wonder what the woman in the window is doing. Two separate worlds collide in one photograph in a narrow alley. Are the people connected, or are they strangers?

HOW TO CAPTURE A SLICE OF LIFE

- **Daily-life scenes** make some of the best travel photos because they are relatable and authentic.

- **Stay aware** and scout your location. You never know where a great photo might pop up.

- **Use wide-angle lenses with caution.** They are both a blessing and a curse. The exaggerated angle can capture extra elements in tight scenes, but it can also cause subjects to appear stretched and abnormal.

»FOGGY AUTUMN

Fall is a season that beckons us to take beautiful pictures. When the feeling strikes, heed the call. This picture is a reminder that cities and nature can exist in equilibrium. The urban environment suddenly becomes a charming nature scene, as the morning mist blends with the yellow and auburn hues. The fence and street remind us that we are in a city, where the monotone color palette wraps itself around the lone pedestrian. The photo seems to invite us to stroll alongside the woman, who adds a needed human element to the frame. The light is key to making this photo work. Get up early, wander in the city, and you'll likely find a picture waiting to be taken.

HOW TO MAKE A LANDSCAPE SING

- **Nature is beautiful,** but people add a complementary dimension. Consider including people in nature scenes for added interest.

- **People often don't mind** being photographed. If you have reservations, simply ask your subjects for permission before you shoot.

- **This scene** would be less interesting without the mist and the hues. Some of the best pictures are made on cloudy or bad-weather days.

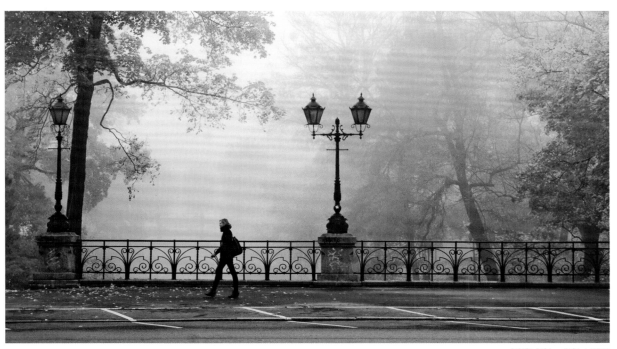

SIGITA SICA — RIGA, LATVIA

163

»COCKTAILS, ANYONE?

One of my favorite ways to get to know a new city is to eat. Food reveals the underbelly of the city. Lately, everyone is taking snapshots of dinner plates. So mix it up and try taking pictures of the restaurant experience instead. The servers, the architecture, and the bartender are often more interesting than what's on your plate. While dinner may seem like the most interesting photo op, light is actually best during the day. So go to lunch or get a mid-afternoon cocktail. You'll get good light, and the restaurant will likely be less busy than it would be at dinnertime, so the waitstaff won't mind if you hang out for a while to get a great picture.

THE PHOTOGRAPHER'S STORY

"One of the best parts of my city of San Francisco is the way the city has allowed for so many artists to follow their passions—whether it is photography or making fancy cocktails. I love popping into the studios, restaurants, and bars to see what new creative juices are flowing."
—Mat Rick

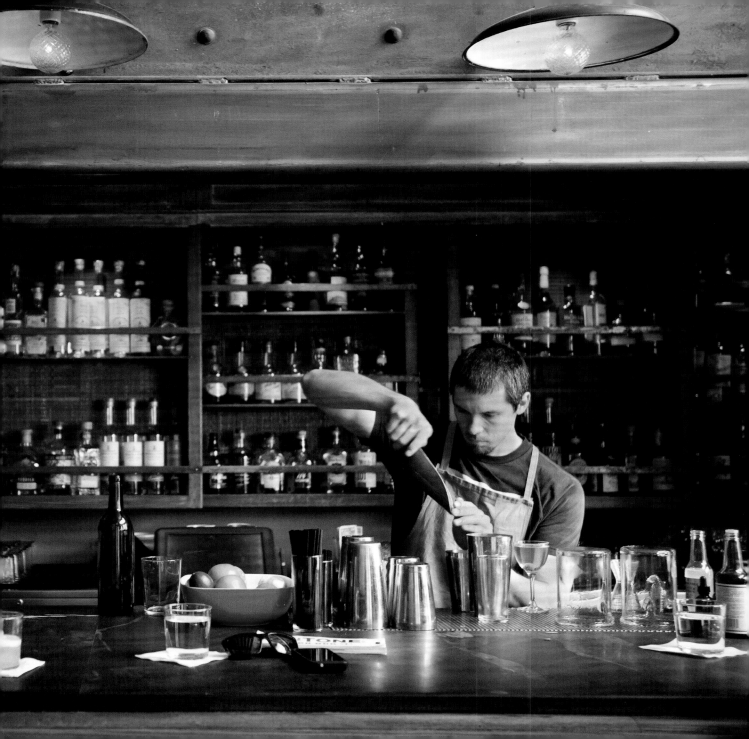

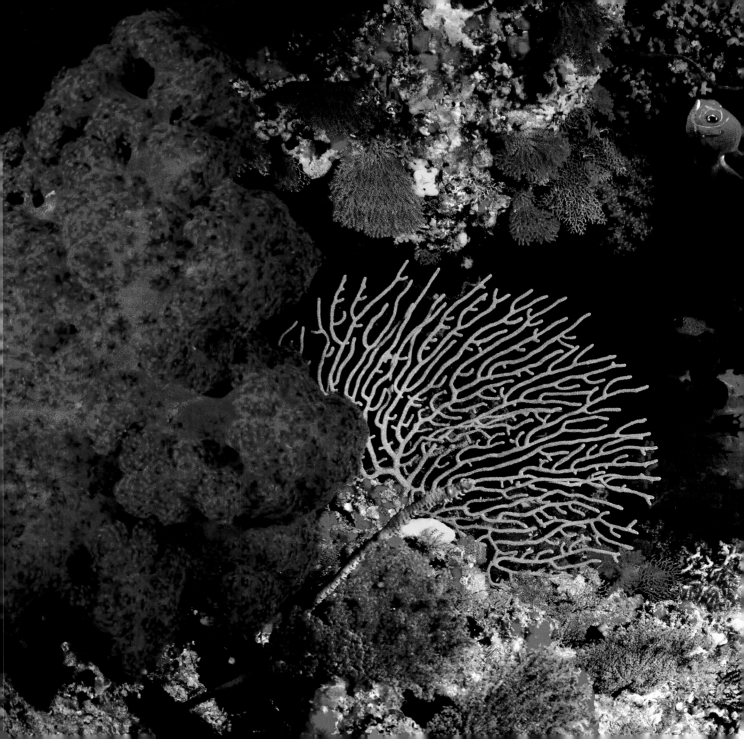

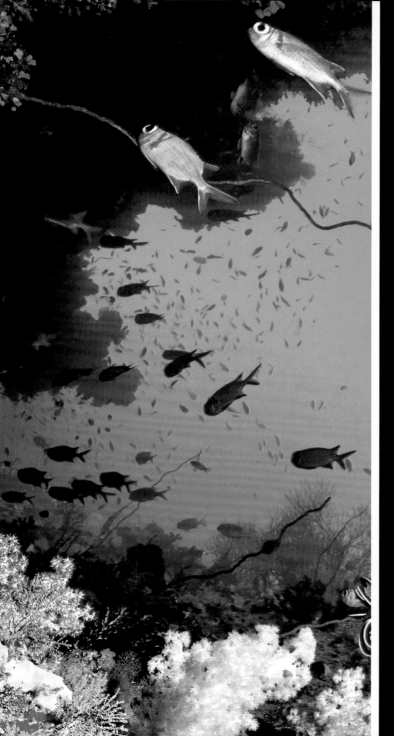

BIODIVERSITY

BY DAVID LIITTSCHWAGER

BEAUTIFUL LIFE

'****ve always wanted to take pictures that mattered. I want to capture images that the world has a use for. Somewhere along my journey, I discovered that beauty is a tool that draws people in. And it can be used to attract attention to and illuminate important issues, such as the impact of biodiversity on the future of our planet.

We need to present the world the way it is. It is full of death and destruction for sure. But we also need photographs that celebrate our planet's natural beauty and inspire people to protect it. This assignment is about capturing biodiversity—the millions of plant and animal species that inhabit different environments. Where do you see nature teeming with life? Your sample size can be as large as a forest or as small as a garden. It can even be a handful of earth. You can focus on a single group of creatures, a defined window of observation, or animals of a certain size. Take a picture of what biodiversity looks like to you.

Nature loves to hide. So shooting biodiversity is often easier said than done. You may need to keep working on some pictures. On an assignment for *National Geographic* magazine, I spent weeks photographing only one cubic foot. Try using different tools to see your subjects, from DSLR cameras to microscopes. Explore what happens to the number of creatures and species you see when you change the scale.

I'll leave you with a quote from biologist Edward O. Wilson, who is possibly the greatest naturalist of our time. I hope you find it as inspirational as I do.

"A small world awaits exploration. As the floras and faunas of the surface are examined more closely, the interlocking mechanisms of life are emerging in ever greater and more surprising detail. In time we will come fully to appreciate the magnificent little ecosystems that have fallen under our stewardship."

ABOUT THE ASSIGNMENT EDITOR

David Liittschwager, NATIONAL GEOGRAPHIC PHOTOGRAPHER

After working with superstar photographer Richard Avedon in New York in the 1980s, Liittschwager left advertising to focus on portraiture and natural history. A World Press Photo Award winner, he is a regular contributor to *National Geographic* and has created several books of his photography.

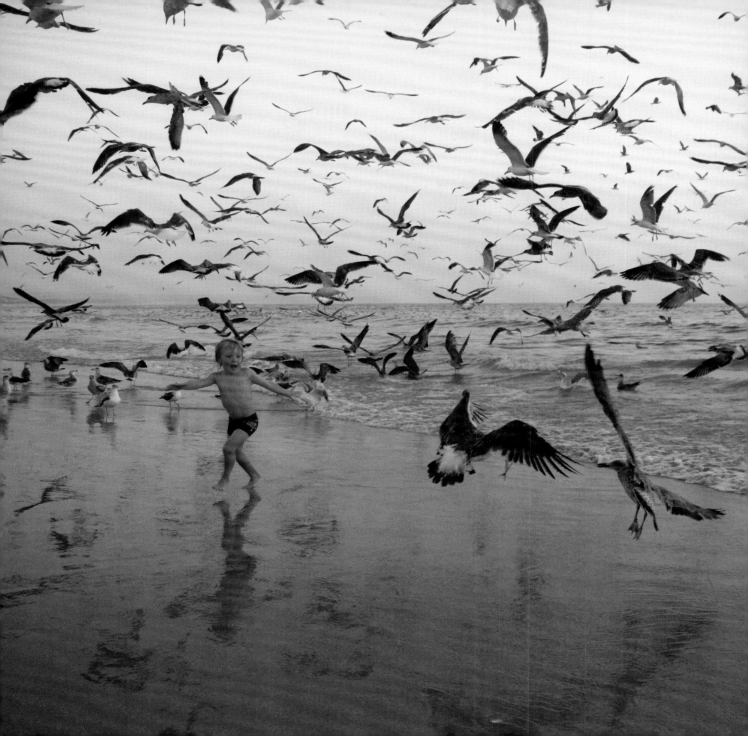

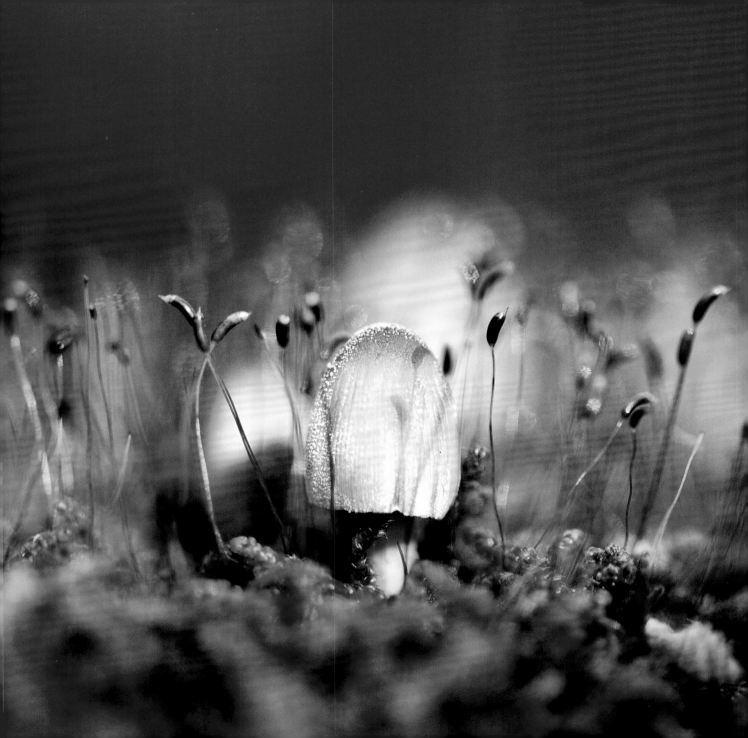

»MAGIC **MUSHROOM**

This idyllic scene is all about reproduction. The mushrooms are the fruiting bodies of fungus. The little reproductive pieces that sprout out of moss are called sporophytes. The soft light creates just enough contrast to throw shadows that create depth and shape. In macro photography—shooting small images extremely close up—the narrow range of focus often makes the background blurry. The photographer uses this limited depth of field to maximum effect, separating the mushroom and sporophytes in the foreground from similar plant life in the background. We see the relationship between species in a frame that is only a few inches tall. This is the scale at which we begin to see the greatest biological diversity.

THE PHOTOGRAPHER'S STORY

"This is a close-up of some mushrooms I saw on a tree trunk. I found the light and setting a bit magical . . ."
—Sebastian-Alexander Stamatis

DENMARK

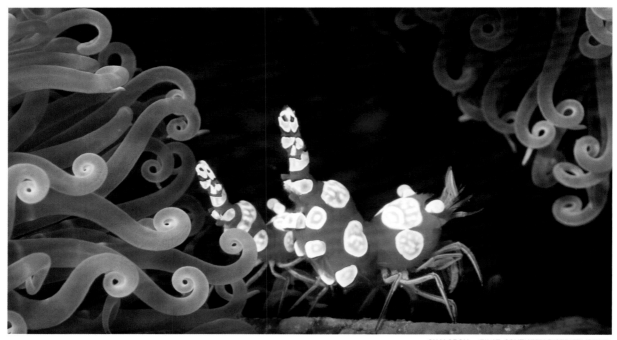

SHAI ORON — EILAT, SOUTHERN DISTRICT, ISRAEL

»SEDUCTIVE SHRIMP

Dubbed "sexy shrimp," these elegant creatures are named for their flashy markings and the way their hips waggle when they walk. Safe in their lair, the male and female shrimp hide among the stinging tentacles of anemones, which keep shrimp-eating predators at bay. This image is an excellent example of biodiversity and a remarkable photograph. The focused, shapely light shows off the almost mathematical precision of the anemone's curled tentacles. And the whiter-than-white spots on the shrimp pop off the soft, dark background. It's an intimate view of sexy shrimp domesticity.

HOW TO PHOTOGRAPH SMALL CREATURES

• **Be patient** and wait for a creature to show itself.

• **Avoid overexposing** the shot. You want to capture the details and textures on the animal's skin or scales.

• **In this picture,** the photographer kept the light focused on the subject, which prevented light from spilling over and creating distractions in the background.

• **Try to use one light source.** If you really need two lights, avoid confusing crossed shadows.

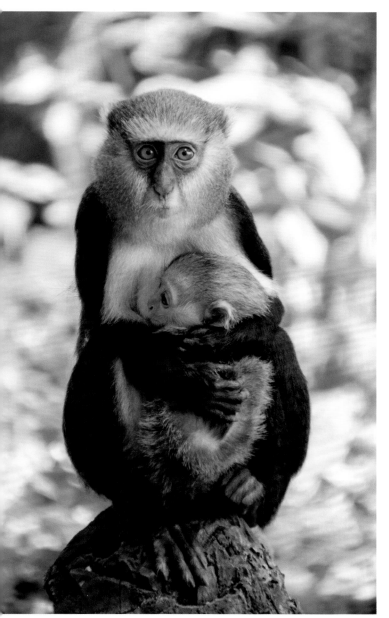

LUCAS FIRGAU — BUABENG-FIEMA MONKEY SANCTUARY, GHANA

»MOTHER AND CHILD

This image of motherhood makes us question how different we are from our primate relatives. The monkeys sit on a pedestal, as if posed for a formal portrait. The photographer captures the mother's direct gaze and her arms in a protective clutch around the baby. With lovely, soft light and a background relatively free from distraction, this image could have been taken in a studio. In reality, it was taken at a wildlife refuge. I wonder how the photographer perceives the monkey and how the monkey perceives the photographer.

HOW TO SHOOT AN ANIMAL PORTRAIT

• **First, find a really good-looking animal.** Seriously, not all individuals of a given species are equally beautiful. Choose the best specimen.

• **A glint or engaging expression** in the eyes makes the animal more relatable.

• **Separate the animal** from its background. The soft shade on this monkey helps it stand out from the blurry, overexposed greenery behind it, thus adding to the sense of formalness in this portrait.

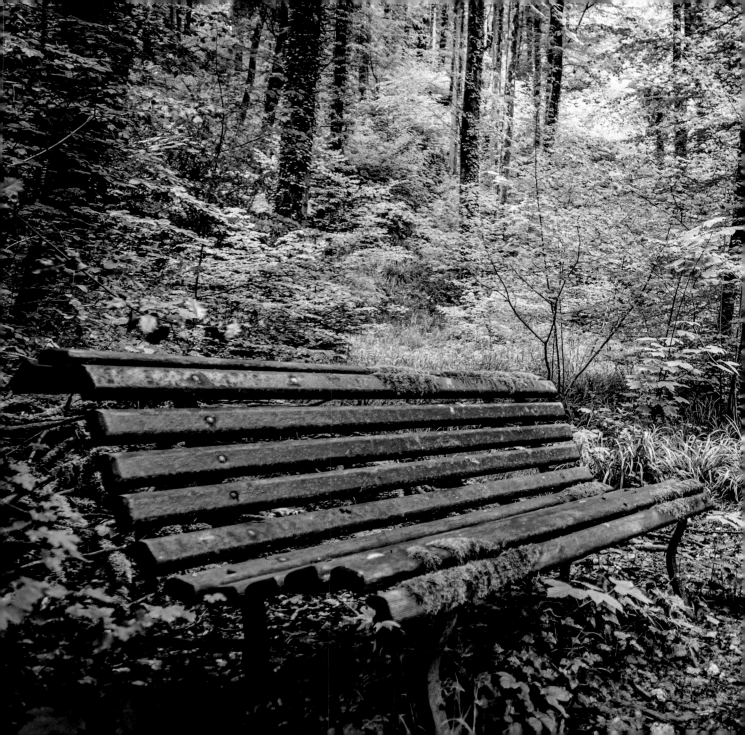

»A RESTING **PLACE**

What a lush and serene place to sit. Peeking through the tree canopy, highlights create a sense of isolation. There is surely another bright and busy world just beyond, but this place cannot be bothered by it. This bench has a story, or lots of them. In time, the surrounding forest will consume the bench and reaffirm humankind's place in the world. Our existence is but a passing moment—a blip on the grander time scale of a forest. I find the message in this picture hopeful and comforting. The shot expresses the natural world's ability to carry on, even with our sometimes heavy-footed presence. What an excellent place for pondering matters such as these.

HOW TO SHOOT IN THE WOODS

● **There is beauty in simplicity.** You can take exceptional photographs of something as commonplace as a park bench.

● **If a scene is dark and shady,** you will need to compensate by decreasing the exposure. Don't rely on exposure meters. They make the overall average of the scene a mid-tone.

● **If you are holding the camera** in your hands, plant your body and keep as still as possible. Photography is more physical than many people think.

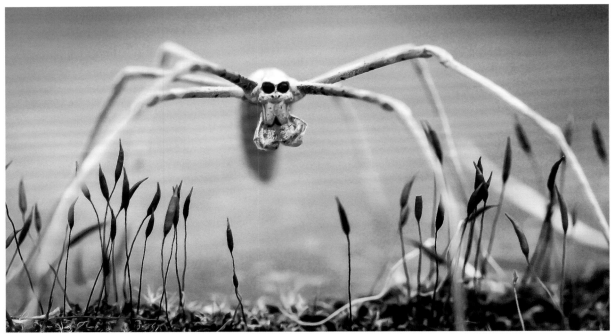

CHERYL BURNHAM — MELBOURNE, AUSTRALIA

»ANGRY **ARACHNID?**

The shallow focus in this macro photograph shows just how impressive this beast is. With its long legs softening as they leave the frame, the spider's body towers over the sporophytes below. It's larger-than-life—a real-world Godzilla that is terrifying at this scale. This male spider, with his dark predator's eyes and prominent pedipalps (the appendages below the mouth), would make me worry if I were smaller or he were bigger. The pedipalps look fierce, but they are used for sexual reproduction and are probably quite titillating for the female of the species: "My, what large pedipalps you have!"

HOW TO MAKE MACRO ANIMAL PHOTOS

• **Remember,** most of the world's biological diversity occurs among small organisms. The entire scene might be only one inch across.

• **Consider investing in** a macro camera lens. (See "Choose the Correct Lens," p. 22.)

• **Get down on the same level** as your subject, and keep the eyes of the animal—or at least one of the animals—in focus.

• **Keep the background simple** to avoid visual distractions.

• **Be mindful** of your footprint. You don't want to step on potential subjects.

»WHITE WONDER

From the poufs of cotton grass in the foreground to the glacier-capped mountain in the distance, this image maintains focus across an impressive panorama. The whimsical cotton balls seem to brush up against the severe, rocky texture of the mountain. And the soft clouds above the horizon match the gentle softness of the cotton below. This photo was taken during one of Norway's long summer days, but I can imagine this scene six months later, when the sun spends little time above the horizon and the cotton grass lies dormant beneath the snow. How will this habitat and its diversity adapt to climate change?

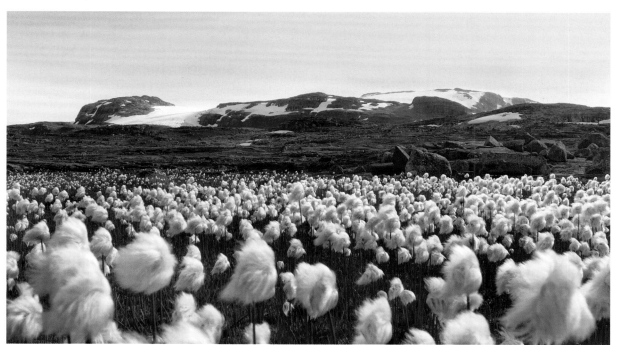

DAIGA ROBINSON — FINSE, NORWAY

»ISLAND **IN THE SKY**

This magical little island looks at once peaceful and lonely as it hovers between the sky and the water. It is separate but connected. What small creatures have found refuge here? What creatures are in the nearby surrounding water, and which ones pass through the air above? It is likely a microcosm—a cast of tens of thousands representing hundreds of species, maybe more. The photographer's point of view creates a magic-carpet effect, as if we are floating above this serene scene. To get this shot, the photographer would have to get up high by climbing a hill or a tree, or snap the scene from a helicopter, an airplane, or even a drone.

THE PHOTOGRAPHER'S STORY

"There is an ethereal, otherworldly feeling to this photograph. This little island, in the middle of remote and wild Tumuch Lake in northern British Columbia, appears as if it's floating in the clouds. To bring us back to Earth, a fish has left a ripple in the water on the left-hand side of the shot . . ." —Shane Kalyn

PRINCE GEORGE, BRITISH COLUMBIA, CANADA

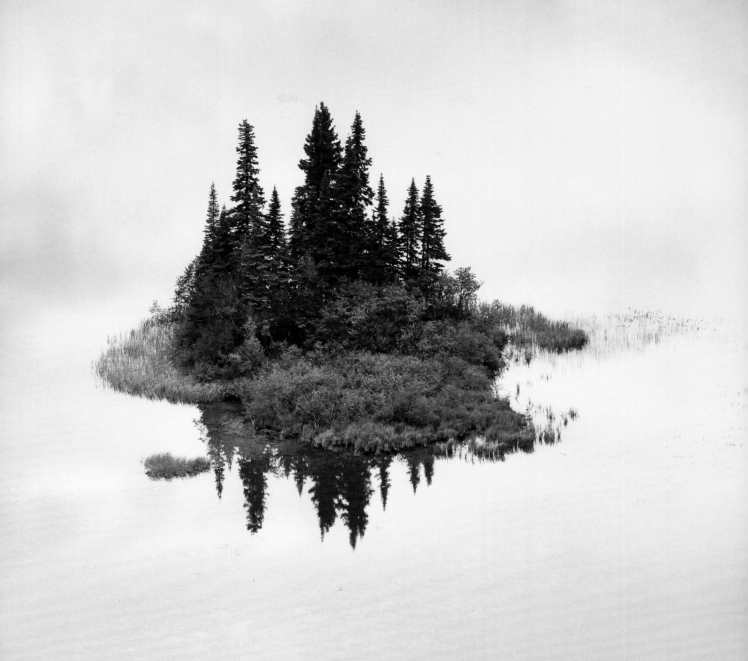

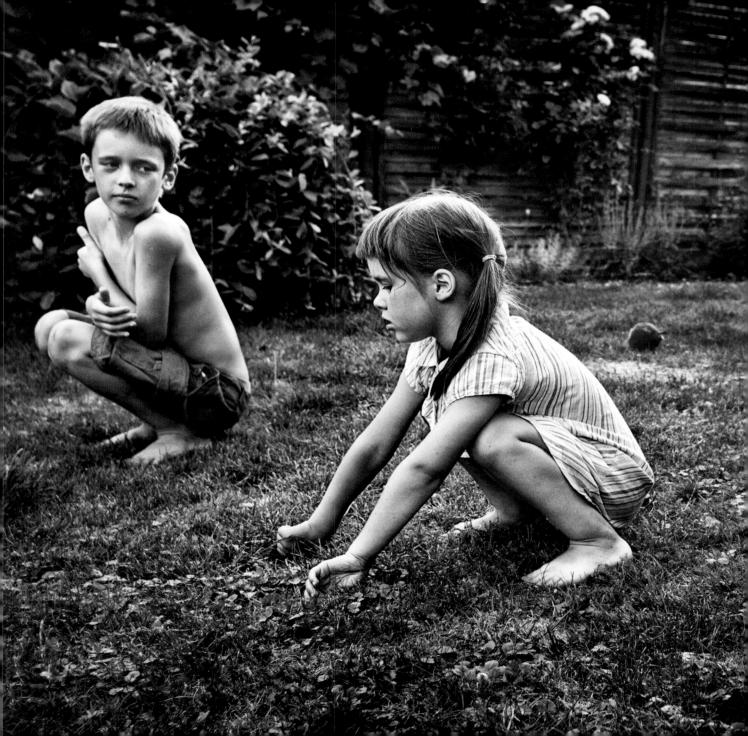

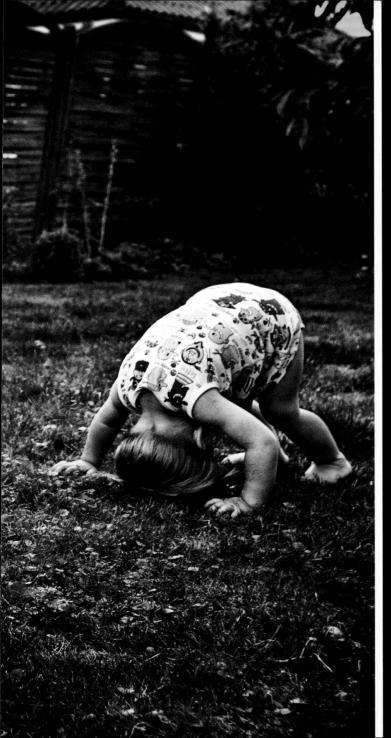

FAMILY PORTRAIT

MONIKA STRZELECKA — POLAND

BY BEN FITCH

A TIME TO REMEMBER

I love visiting my grandmother's house in Vermont. The Yellow House, as we call it, has been in my family for nearly 60 years. My great-grandparents, cousins, and others from different branches and generations have all lived there or visited over the years.

Tucked away in old bookshelves and cabinets throughout the house are faded envelopes filled with old pictures, left behind by various family members and dating back decades. Whenever my family visits the Yellow House, we find ourselves looking through these old pictures. We handle each one with great care, as we treasure the images that provide glimpses into the everyday lives of our relatives, some of whom we never knew.

My favorite thing about family pictures is how well they can pass down stories through a series of often informal and personal moments. Part of what makes photographing members of your own family so interesting is the close relationship you have with them. This assignment is an opportunity to show the intimate and meaningful connection between you (the photographer) and your subject matter.

Families come in all shapes and sizes, and the term has never been more all-inclusive or had so many different meanings as it does today. Your family might include your brothers and sisters, your sports team, your classmates, your pet, and even your larger community. No matter how you define the word *family,* show how yours is unique. Think about what you'd like others to learn about your family story by looking at your pictures. Both posed and candid portraits are a great place to start, but also think about illustrating the important traditions, places, and personal qualities that make your family story special. After all, if you as a photographer don't record your family's story, who will?

ABOUT THE ASSIGNMENT EDITOR

Ben Fitch, *NATIONAL GEOGRAPHIC TRAVELER*

A photo editor for the magazine, Fitch finds inspiration in all forms of visual art, with a special affinity for the French and Spanish Romantic painters of the 18th century. He loves hiking, a good diner, and making portraits.

MARC MANABAT — NORTH HOLLYWOOD, CALIFORNIA

»A CLOSE **SHAVE**

All great photographs have emotion. A picture can be perfectly executed from a technical standpoint, but if it doesn't make the viewer feel something, it likely won't be memorable. Here the photographer captured emotion in a very literal way by shooting the dramatic expressions of a groom, who is being shaved in preparation for his wedding, and his daughter, who is in tears. My eyes travel back and forth between the girl and the groom, who are equally expressive but overcome with completely different emotions. The girl, with the skinned knees typical of an adventurous child her age, looks in horror at the man who has taken a razor to her father, who laughs back at his daughter's innocent misunderstanding. It's an entirely authentic moment—and a great illustration of family dynamics.

THE PHOTOGRAPHER'S STORY

"According to tradition, the man in front, the groom, is shaved by the godfather with a knife. His daughter is crying because she's scared." —Vasile Tomoiaga

BUCHAREST, ROMANIA

»LOVE OF A LIFETIME

The arresting gaze of the male subject looking directly into the camera immediately pulls viewers into this photograph. The man died shortly after the picture was made, which means this was one of the last portraits of the aging couple together. Even without the caption, we are able to grasp the solemnity of the moment through the image itself, especially from the way the woman looks longingly at her husband and the tight clasp of their hands. This frame is an example of how shooting from a unique perspective—here, from above the bed—can add an unexpected level of meaning and dimension to a picture.

HOW TO HOW TO GAIN PERSPECTIVE

● **Try photographing one subject** in three different ways as an exercise in shifting perspective. For example, photograph an object from a low angle, straight on, and from above to see how your perspective changes the image.

● **Take pictures** of the everyday moments in your life. These images end up being some of the most personal and powerful because we approach them with such intimacy.

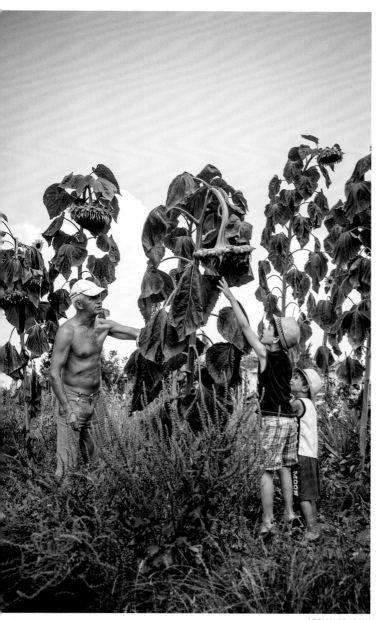

ADRIAN CRAPCIU

»GROWING **TALL**

The boys look curious about and intrigued by the towering sunflowers. For me this image is about the grandfather passing his respect and love for the land on to his young grandsons. The photographer was smart to shoot this image from a distance, allowing us to appreciate the scale of the flowers against the height of the figures. Had this image been shot closer in, the flowers wouldn't have dominated the scene in the same way. Depending on your subject, you may benefit from more or less environment in your photograph. Think about which elements are important to include in your composition when constructing your visual narrative.

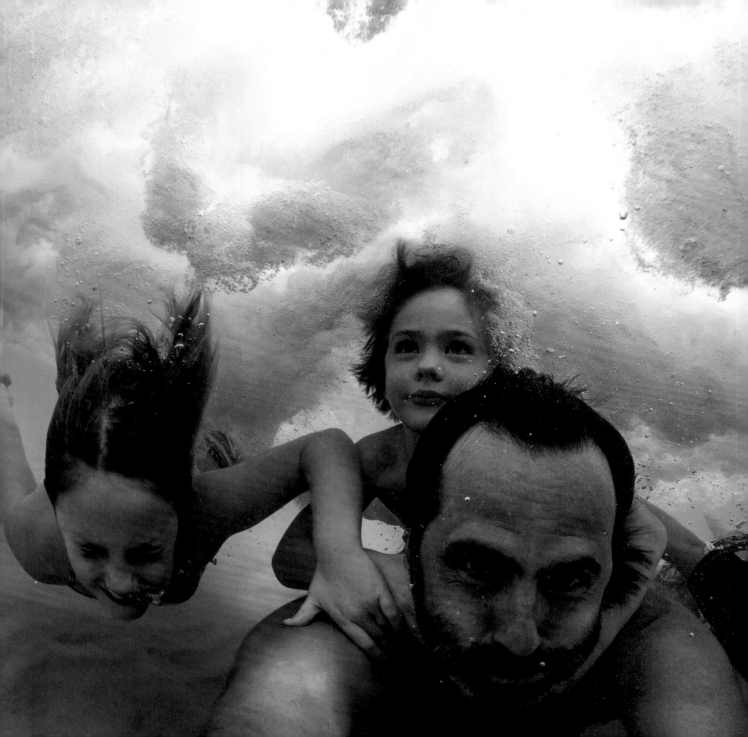

»TAKING **THE PLUNGE**

I n a time of ubiquitous selfies, this self-portrait of a father and his children is unique and compelling. I was originally drawn to the image by the dynamic composition. The image was taken at just the right moment, seconds after the family dived into the water, causing a cloud of bubbles to fill the top half of the frame. The bubbles intensify the sense of movement in the image. The tight focus emphasizes each person's expression as the family swims out from the bottom of the photograph. This image so clearly illustrates the notion of family. The patriarch leads his kids forward with utmost confidence as they follow with looks of excitement and wonder.

THE PHOTOGRAPHER'S STORY

"This photo really shows the trust and love of a father and his children. This self-portrait shows all the children following their father through the turbulent waters of a breaking wave. Each child has one hand on the father for support. But their faces do not show fear; instead their expressions show the trust they have for their father." —Sean Scott

GOLD COAST, QUEENSLAND, AUSTRALIA

»BLOOD BROTHERS

This portrait is powerful in its simplicity. The photographer's choice to center his subjects is especially meaningful, as the symmetry of the image highlights the twins' similarities. The bright towel not only provides a welcome pop of color against a muted palette, but also reinforces the brothers' physical and emotional connection. When shooting portraits, think about what makes your subject unique. Look for ways to highlight these special qualities, perhaps by inserting into the frame other elements that accentuate those characteristics.

ANDREW LEVER — BOURNEMOUTH, ENGLAND, U.K.

HOW TO MAKE A PORTRAIT

• **Get to know your subject** before taking his or her picture. You'll find that the comfort level between you grows, and that translates to a more natural-looking and personal portrait.

• **Find ways** to highlight your subject's unique qualities through composition and framing.

• **Think about** how the subject's environment can add context to the person's story.

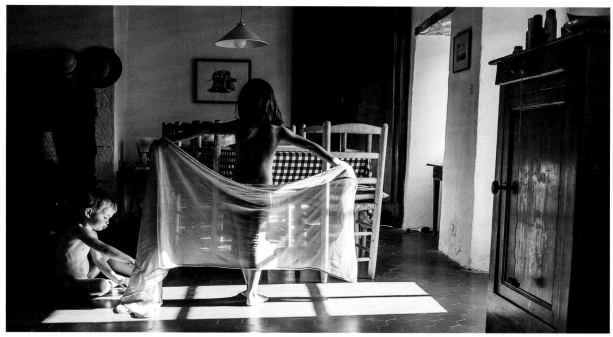

KARINE PURET — PARIS, FRANCE

»CHILDHOOD **INHIBITION**

When I think about family, I inevitably think about the home I grew up in. This image strikes me because of how well it illustrates the comfort of the domestic setting, which goes hand in hand with family. Small details in the frame add to this timeless depiction of home—the checkered tablecloth, the worn wooden cabinets, and the warm light streaming through the window. The kids, playing in the safety of their kitchen, seem lost in a make-believe world. It was crucial for the photographer not to disrupt the magic of the scene taking place. Had the kids been aware of the camera, the photo wouldn't be nearly as authentic and compelling.

HOW TO MAKE AUTHENTIC PHOTOS

• **Sometimes the best shots** happen when the subject is unaware of the camera. Be sure to ask permission to keep the photo after you shoot it.

• **The longer you stay** in a place, the more the comfortable the people around you will become, and the greater the potential for capturing a one-of-a-kind moment.

• **Use a wider lens** and get close to your subject. Many great moments are subtle ones, made special by the slightest expression or gesture.

»FAMILY **CIRCLE**

This portrait shows the child within the context of his greater family and community. Although we can see only the child's face, the anonymous figures around him symbolize the circle of those who support him. I particularly like the soft gestures of the outstretched hands reaching into the center of the frame and the range of patterns in the various white fabrics. This photograph is a lovely example of how to distill a busy scene into one strong, isolated moment. If the photographer had pulled back and included more of the surrounding figures in his picture, the scene could have been too chaotic to digest. Instead the photographer focused on a small piece of the scene that was just enough to tell the whole story.

HOW TO | ISOLATE THE MOMENT

• **A good place to start** when taking pictures is to determine where the best light is in the scene. Then stick around to see what happens in that spot.

• **When shooting a busy scene,** start wide and then go tight. If you are looking everywhere, you are less likely to miss a great moment.

• **Don't plan** all of your pictures. Take time to roam around a location and look for images in places you wouldn't expect to find them.

ABIR CHOUDHURY — CALCUTTA, WEST BENGAL, INDIA

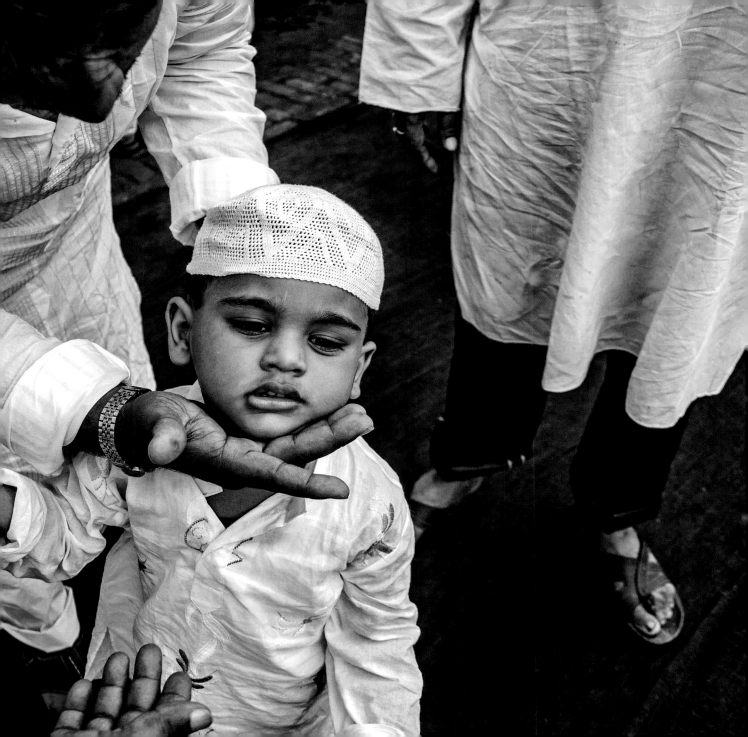

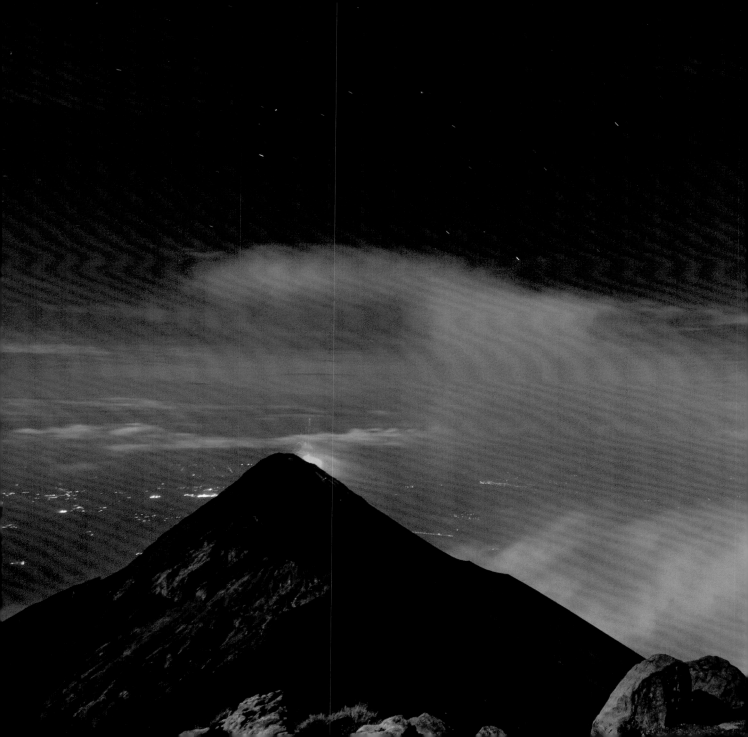

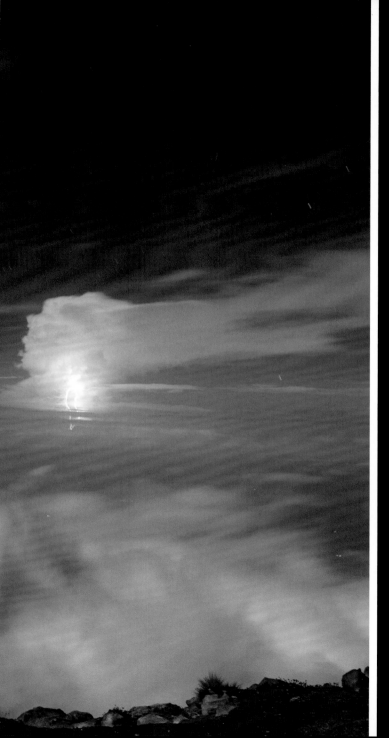

THE
MOMENT

BY JAY DICKMAN

GETTING IN ON THE ACTION

Photography is all about moment. It's the big, loud moment of the wide receiver going up for the football with eyes popping out, sweat flinging out from his helmet, fingers stretching to grasp the ball. Or it's the quiet moment of two friends meeting on the street, one throwing her head back in laughter or gesturing in response to something the other has said. Each of these situations, and everything in between, has a moment that is the job of the photographer to capture.

Moments bring power and impact into the photograph. They resonate with viewers and engage them with the photo. The moment image can be the central image in a larger story, or it can stand alone as a powerful testament to an event, a way of bringing everything to a visual fruition.

For this assignment, I'd strongly suggest that photographers work on staying with the scene and watching it build up to—and beyond—the moment. Thinking you've reached the height of a moment is similar to a mountain climber reaching a false summit, only to discover the real summit off in the distance. You'll tend to shoot what you think is the peak frame and then lower the camera to admire your photo, only to look up and see the real moment occur. So stay with that scene to make sure that the great photo you just captured isn't only a step up to the climactic moment.

The famous French photojournalist Henri Cartier-Bresson said that every situation has its decisive moment; you watch as something builds and wait for that peak. Applying the idea of a moment to your photography will make you a more observant and connected image maker. The moment trumps everything. The waiting is the hardest part.

ABOUT THE ASSIGNMENT EDITOR

Jay Dickman, NATIONAL GEOGRAPHIC PHOTOGRAPHER

A Pulitzer Prize–winning photographer, Dickman has shot more than 25 assignments for *National Geographic* and has visited every continent as an expert and photo instructor on National Geographic Expeditions travel tours. With his wife, Becky, he founded the acclaimed FirstLight Workshop series.

BETTY CATHARINE HYGRELL — TENGBOCHE MONASTERY, NEPAL

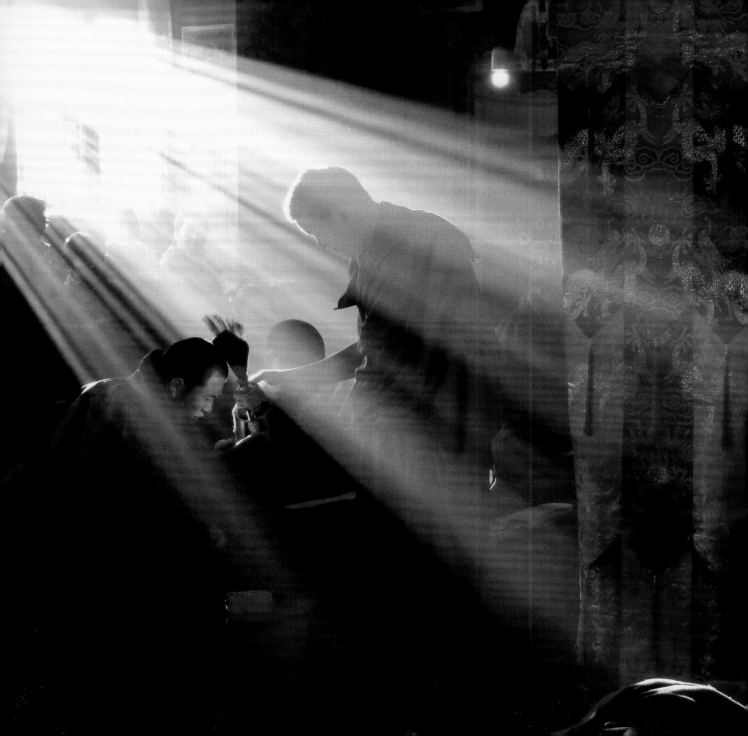

»AIRBORNE

Capturing just the right moment can bring joy and energy to a photo. When we dissect this image, we see what makes it work and why it resonates so strongly with the viewer. The photographer has captured a delightfully happy baby at the peak of motion, as the child is tossed in the air (and hopefully caught!). The baby's face is priceless. He faces the viewer with an expression of pure happiness, adding another layer of energy to this wonderful moment. The beautiful sky and clouds create a beautiful background to this joyful scene.

THE PHOTOGRAPHER'S STORY

"This was the ending of a family portrait session, and a storm was rolling in over the Front Range. I had just finished some father-and-son shots when I looked down at my camera and back up to see him tossing his boy in the air. I was lucky to get this shot and also to have this beautiful dark sky in the background accompanied by the golden light of the late-summer evening. The joy in the boy's face is there because he sees his mom standing behind me. I knew immediately that this shot would be special."
—*Christy Dickinson-Davis*

DENVER, COLORADO

»THE INVISIBLE KITE

The most powerful photographs pull the viewer's attention into the moment that is taking place. In this engaging photo, I feel as if I'm standing there, enjoying the boy's enthralled expression as he pulls the kite string. The child's gesture is at its peak, and its energy fills the white space created by the wall. All components of this shot provide important information. The buildings along the street tell us about the place, and the road curving off to the left reinforces the movement of the subject. As photographers, we're responsible for the entire frame. And everything in this shot is working together to put the audience "in the frame."

HOW TO SEE THE PEAK

- **When you see a moment,** the time to shoot is now. Select your exposure mode, and keep the camera "awake" by touching the shutter button so it's ready to shoot immediately.

- **The viewfinder is your canvas.** Your responsibility as the photographer is to make sense of the visual chaos in front of you.

- **Watch carefully** for peak moments. A moment can be big and loud or small and quiet. But it's still a moment.

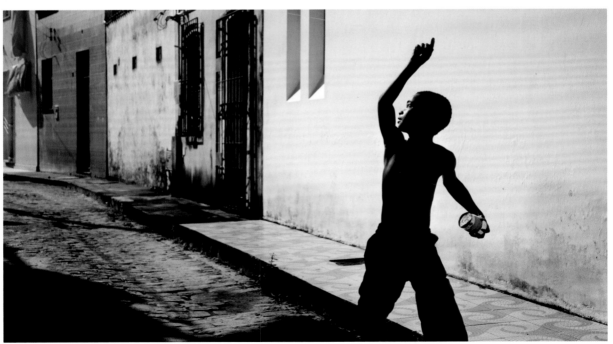

BARBARA BELTRAMELLO — ITAPARICA ISLAND, BAHIA, BRAZIL

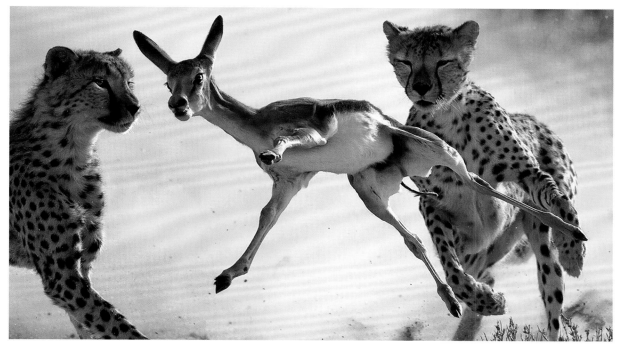

BRIDGENA BARNARD — KGALAGADI, BOTSWANA

»IN FOR THE KILL

This is a stunning wildlife moment. The composition couldn't have been choreographed more perfectly. The airborne gazelle is frozen, mid-leap, and book-ended by the two pursuing cheetahs. The photograph conveys information so efficiently that there is no ambiguity about what is happening. This image also illustrates the amazing power of still photography—how it allows us to study an extremely frozen moment in a frenetic scene. We can't share this intimacy through moving film or video. It takes the still photograph to illustrate that millisecond of finality.

HOW TO SNAP ANIMALS IN ACTION

- **Shoot very early or very late** for the best chance at capturing great wildlife photos. Animal activity—and light—tend to peak at these times of day.

- **To photograph wildlife** in action, you will need a large telephoto lens with maximum speed. Check out lens rental companies if you are not ready to make this pricey purchase.

- **Practice, practice, practice.** Before you go on that big safari, warm up by taking pictures of birds or of dogs chasing Frisbees.

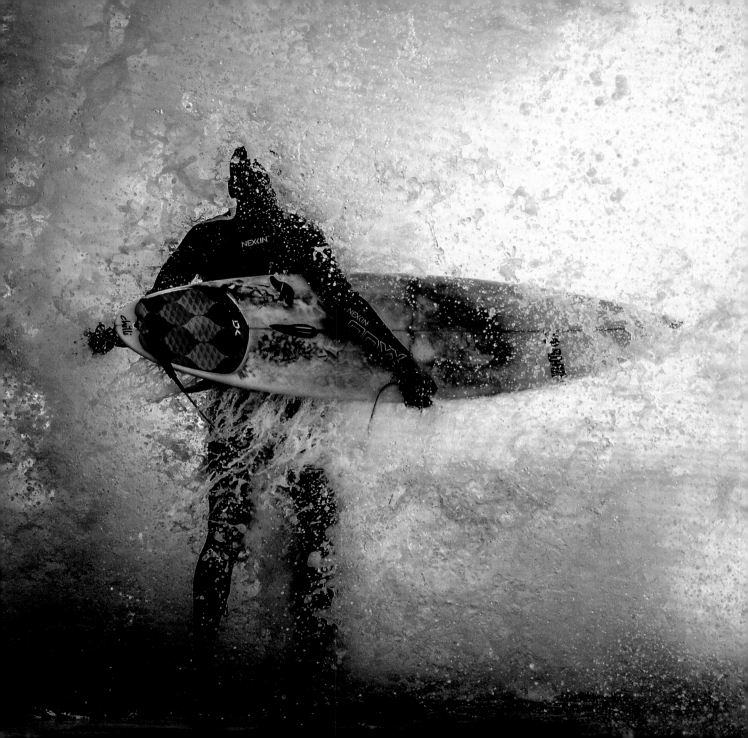

≫SPLASHDOWN

If the photographer had pressed the shutter a millisecond earlier or a millisecond later, this image would not have existed. We can feel the blast of the wave as it hits the surfer. The highlights build toward the left side of the frame and allow our perception to fill in the blanks. We can almost hear the water crashing just outside of the frame. The beautiful light on the back of the surfer illuminates the water wrapping around the body and provides that critical detail of texture. What a perfect illustration of a moment in this mesmerizing photo. Surf's way up!

HOW TO SHOOT WATER SCENES

- **When shooting near water,** consider using a waterproof case, and I suggest carrying a chamois to use as a "raincoat" for your camera or to wipe off water from spray and splashes.

- **If you are shooting** above and below the water's surface in a single frame, use a water-sheeting product, which makes the water "sheet off" the front, thus minimizing water beading.

- **High shutter speeds** will "freeze" water in motion and allow the viewer to see the incredible detail in the droplets.

SEBASTIÃO CORREIA DE CAMPOS — MONTE ESTORIL, LISBON, PORTUGAL

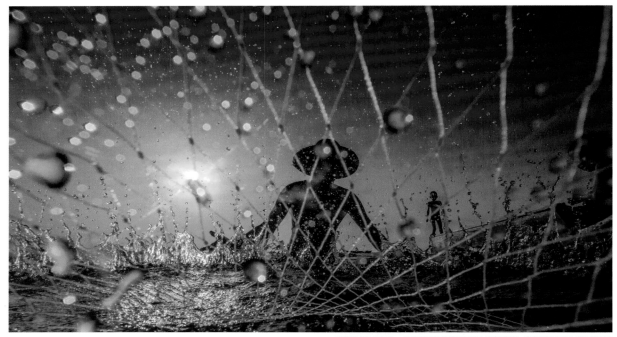

»THROUGH **THE NET**

The viewer doesn't have the luxury of hearing the sounds of the ocean and the fishermen talking, or of smelling the salt spray and the odor of fish. But this photo helps us imagine the sensations that the photographer experienced at that moment. The net, which fills the frame edge to edge, is such a critical component of this beautiful photo. The attire of the person fishing, the warm light, and the water drops help us feel the humidity in the air and the sogginess of the net. The photographer worked this situation so well, bringing together texture, palette, and setting to create a palpable sense of place and immediacy.

HOW TO FILL THE FRAME

- **Get close,** and then get closer. Sometimes your best zoom lens is your feet.

- **Make sure** everything in the picture is relevant to the image.

- **Know your equipment** so well that it doesn't get in the way. If you are not familiar with your camera's menu or ergonomics, it creates a wall of interference between you and the subject. The camera should be invisible in the process.

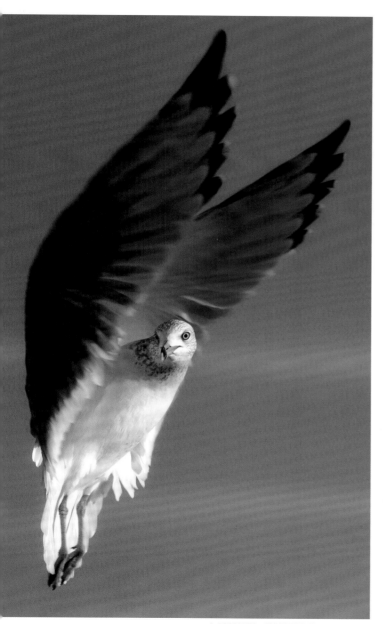

»A WINGED **VICTORY**

When the photographer confirmed this shot in the camera's monitor, there was probably a shriek of joy. This image not only captures the bird in an amazing position, but also achieves that perfect confluence of composition, framing, palette, and moment. The power of this image lies in the animal's eyes. Notice how you look almost immediately and directly at the eyes and then let your gaze sweep across the rest of the image. But you always come back to those eyes. The motion of the bird is vertical, which creates added visual interest in a world where horizontal images are often the default. As a photographer, you shoot and shoot with the hope of capturing that perfect moment. This photographer has achieved that shot.

J. GOODMAN — VENICE BEACH, CALIFORNIA

HOW TO CREATE VISUAL INTEREST

• **Think of shooting vertical,** if it suits your subject. By varying the orientation, you create a more interesting group of images.

• **Eye contact** often makes for more compelling photos of people and animals.

• **Consider carrying** two cameras: one with a wide zoom lens, the other with a telephoto zoom. These two cameras will meet 90 percent of your photographic needs.

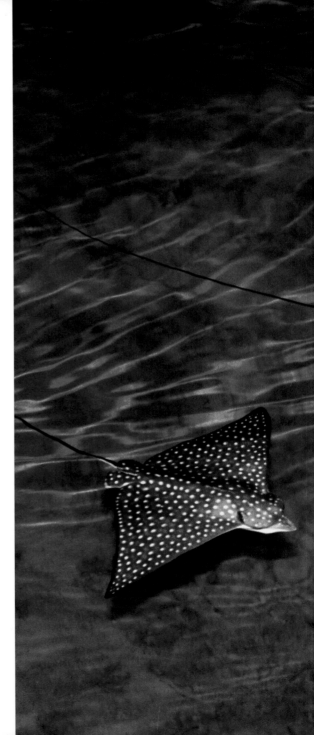

»NIGHT FLIGHT

This serene image weaves a complete story through the simplest details. The color of the water and the spotted pattern on the stingrays tells us that this is likely a tropical location. We are definitely not in Kansas anymore! The photographer introduces us to our lead characters—these incredible rays—and lets our eyes luxuriate on their patterns and the graceful shapes of their bodies. The formation of the stingrays creates a sense of direction and a moment of perfect symmetry. The shadows and grasses on the ocean floor tell us this water is shallow enough to wade in. We feel as if we could just step into the frame and dip in our toes.

THE PHOTOGRAPHER'S STORY

"Young spotted eagle rays feed in a shallow lagoon at night—truly a 'National Geographic moment.' These rays had been feeding individually, then ran into each other and turned together, then split up again immediately after the shutter tripped. I had waited for six hours over two nights, ever prepared to shoot individuals entering the sweet spot. My heart raced as I saw this image coming together right in the spot that I had dialed in to." —Courtney Platt

GEORGE TOWN, CAYMAN ISLANDS

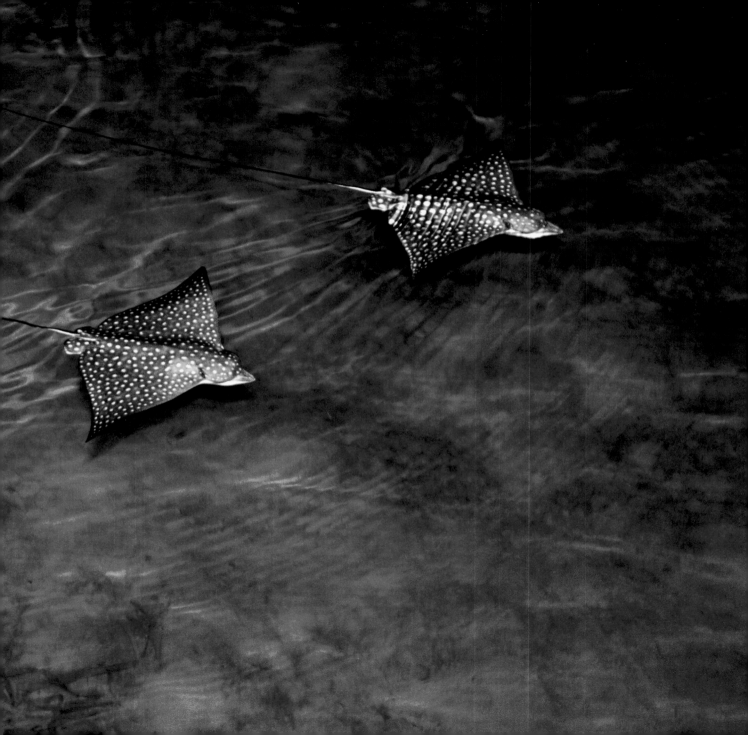

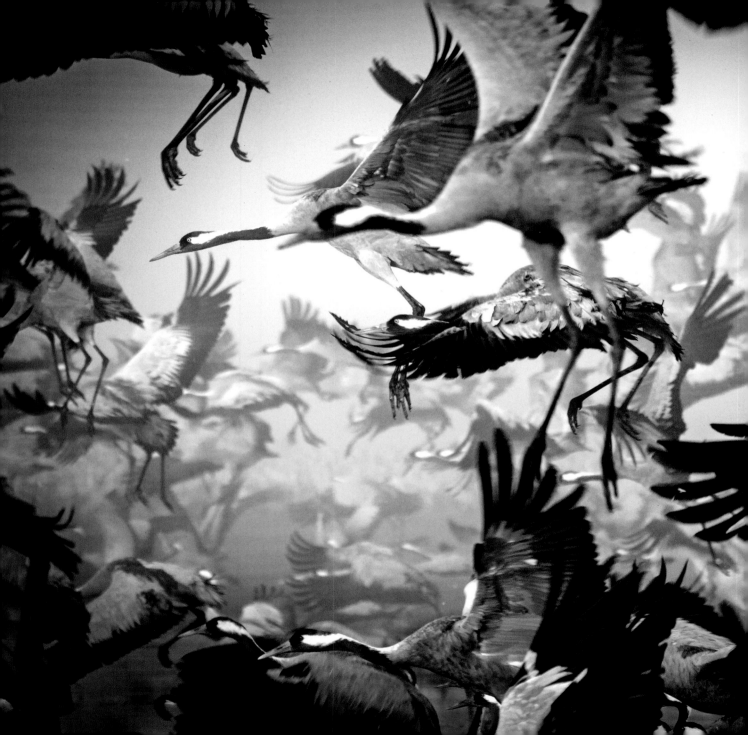

EMBRACE
THE UNTAMED

BY EVELYN HOCKSTEIN

A WALK ON THE WILD SIDE

What does it mean to embrace the untamed? The goal for this assignment is to shoot photos that are a visual celebration of wildness. Everything from the deer in your backyard to elephants on an African savanna is fair game (no pun intended!). Raging rivers and daunting mountain peaks are also a perfect fit for this assignment. Capture nature displaying its untamed majesty. One rule: no pets allowed!

I can't resist a good portrait of an animal—a close-up of a lion, a gorilla, an owl—but the images that blow my socks off are the ones that capture the spirit and context of this wild world we live in. Try to portray an animal's spirit or environment in the shot. Rather than photographing a bird close up, snap a picture of a flying bird that conveys the space, height, freedom, or vastness of the natural world. Including more context in an image can help unleash that untamed feeling.

Zoos are great places to see animals that you might not have a chance to see otherwise, but this assignment is about photographing nature and animals in their natural habitats. You don't have to go to an exotic location to take great photos of animals. You can go to a local park, a nature trail, or a pond or lake. The animals that live there are just as wild as the wildebeests of the Serengeti.

For landscapes, aim for sweeping shots, with dramatic light, weather, or terrain. Look for landscapes that feel untamed—that portray Mother Nature as the wild, awesome force that dwarfs and awes us with her power and beauty.

Keep in mind that with every photograph, you are telling a story. Close-ups can be evocative and compelling, but also try to shoot big and wide—and thoughtfully. Take viewers to the place where you are shooting. Let them experience all the textures, colors, sounds, spaces, movements, smells, and creatures. Keep going wild!

ABOUT THE ASSIGNMENT EDITOR

Evelyn Hockstein, PHOTOJOURNALIST

Hockstein is an award-winning photojournalist who has worked in more than 70 countries for news outlets including the *New York Times*, the *Washington Post*, *TIME*, and *Newsweek*. She has won two Pictures of the Year International awards, and her work has been exhibited around the world.

TERRY SHAPIRO — LIVERMORE, COLORADO

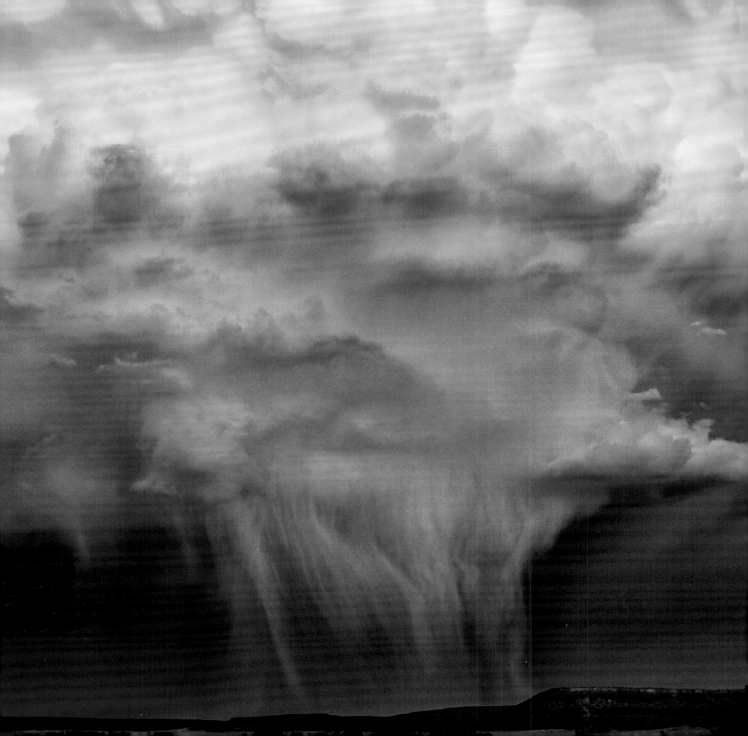

»TRUNK **TO TRUNK**

Elephants are majestic and highly intelligent animals. Many of their behaviors are humanlike. This photographer deftly captured an affectionate moment between these tremendous mammals as they interact with each other. The sharp white tusks jutting out beneath their trunks create an interesting contrast against the dark skin of the elephants and the gentle act of one elephant wrapping its trunk around the other elephant's head. Strong wildlife photography requires the patience to wait for the perfect moment that will convey the personality of the animal to the viewer.

THE PHOTOGRAPHER'S STORY

"Totally wild and untamed, these amazing animals show humanlike behavior. Etosha National Park in Namibia was the scene of this show of affection by two family members in a herd of over 40 elephants." —Ian Rutherford

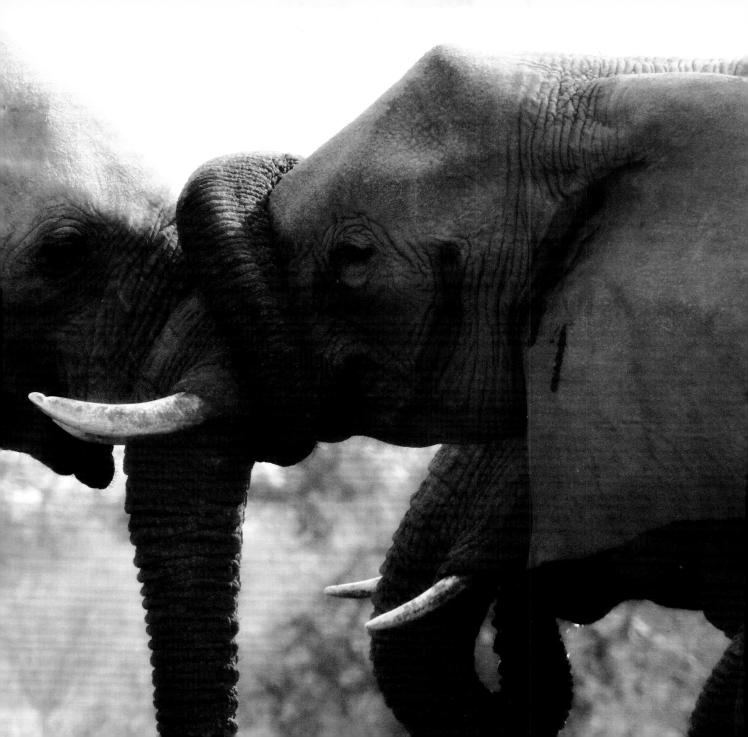

»NIGHT MOVES

So many elements contribute to this exceptional image. The stars twinkle in the rich purple-and-blue sky. Light emanates from behind Oregon's Mount Hood and highlights its snowcapped peak. The flowing white water perfectly complements the white of the mountaintop. The dark hills contrast beautifully with the highlights in the stream and lead the viewer's eye toward the peak, glowing in the distance. Capturing this image was no small feat. In order to get a balanced composition and to use leading lines, the photographer actually had to stand in the middle of the stream. This required a sturdy tripod, a slow shutter speed, and serious dedication.

HOW TO GET THIS SHOT

• **Sometimes** you have to place yourself in an uncomfortable position to get the perfect shot. But be careful. There's a difference between uncomfortable and unsafe.

• **Use a slow shutter speed** to capture the movement of flowing water. Try a shutter-release cable to ensure you don't move the camera when you release the shutter.

• **Want a less expensive alternative?** Use the self-timer setting on your camera instead.

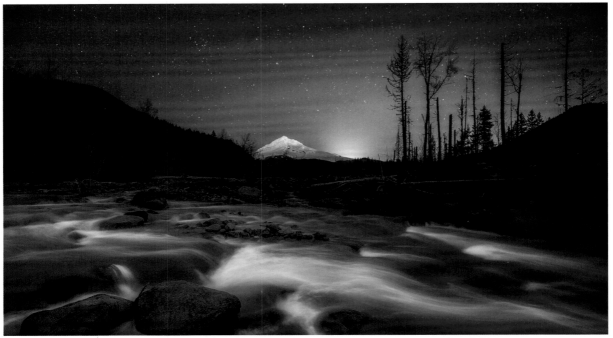

PAUL WEEKS — RHODODENDRON, OREGON

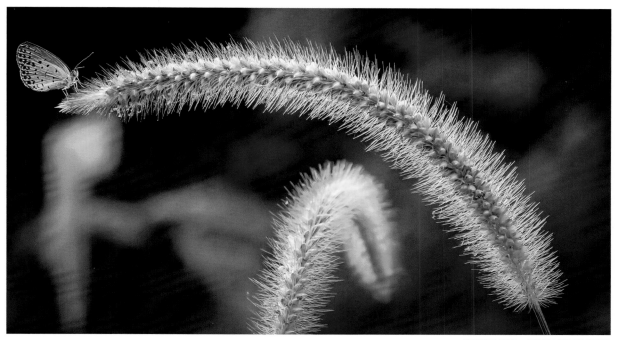

JEREMY AERTS — DAEGU, SOUTH KOREA

»WINGED **VISITOR**

The beautiful light, soft colors, and texture of this illuminated wheat stalk are absolutely stunning. As the stalk bends, your eye follows its curve to a gentle lavender moth perched on its delicate tip. The lavender complements the green background, and a warm glow emanates from the stalk. This image is a testament to the untamed beauty found right in our own backyards. A field of wheat or tall grass is a common sight, but with great lighting, crisp composition, and a well-timed landing, the photographer created a striking image. And caught on camera, this insect offers more insight into the natural world that we might be able to see with the naked eye.

HOW TO SHOOT WILDFLOWERS

- **You can capture** beautiful light at any time of day. Backlighting and strong shadows can create dramatic effects.

- **When photographing** plants or flowers, an element of interest, such as an insect, can make the picture even more exciting.

- **When shooting** the intricate detail of flora, use a shallow depth of field to remove background distractions and keep the focus on the subject of the photograph.

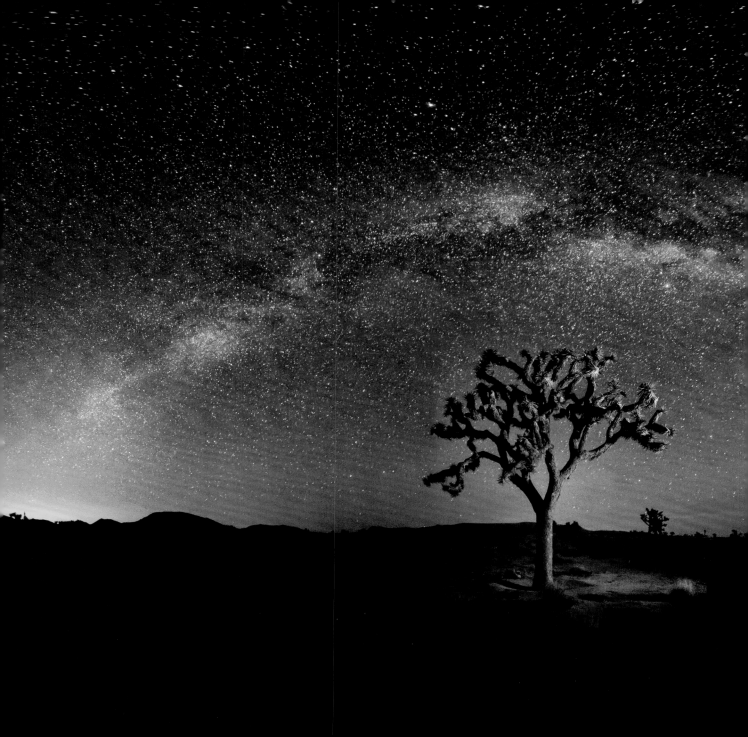

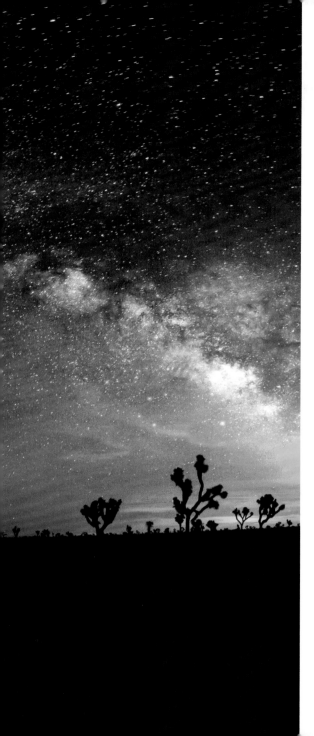

»HEAVENLY LIGHT

The Milky Way is a beautiful sight to behold, and this photographer masterfully captured the myriad of stars that we so often can't see with the naked eye. The lone Joshua tree has an ethereal glow and stands out perfectly against the evening sky. What makes this image even more special is its perfect composition. The subtle arch of the Milky Way gracefully frames the tree and echoes its shape. Rich gold, red, and pink colors emanate from the horizon, contrasting with the deep blue of the star-studded sky. This photograph successfully uses Earth's landscape to make us feel more connected to the greater universe.

HOW TO CAPTURE THE NIGHT SKY

- **When photographing** the night sky, add a compositional element to the foreground to give the image perspective.

- **A slow shutter speed and low ISO** reduces digital noise—speckles in the picture, which detract from the clarity of the image—that might appear in the shadows at a higher ISO.

MANISH MAMTANI — JOSHUA TREE NATIONAL PARK, CALIFORNIA

217

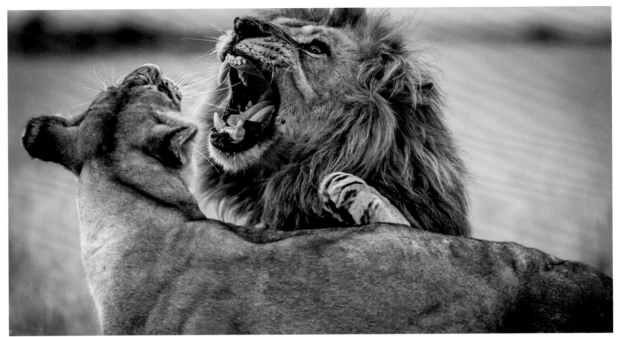

»HEAR ME ROAR

This is the moment wildlife photographers wait for. Animals are beautiful when they are still or resting, but a wildlife image is infinitely more interesting when an animal's wild nature comes through. It is important to look beyond the straightforward portrait of a majestic animal. How does the animal behave in its habitat? What is the character of the animal? This image beautifully captures the personality of the lion, its powerful teeth, and its interaction with the lioness. I love the wild look in this lion's eye. I can practically hear this lion roar—a sure sign that the photographer has done his job well.

HOW TO CAPTURE THE "MANE" EVENT

- **Patience is essential** when photographing wildlife, and that applies to a deer in your backyard or a cheetah on the hunt. A wild animal isn't going to pose for the camera or walk into the perfect patch of sunlight on cue.

- **Wait for a moment of action** or a moment when the animal wears an engaging expression.

- **Images of animals** playing, being affectionate, or living in a community evoke a human response and make your pictures more interesting than just portraits.

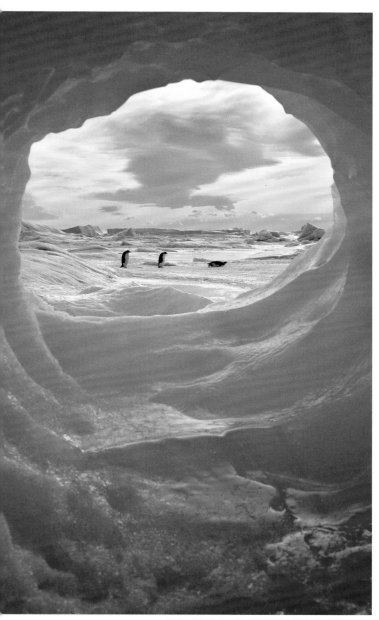

KEITH SZAFRANSKI — SNOW HILL ISLAND, ANTARCTICA

»PENGUIN **PEEPHOLE**

This once-in-a-lifetime photograph creates a wonderful sense of place. A shot of emperor penguins marching along the icy Antarctic landscape would be a winner by itself. But this photographer raises the bar by shooting through an ice tunnel, creating a uniquely stunning composition. We drink in the rich blue of the ice, which perfectly frames the soft purple of the snow and the orange and purple in the sky. Shooting with a wide angle brings the texture of the ice into the image and helps convey the vastness of the Antarctic. Think about a unique feature of the landscape you are shooting, and see how you can incorporate that feature into your photograph.

HOW TO CREATE CONTEXT

- **Bringing the habitat** into your photograph helps tell a story about the animal.

- **Don't be afraid to shoot wide.** A wider angle gives the viewer a sense of what the animal's life is like and the environment in which it must survive.

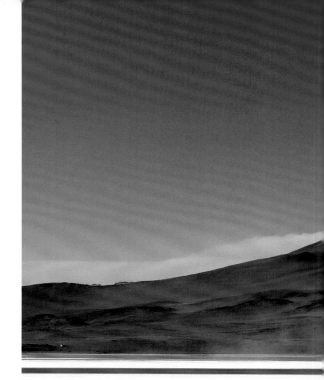

»SEEING RED

This lake's startling red color—caused by algae—pops off the page, but the flamingos dotting the water add an essential element of interest. As your eye travels from top to bottom, the bands of color create a beautiful, clean composition: first the royal blue sky, then the deep blacks in the mountain shadows, then a striking band of white salt, and finally, the deep red. The flamingos in the foreground echo the bands of salt, break up the predominant swath of red, and take this image beyond a straightforward landscape.

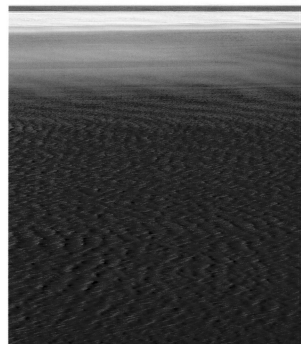

HOW TO SNAP A GREAT LANDSCAPE

• **In landscape photography,** use greater depth of field to ensure that as much of your scene as possible is in focus.

• **Horizontal lines** are visually interesting and add stability to your image. Lines often serve as dividing points that let your eye focus on different sections of the photograph almost as individual images within the single frame.

DHARSHANA JAGODA — JUNTACHA, POTOSÍ, BOLIVIA

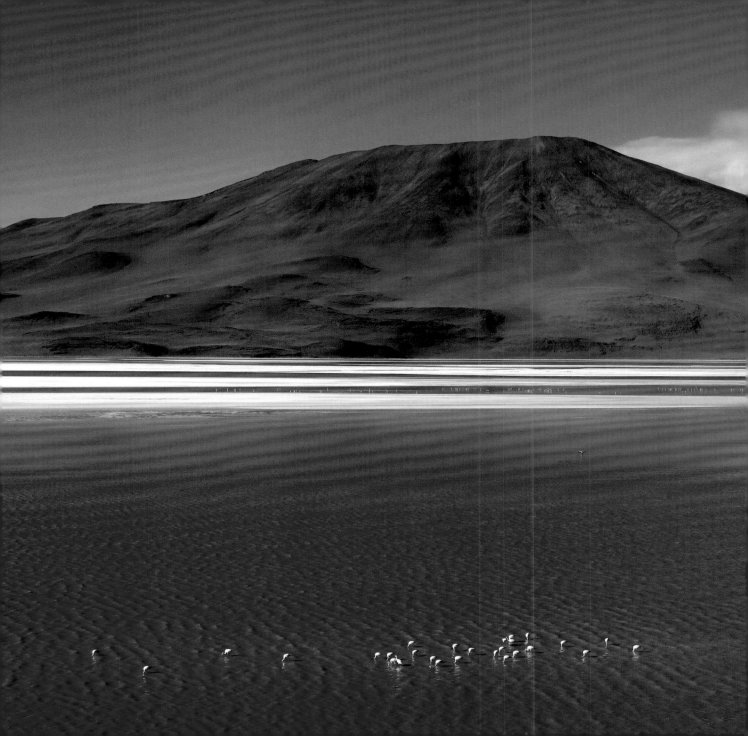

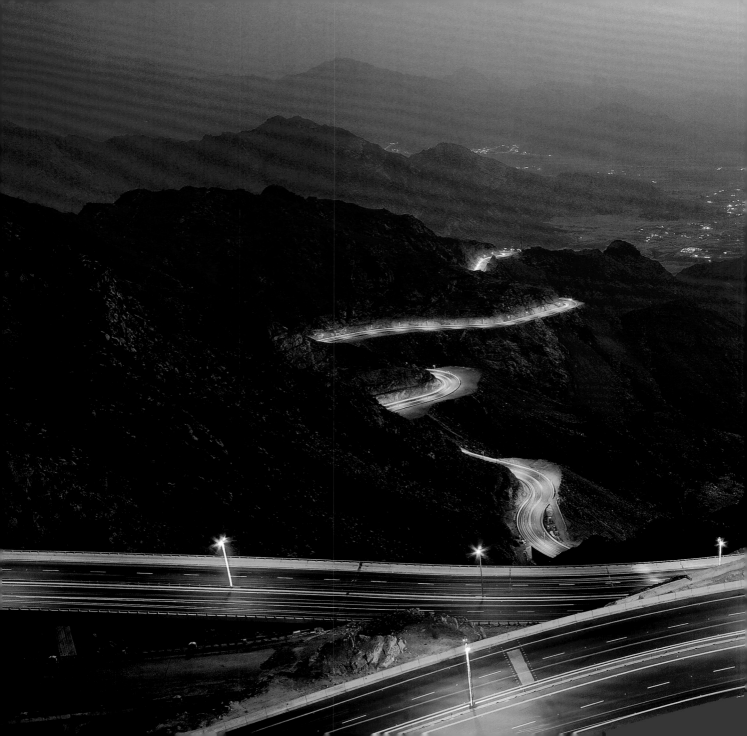

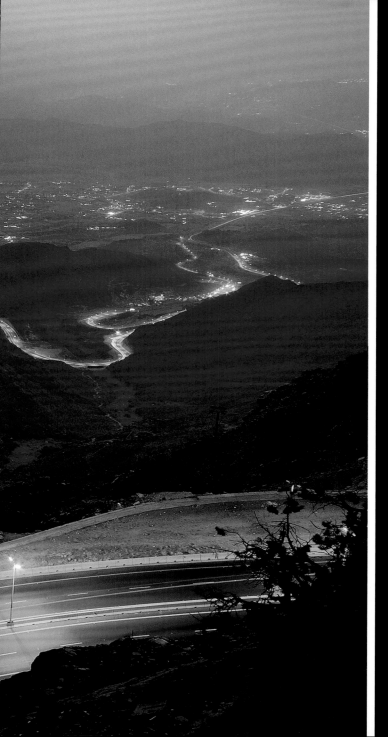

EXPLORE OUR CHANGING WORLD

BY CORY RICHARDS AND SADIE QUARRIER

THE POWER OF A PICTURE

C hanges in our world are happening at breakneck speed. Great photographs provide us with the opportunity to slow down and see the world in a new way. They can inform, delight, engage, and broaden our worldviews. Evocative images can also direct attention to important issues. That's when the power of photography really emerges. It enables us to document and explore what these changes mean for ourselves and for our communities.

This assignment is about finding examples of change. Your pictures might come from your own community or backyard, or from a place that you are seeing for the first time. Ask yourself what is special, or perhaps disappearing, in your world. The list of ideas is endless. "Our Changing World" can include weather (droughts, floods, storms, or fires), landscapes (pristine areas under threat or aerials showing suburban sprawl), or culture (vanishing traditions or new trends). Pictures that juxtapose old and new also work well to demonstrate change.

Take pictures of what inspires you, and challenge yourself to create thought-provoking examples of change, whether positive or negative. Look for unique vantage points, unexpected moments, and interesting details.

With this assignment, we hope you will embrace the power of photography, which connects us and inspires us to care about our evolving planet. Photography not only captures change, but also creates change. Have fun with this assignment and enjoy seeing in a new way.

ABOUT THE ASSIGNMENT EDITORS

Cory Richards, NATIONAL GEOGRAPHIC PHOTOGRAPHER AND **Sadie Quarrier,** *NATIONAL GEOGRAPHIC* MAGAZINE

One of the world's most acclaimed adventure photographers, Richards (right) has been named a National Geographic Photography Fellow and a National Geographic Adventurer of the Year. His photography has appeared in *National Geographic* and *Outside* magazines, and in the *New York Times.*

As a senior photo editor, Quarrier (left) specializes in editing adventure stories for the magazine. She has won numerous awards for her work and is a voting member on the National Geographic Society's Expeditions Council.

MICHELE MARTINELLI — RANOHIRA, MADAGASCAR

»LIGHT **TAKES FLIGHT**

At any given time, half of our planet exists under the cover of darkness. In this seeming absence of light, it's easy to set our cameras down. *Don't!* Nighttime is *not* an absence of light, but an opportunity to use it differently. In this image, we see a creative interpretation of form and composition, as well a playful inquiry into how we can bring a world in shadow to life. A wingspan, light trails, headlights, a cityscape, and a figure come together as a story begging to be told. Using techniques like shutter drags, long exposures, flash, and even high ISOs, we can create graphic imagery while much of the world is fast asleep.

HOW TO BALANCE MOTION AND STILLNESS

- **Find your anchors.** If everything moves, your photo becomes one big blur. Make sure to include nonmoving elements to anchor your image.

- **Turn your flash on.** Use a combination of flash and slow shutter speed to freeze some elements, while capturing the movement of others through light paths.

- **Follow the light.** Look for interesting colors or bursts of light to create a busy, but not overwhelming, scene.

JUAN OSORIO / SOLAR-POWERED PLANE — ROCHDALE VILLAGE, JAMAICA, NEW YORK

226

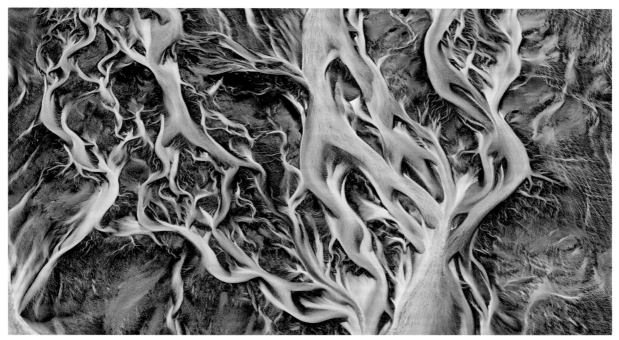

»THE RIVER **WILD**

Sometimes the best way to tell a story is to change the way we see it, both mentally and spatially. This image is such a perfect use of that technique. Because we experience Earth from its surface, we overlook so much of our surroundings and mistake the extraordinary for the ordinary. This image offers us a new vantage point. From ground level, all we would see is a simple floodplain. Here it becomes an intricate tapestry and palette that tells the story of gravity, water, and minerals. This photo provides a fresh look at how dynamic and alive our planet is.

HOW TO TAKE AERIAL SHOTS

● **Get up high** in an airplane, in a helicopter, or on a mountaintop for a new look at the landscape below.

● **Aerial shots let you** show huge stretches of scenery at once. Use this perspective to create a sense of the world below.

● **Seek out patterns and shapes** in the landscape. Natural and man-made landscapes can become abstract when you look at them from the right angle.

» ON THE ROAD

Sometimes great images are more than what we see at first glance. The beautiful use of dusk light combined with the ambient glow of the lantern gives the foreground subjects contrast and life. The cart and the ox, falling off into the shadows, begin to give us a larger narrative. But what I really love is the contrast between old and new, traditional and modern. The cityscape on the horizon tells us that even among the hustle of contemporary metropolitan life, a simpler and, at times, overlooked way of life persists. Great photography so often depends on finding and illuminating the unexpected, balancing what we know against what we so easily overlook—or simply choose not to see.

THE PHOTOGRAPHER'S STORY

"This Tambobong *(roofed oxcart) is a mobile retail store, loaded with local handicrafts made from bamboo and rattan products manufactured by peasants to augment their income from farming. They travel and sell their wares in the urban areas during the period between post-planting and pre-harvest season. The proliferations of colorful plastic merchandise decreases the demand for handicrafts and threatens the extinction of Tambobong to its last journey."*
—Danny Victoriano

ANTIPOLO, CALABARZON, PHILIPPINES

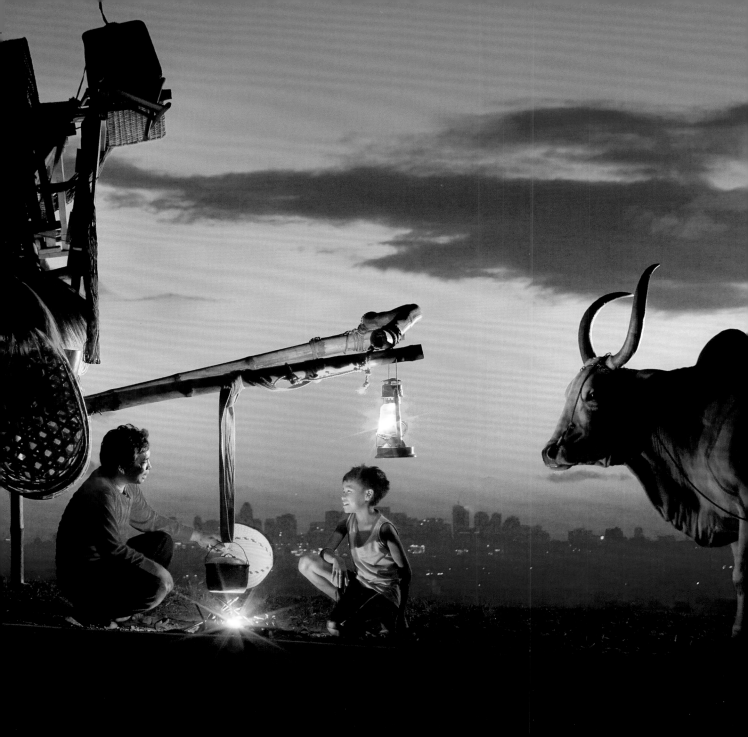

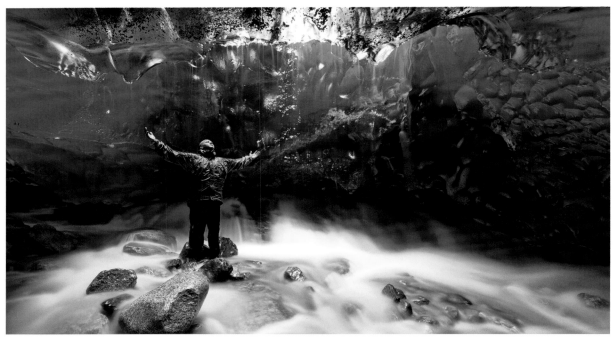

»TANGLED UP IN BLUE

Of all the elements that make up our constantly changing planet, I find water to be one of the most captivating. Ice holds a deep fascination, as it signifies both hostile environments and the lifeblood that sustains us. Ice landscapes are at once ferocious and meaningful. This image places a human in an inhuman landscape, using color, texture, light, and form to illustrate both our impact and our reliance on Earth. The low shutter speed shows the ice melting, morphing into water. The translucent blue light illuminates a world in which we cannot survive—and yet we cannot survive without it.

HOW TO PHOTOGRAPH A GLACIER

- **To get the full effect** of the intense blues and other colors, turn the automatic white balance on your camera to tungsten.

- **Finding natural light** in a cave is hard, but it can be done. Look for the places where light streams in, and notice its effect on the glacier walls.

- **Bring your walking shoes.** This photographer hiked nearly two and a half hours to get to this cave. Hard-to-access places can make for very special photos.

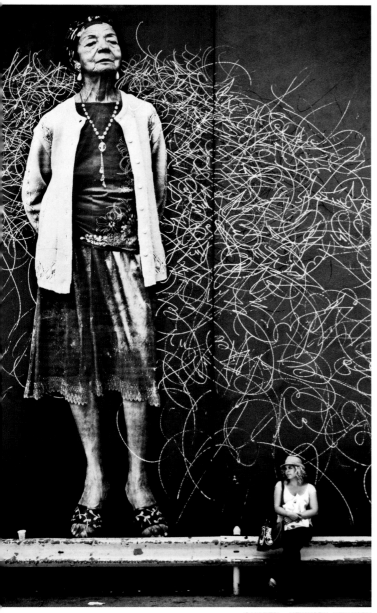

SAM BER — NEW YORK, NEW YORK

»A GIANT AMONG US

've always loved it when a photographer manages to play a trick on me. This image does that every time I look at it. We can often use scale to throw the eye, whether through spatial variance or through actual size differences. When you first look at this image, you see a proud older woman, three-dimensional and alive. But it's only when you see the smaller "real" figure on the bench that the image truly comes to life. The composition of this capture is extremely simple, yet paramount to its success. The black-and-white tonality allows us to experience the creativity and playfulness of the image without the distraction of color.

HOW TO SHOOT STREET ART

- **Contrasts between** art and the real world can create intrigue.

- **Look for clean lines.** A vertical line separates the elements in this frame, while a horizontal baseline keeps things grounded.

- **Show context.** Street art and graffiti come in all different shapes and sizes. Showing the wall, mailbox, or sidewalk where the art lives gives the viewer a sense of scale and context.

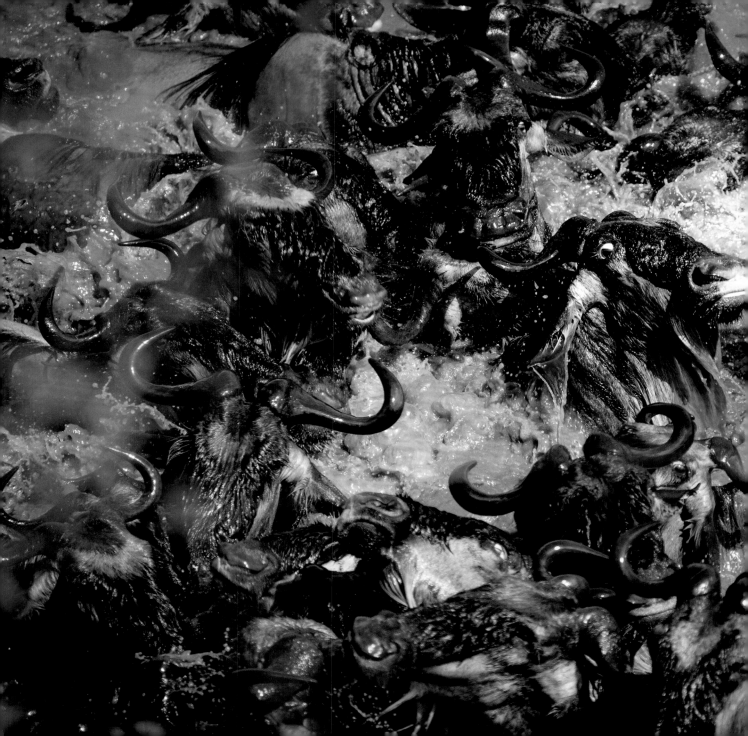

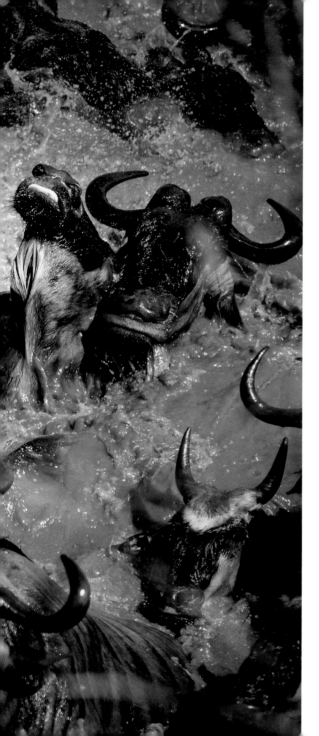

»MASS MIGRATION

The simple magnitude of a scene can be enough to make a good image. But how we choose to capture the energy in that scene can make it truly great. A wildlife migration can be a dramatic and provocative illustration of energy. This image captures chaos, motion, and change. Using a long lens, the photographer isolated a group of animals and created a visual vacuum, suspending us amid the chaos with no escape. We feel the immediacy of the migration frozen in every clashing wave and drop of water. And then there is the eye—a moment of panic and urgency serendipitously captured at center frame. I'm drawn into this image because I know there is no way out.

THE PHOTOGRAPHER'S STORY

"Forced to find new river crossing points in the Serengeti-Mara region of East Africa, the wildebeests descend into individual despair and collective chaos. Fast currents and steep banks all but deny escape onto the tree-covered banks. New arrivals try unsuccessfully to scramble over the lead group, which cannot climb quickly enough onto the available dry ground. Such scenes may become more common as the great migration faces more variable climate and narrower corridors from changing land use."
—Karen Lunney

MAASAI MARA, GREAT RIFT VALLEY, KENYA

»GONE FISHING

This image is all about light. The color of the backlit fishing nets contrasts with the deep shadows of the background. The light coming through the spray of the water creates playful shapes, drawing our eyes through the composition. We are so captivated by the color that it takes a moment to notice the larger cultural narrative. This kind of image takes equal parts skill and timing. In trying to capture powerful cultural illustrations, we need to be aware of all aspects of our surroundings, including when and where we can use light most effectively as a visual hook.

HOW TO CAPTURE CULTURE

• **Know the culture,** especially when shooting in a foreign country. Photography etiquette varies around the world, and it's important to be respectful.

• **Act like a local.** You'll find some of the most interesting scenes when you venture off the beaten path.

• **Some shots** are all about timing. Set your camera on burst or continuous mode to take a series of pictures in rapid succession to capture a scene in motion.

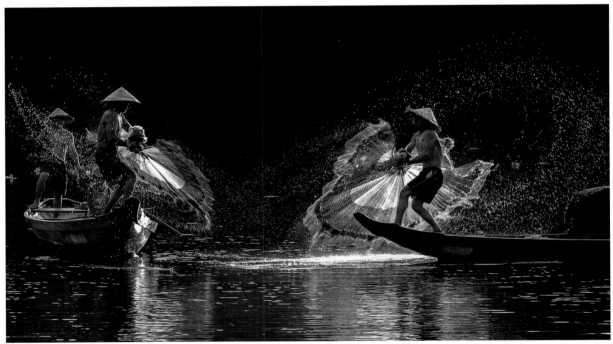

HOANG GIANG HAI / TRADITIONAL THROW FISHING — THUA THIEN-HUE PROVINCE, VIETNAM

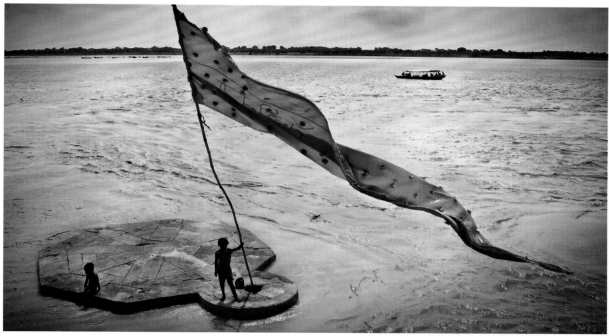

»FLAG DAY

We don't always have to be in someone's face to tell an intimate story. The scale of this image—created through the composition—makes it particularly evocative. Look at the vastness of the water and the size of the boat juxtaposed against the small children holding an enormous flag. It's a quiet moment of autonomy that leaves us connected, despite the stark absence of personal information. As we try to tell the story of culture, incorporating landscape can be pivotal to our success. In this case, through the use of negative space and a monochromatic palette, we get a glimpse of a life unknown . . . but with just enough intimacy to invite us in.

HOW TO MAKE A DRAMATIC STATEMENT

- **Give it some room.** Don't crowd your frame. When each element has its own space, it has a greater impact on the viewer.

- **Let a person be a shape.** Silhouettes can be just as interesting as a person in full focus.

- **Put harsh light to work.** The bright midday light can create interesting effects in your photography. See if you can make it work for you instead of compensating for harsh light.

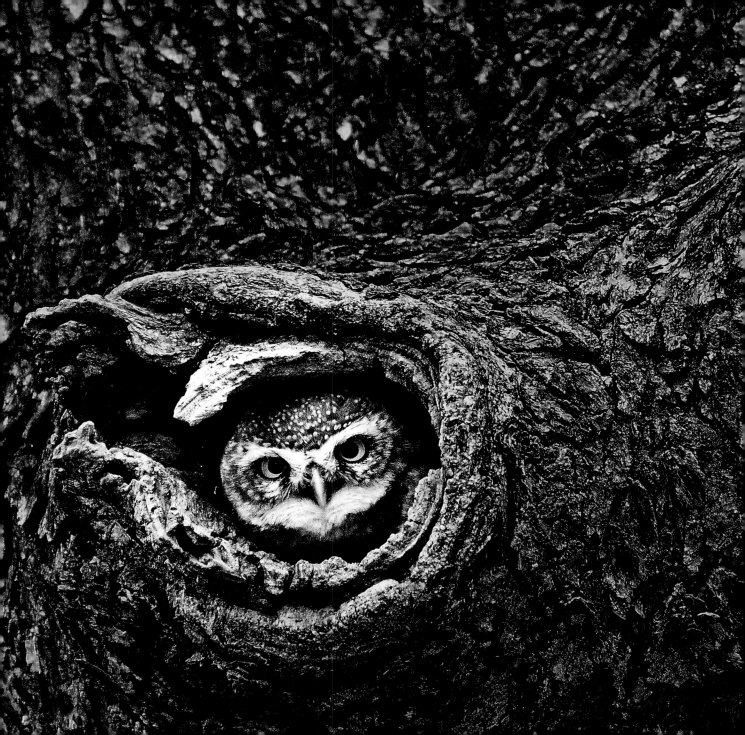

NATURE IN
BLACK & WHITE

BACK TO THE ELEMENTS

I recently discovered Ansel Adams's book *Sierra Nevada: The John Muir Trail,* which showcases the stunning wilderness of California's Sierra Nevada. Adams's photos immediately struck me as simple yet elegant compositions; his straightforward black-and-white approach perfectly complements the purity of the mountains. These images left an indelible impression on me.

This assignment is a chance to channel your inner Ansel Adams by shooting nature in black and white. Many of Adams's photographs of nature elevate form by reducing a scene to its elemental components. Adams described this as "an extract of nature"—a way to turn landscape photography into an avenue for personal expression.

Black-and-white photography strips away the distractions and lets that message ring loud and clear. These photos are a departure from the reality we see every day; they carry the viewer to a different world. Try to capture the sacred spaces you've found in nature.

Seek out nature images that look more dramatic in black and white than in color. Usually this requires subjects for which form, light, and design are the dominant elements. Set your LCD display on your camera to monochrome so that you can see how the photo will look in black and white as you are shooting.

Ansel Adams and other early photographers portrayed nature as a Garden of Eden. Today we have a different view. We now know that all aspects of nature are interconnected and that humans can impact nature in a detrimental way. So, photographing nature can mean shooting a city park or a reclaimed industrial area, both of which are ecologically important and beautiful in their own ways. Nature photography can now include just about anything on Earth—an exciting prospect to discover and to enjoy.

For me, nature is a subject matter with no limits for a photographer with clear eyes and a receptive heart. I hope you feel the same.

ABOUT THE ASSIGNMENT EDITOR

Peter Essick, NATIONAL GEOGRAPHIC PHOTOGRAPHER

One of the world's most influential nature photographers, Essick has spent the past two decades photographing natural places around the world. His work has been featured in some 40 articles in *National Geographic* magazine.

MANISH MAMTANI — YOSEMITE VALLEY, CALIFORNIA

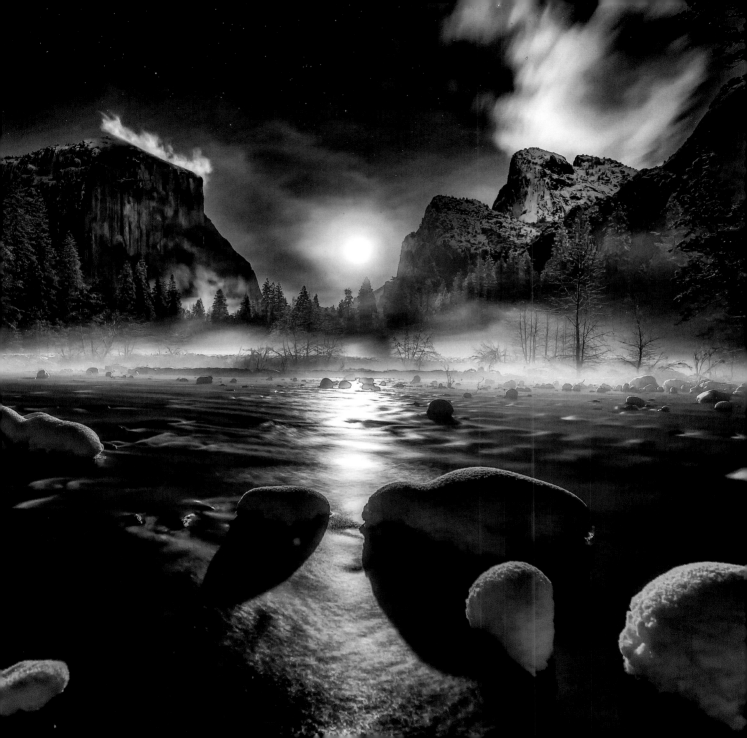

»UP IN **THE CLOUDS**

Outstanding landscape photography is often a matter of timing. Sometimes luck is on your side, but more often it is a matter of doing your research and making a concerted effort to be in the right place when conditions are optimal. Storms produce some of the most memorable landscape photos. In this case, a storm has passed over the Grand Canyon and has left a dusting of snow on the South Rim. The North Rim is hidden in the clouds, but just enough sunlight pokes though the clouds to light up the rock formations in the canyon. Not every storm produces perfect photographic conditions, but watching the weather and planning trips in off-seasons usually pay dividends. A photographer's definition of a beautiful day often differs from most people's—photographers frequently forgo comfort to experience a spectacular natural display.

THE PHOTOGRAPHER'S STORY

"It's the day after an all-day snowfall. This morning the weather was better already, but changing: clouds coming and going, occasional snow, and the sun peeking in and out. The Grand Canyon is always awe-inspiring, but with all of this light and shadow, with the misty clouds, and with snow-covering the top of cliffs like powdered sugar on a cake, it was just beyond my imagination."
—Veronika Pekkerne Toth

GRAND CANYON, ARIZONA

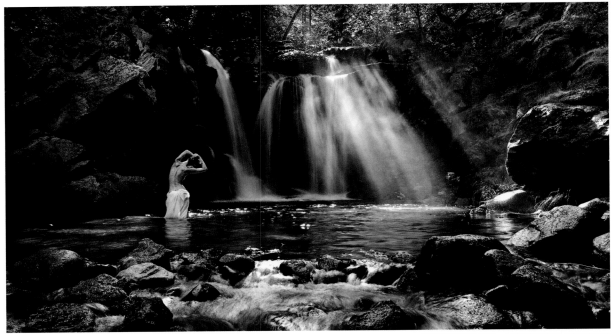

»PARADISE **FOUND**

Creating a mood in a photograph can sometimes be more difficult than finding a good composition or making the correct exposure. This photograph makes you feel as if you are peering into a secret world. The graceful lines of the woman's figure convey a sense of calm. Soft light rays, filtering through the forest in the background and passing over the waterfall, create the impression of a mystical place. The water in the pool looks refreshing and inviting. The woman is small in the frame but stands out because she is sunlit and against the shadowy rocks. Somehow the photo invites us into an intimate space rather than making us feel like outsiders.

HOW TO CREATE MOOD IN PHOTOGRAPHS

- **Use soft lighting,** or shoot in the early morning or late afternoon.

- **When photographing** moving water or clouds, try a long exposure to capture a soft, dreamlike feeling. Don't forget to use a tripod to steady the camera.

- **Mist or fog** can produce an atmospheric effect in a landscape.

- **Create compositions** that are pleasing to the eye without any jarring elements, especially near the edges of the frame.

»CREATURE **OF THE SEA**

This unusual black-and-white underwater photograph of a stargazer fish uses directional lighting from below to create a feeling of mystery. The overall mood is one of an otherworldly creature lurking in darkness at the ocean bottom. At first we aren't sure what we are looking at. The sand covering the back portion of the fish makes the image resemble a stone statue or carving. Then we see the Frankenstein-like lighting, casting shadows upward on the eyes, and the realization hits us: This is a living organism, with very sharp teeth! In photos like this, the photographer often darkens the sides of the image to make the subject stand out. This technique increases the contrast in what could otherwise be a flat or unevenly lit image—with a captivating result.

HOW TO TO CREATE MYSTERY

- **Light small areas** of the image, and let the rest go into darkness.

- **Use symbolism** in your choice of subject matter. For example, moviemakers often use certain subjects, such as dark forests shrouded in fog, street lamps, moonlight, masks, or curtains, to evoke a mysterious mood.

- **Lighting from below** can create a fantastic, ghoulish effect.

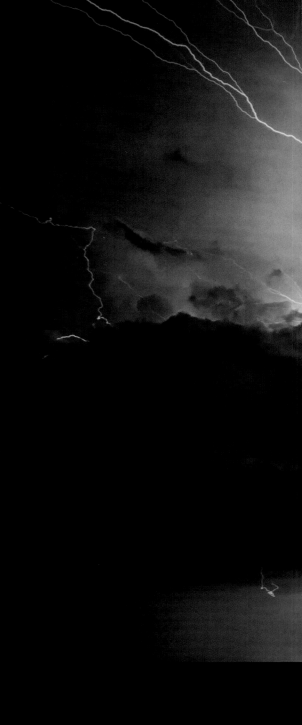

»NATURE'S FURY

Lightning is a favorite subject of photographers, and for good reason. These images can be dramatic and beautiful in depicting the raw power of nature. Rendering lightning and storm clouds in black and white only enhances the drama. What makes this lightning photo special is that it captures both the downward bolt striking the ocean and multiple bolts radiating upward. Often lightning in the clouds doesn't photograph well and appears as just a flash of light, but in this case the lightning is spectacular. It is also fortunate that the upward bolts are balanced on the right and left sides of the frame. No one can plan for this, but if you can take many exposures during an intense thunderstorm, your odds of getting a breathtaking shot increase.

HOW TO PHOTOGRAPH LIGHTNING

- **Choose a safe location** that isn't near any tall objects.

- **To increase your chances** of seeing cloud-to-ground strikes, shoot from a location where you can see a great distance.

- **At dusk or at night,** open the lens for up to 30 seconds with an aperture of around f/8. Shoot frequently and hope for a lightning strike.

- **During the day,** use a lightning trigger. It will open your shutter when it senses the bolt of lightning.

RUDI GUNAWAN — TANJUNG LESUNG, WEST JAVA, INDONESIA

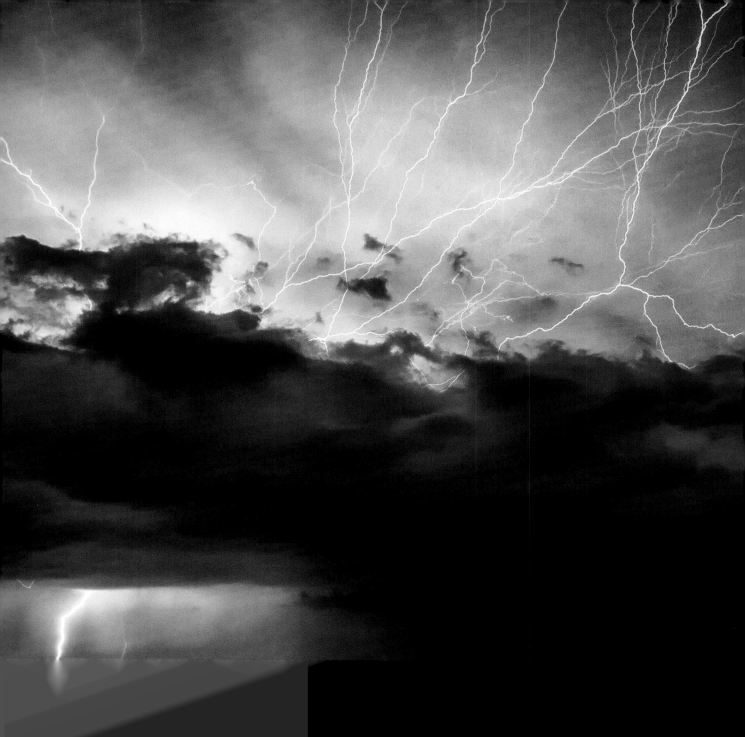

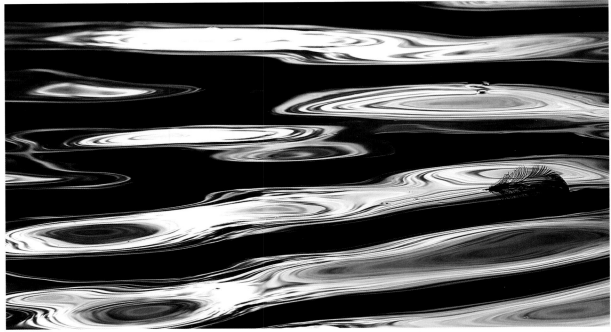

»RIPPLES **OF LIGHT**

Reflections in water offer an infinite variety of patterns for a creative photographer. Unfortunately, the results are often disappointing because of movement on the water's surface or a high contrast between the surface illumination and the reflection. It is important to know where the light is coming from. If you are looking down at the water from a 45-degree angle, the water is reflecting the scene in the background 45 degrees above the water. Following this principle, you can pick the best position from which to see a reflection. Here, the photographer adds another dimension by capturing the silhouette of the feather floating above the reflection.

HOW TO CAPTURE LIGHT ON WATER

- **Use a medium** telephoto lens to isolate a section of the reflection.

- **Focus in the middle** of the scene. Then close down the aperture to get enough depth of field to keep the water's surface in focus. The reflection should be out of focus.

- **Try to balance** the intensity of the reflected light and the ambient light to get a good exposure.

- **Look for** foreground objects or floating items to create a third dimension.

»WHO IS **STALKING WHOM?**

Photographing a wild African leopard in dense foliage is no easy task. The first order of business is to locate a leopard. These predators are active at night and in the early morning, so whether you are on safari or at a local zoo, these are usually the best times for photography. In this image, eye-to-eye contact between the photographer and the leopard first draws in the viewer. The pattern of the coat is so different from the surrounding vegetation that the leopard stands out, though its body is mostly obscured. The leopard's piercing eyes, peering out through the vegetation, add to the mystery and the sense of discovering an elusive creature.

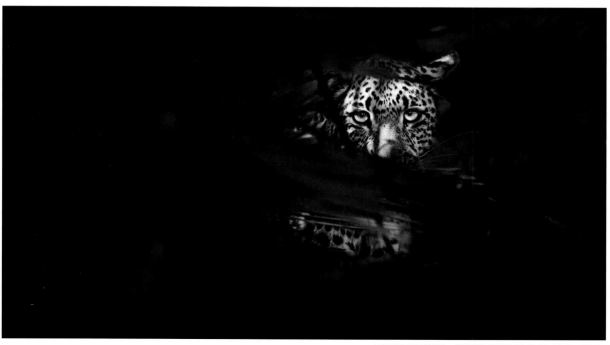

MORKEL ERASMUS — KRUGER NATIONAL PARK, SOUTH AFRICA

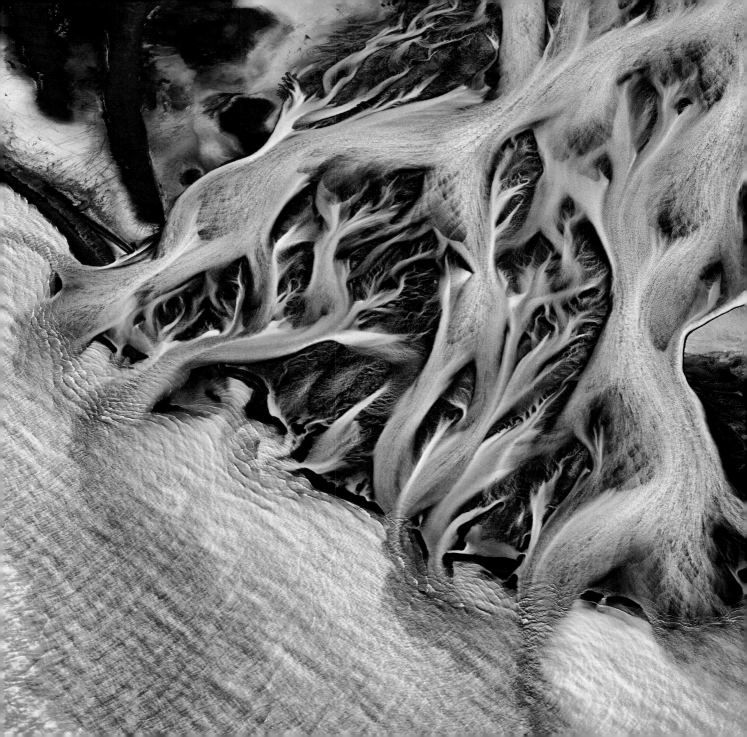

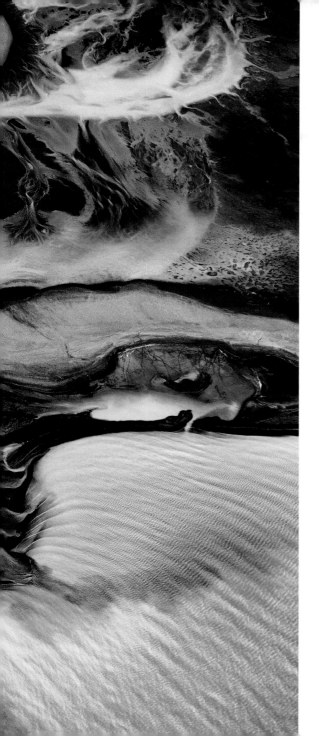

≫GOING **WITH THE FLOW**

The natural shapes in this photograph are extraordinary. We see rivers of water and silt flowing into the windswept waves of the ocean. The framing—what the photographer chose to include and exclude—gives the photograph form and balance. You first see the main flow of the river, which leads the eye into the frame from left to right. The secondary elements—horizontal white water on the right and two dark water channels on the left—fill in the space to create visual equilibrium. What's even more amazing is that the photographer shot this scene from an airplane—a testament to the power of a great eye and a serious zoom lens.

THE PHOTOGRAPHER'S STORY

"This is an aerial of the delta of the Fulakvisl River and Lake Hvítárvatn in the Icelandic highlands. The river contains silt from the glacier Langjökull and forms a magnificent delta. The conditions were very windy, and I had to abort the flight shortly after taking this picture due to motion sickness. I used a Hasselblad digital medium format camera for the shot. The altitude was about 400 meters above the lake." —Hans Strand

LAKE HVÍTÁRVATN, ICELAND

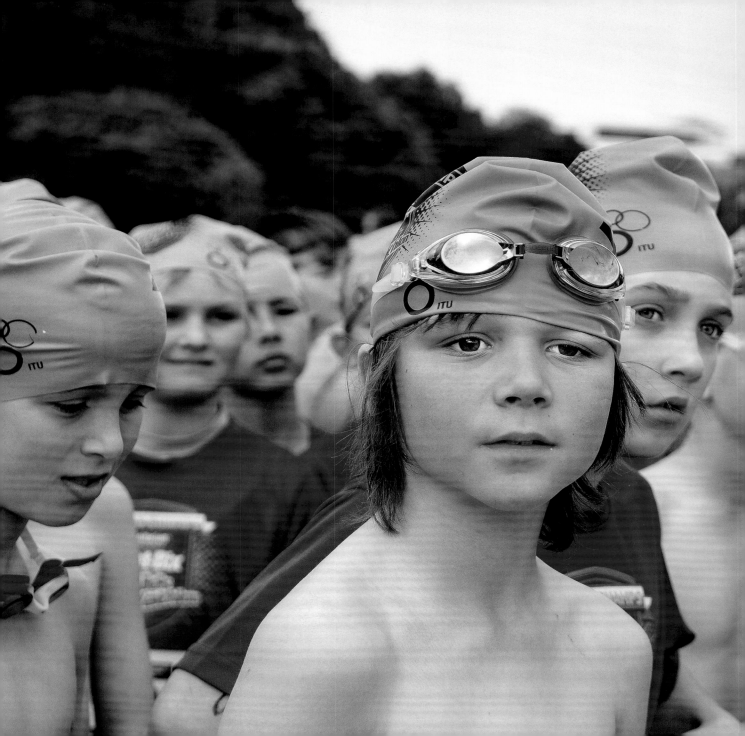

HOW CLOSE
CAN YOU GET?

BY ED KASHI

THE ART OF INTIMACY

Getting close is not only about physical proximity. It's about capturing a feeling, a mood, an emotion, or a sense of intimacy. It's the quality in a photograph that gives the viewer a feeling of being there in the scene as a silent, unseen observer. I call this "candid intimacy," and it's a quality I strive for relentlessly in my photography. I love being close to my subjects—not just physically, within touching range, but psychologically and emotionally.

For this assignment I want you to find a subject—preferably a human subject—and make an image that feels close. Avoid relying on a long or medium telephoto lens. Instead, move in closer physically and learn how to navigate the emotional and psychological landscapes where human (and, yes, animal) moments occur. The goal is to capture the essence of a moment, a person, or a scene.

To get close you must make eye contact and gain acceptance. The culture you are working in also dictates the appropriate distance or proximity to maintain. Gender plays a role as well. Invariably, if you work in a respectful, humble, and gentle manner, people of most cultures will accept you.

Here are my rules to shoot by: Be curious and open. Don't judge. Exude warmth, comfort, and safety. And be confident and sure of yourself. If you believe in what you are doing, others will accept you more easily and feel comfortable with your presence.

Getting permission before shooting is not just advisable; it is the right thing to do whenever possible. Always respect your subjects, and remember that you have no reason, in the normal world, to be there with a camera. Use your camera as your passport when entering these worlds.

ABOUT THE ASSIGNMENT EDITOR

Ed Kashi, NATIONAL GEOGRAPHIC PHOTOGRAPHER

An award-winning photojournalist and filmmaker, Kashi has produced 17 stories for *National Geographic* magazine. He has been a multimedia pioneer, documenting the social and political issues that define our times.

JAMES DUONG — HO CHI MINH CITY, VIETNAM

»A PAINFUL **GAZE**

Photography is a privilege. Sometimes getting close means capturing something that would otherwise go unseen. Here, we glimpse a mysterious scene that outsiders normally do not witness. The man's eyes, peering through his head covering, create a sense of secrecy. The downward perspective and the smoke add to the moodiness, and the composition creates a strong visual statement. The repetition of circular shapes—the hole in the ground, the person's head, and the basket—binds the photo's elements together. The muted bluish hue of the image makes the man's face pop out of the mask. We feel a powerful desire to know what this photo is about.

HOW TO GAIN ACCESS

● **A photograph like this** requires access, trust of the subject, and quite possibly official permission to enter the workplace. Obtaining this requires grace, charm, sometimes an official letter, and knowing the right person.

● **Wait for the right moment** for maximum impact. If the worker's head had been down, or if he had been looking away from the camera, this magical image would not have been possible.

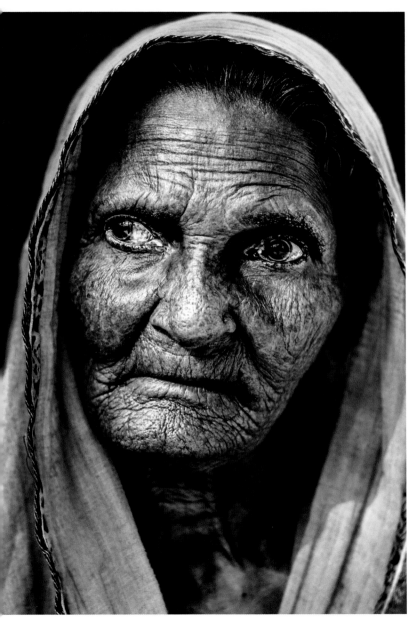

»IN HER **EYES**

We say that the lines of a face show the character of the person. That statement perfectly describes this captivating image. The eyes. The face. The grace of the head scarf. These elements, along with light and texture, make this photograph a stand-out. The woman's cloudy cataracts add a devastatingly powerful accent. Capturing this simple image did not require fancy photography tricks, but it is nonetheless striking and beautiful. The slight tilt of the head, the direction of the eyes, the way the woman's scarf falls—these small details are the difference between a pedestrian image and visual poetry.

HOW TO SHOOT AN INTIMATE PORTRAIT

• **You would need** a medium telephoto lens, with a focal length between 50mm and 105mm, to photograph a portrait like this one.

• **When your subject** has a face like this, don't be afraid to keep it simple and honor the subject. Sometimes simple is better.

• **Pay attention** to eye contact in portraits. Direct eye contact can reveal the soul and spirit of the subject, while an averted glance may tell more about your story.

»GROOMING RITUALS

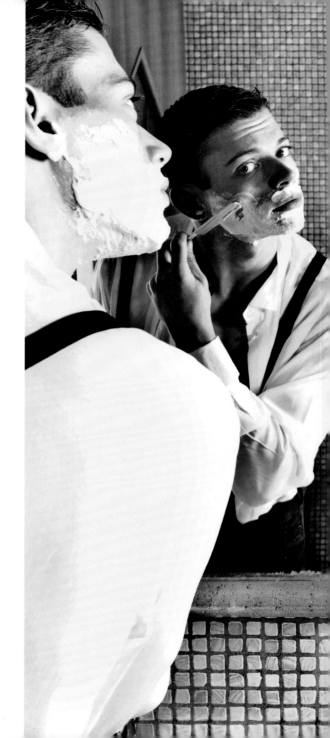

Working with the foreground, middle ground, and background of an image can add drama and visual tension. Creating these layers is challenging, but it allows you to tell a story. In this photo, the position of the woman's face and her incredible eye in the extreme foreground set up a dynamic tension between the subjects. The fact that his eyes are looking back makes the scene all the more compelling. This photograph tells a story by including two subjects who seem dislocated in space but connected by eye contact. Notice the wonderful detail of the lipstick marks beside the man. This photo makes us feel chemistry between the subjects and wonder, even speculate, about their relationship.

HOW TO LAYER WITHIN A FRAME

- **Use a focal length of** 28mm to 50mm to accomplish this kind of layering. If you go too wide, the background recedes into the distance and causes distortion along the edges. You'll need an f-stop of f/8 or f/16. Increase your ISO to suit the light level.

- **When layering,** pay attention to your point of focus. Would this image be more effective if the woman were in sharp focus and the man were out of focus?

ANGELO FORMATO — NAPLES, ITALY

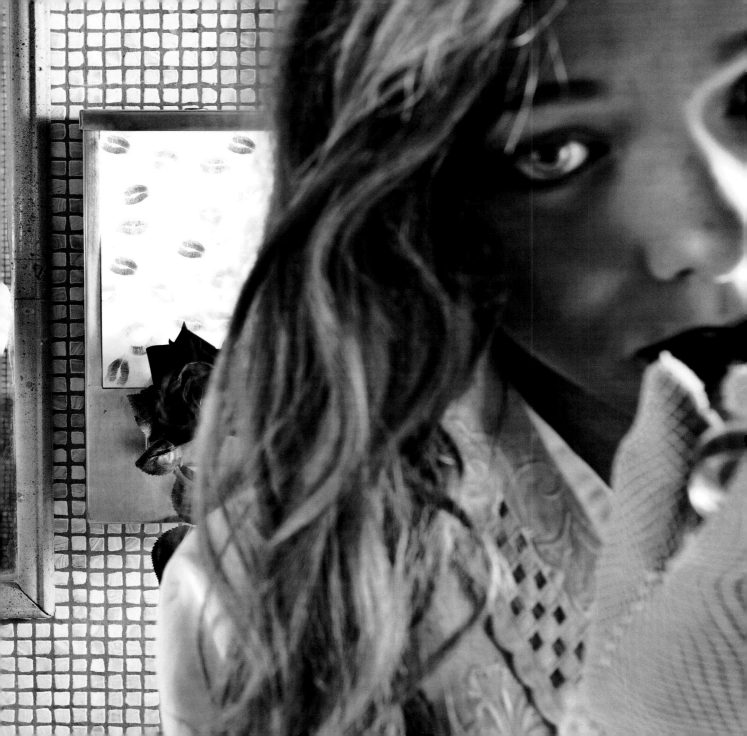

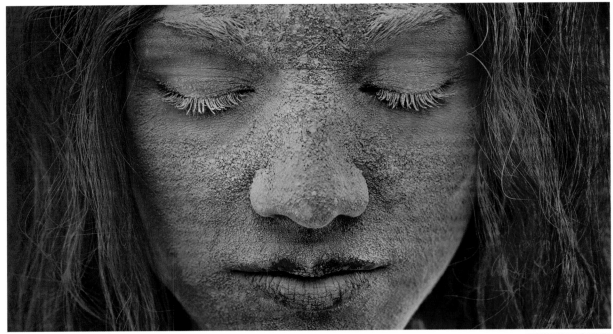

CHRISTOPHER DORMOY

»TECHNICOLOR **DREAM**

I get lost in this image as I traverse the colorful textures of the powder, the beautiful features of the woman's face, her insanely lush eyelashes, and the soulful expression of her downcast eyes. Great light delineates the clean and vibrant details. From this close perspective, the viewer can absorb it all and luxuriate in the magic. As photographers, we seek out subjects that photograph well. These subjects call to us as "can't-miss" opportunities. But an ideal subject doesn't always guarantee a successful photo. What sets this image apart is the photographer's dignified and graceful approach to a striking subject.

HOW TO CAPTURE THE DETAILS

- **Shooting in bright,** but not contrasting, light allows details and colors to pop without losing anything in the highlight or shadows.

- **Select the right depth of field** for your subject. In this image, if the depth of field were too shallow, parts of the woman's face would be out of focus.

- **Play and experiment** with different expressions. How would this image have looked if the woman had directed her glance at the camera?

≫DEVILISH **FUN**

This image pulls us right into the middle of the action. Fantastic lighting from the fireworks creates excitement and energy. The character with sunglasses creates a human point of reference, making the photo about more than special effects or cool lighting. The position of the hand over the burst of light is key to the success of this photo. The viewer's eye always goes to the brightest point, so without the hand, the burst would have drawn attention away from the rest of the frame. The photographer put all of these qualities together, creating a marvelous image with energy, character, and color.

HOW TO SHOOT A FESTIVAL AT NIGHT

● **In a scene** with extreme highlights—such as the light from these sparklers—make sure the people have light on them in order to avoid blown-out highlights or deep shadows.

● **When shooting fireworks,** expose for the highlights.

● **This image requires** a wide-angle lens. In this case, avoid having objects or people on the edges of the frames, as they will get distorted.

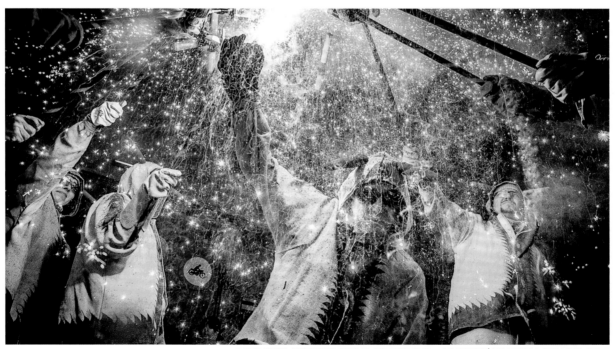

ANIBAL TREJO / CORREFOC FESTIVAL PERFORMANCE — SANT QUINTÍ DE MEDIONA, CATALONIA, SPAIN

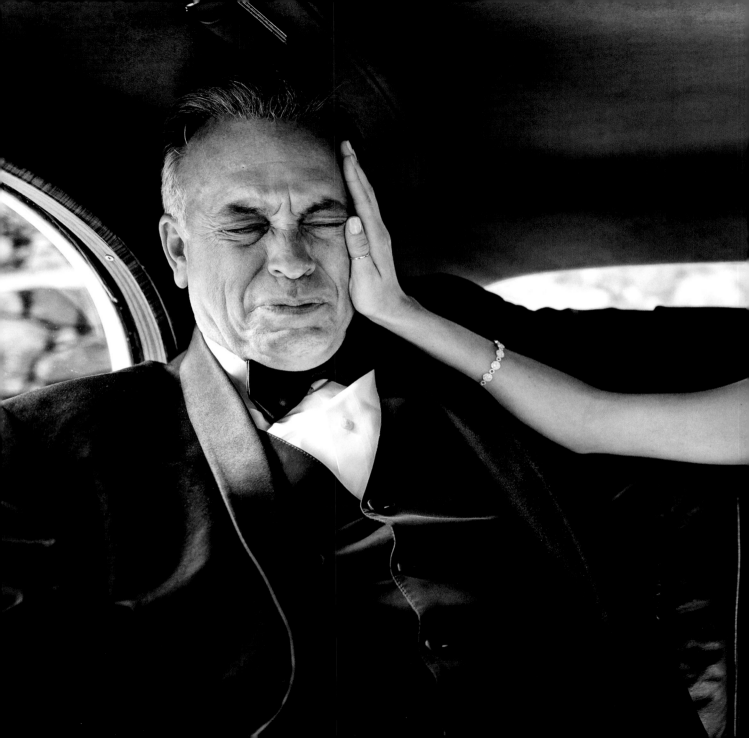

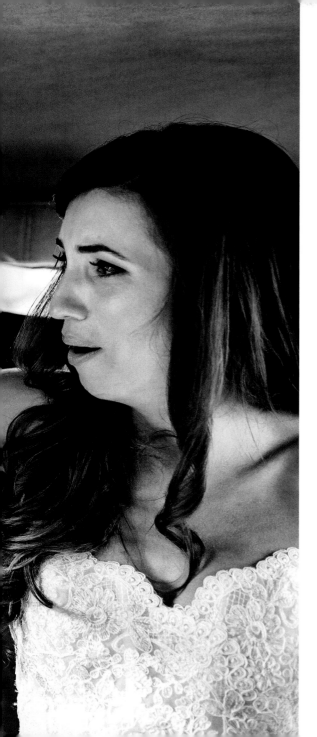

»A FATHER'S LOVE

Raw with emotion, this moment captures a universal aspect of a father-daughter relationship. Only a photograph can capture this moving and, in some ways, crushingly beautiful scene—the comforting hand on the cheek, the expressions on the subjects' faces, the distance between the photographer and the subjects. What an honor to be allowed to witness, let alone capture, this moment. These are the situations that remind me why we must honor and respect our subjects. Capturing a photo like this requires instinct, anticipation, and the reflexes of an athlete. You can't know when those touching moments will happen, so be observant, pay attention to emotional cues, and have your camera settings ready so you can snap at a moment's notice.

THE PHOTOGRAPHER'S STORY

"Iki's Dad, Bud, breaks down en route to the church to give away his little girl on her wedding day. A hundred percent trust and access are big parts of a wedding photographer's job. I sat backward in the front seat and just waited; I was only a few feet away when this moment transpired. Bud's love for his daughter was very poignant and beautiful to witness." —Tracey Buyce

LAKE GEORGE, NEW YORK

»A SACRED MOMENT

What a pose! What a composition! In this close-up of a human being who is vulnerable and exposed, I feel her dignity and beauty preserved. Magic! This image has everything—color, composition, lighting, a candid moment, emotion, drama, and mystery. The wonderful relationship between the main figure and the shadows creates a second story. At first glance, you might think she is alone. What is she doing? What's wrong with her? But as you notice the shadows, you realize she has an audience. Sometimes good photography asks as many questions as it answers.

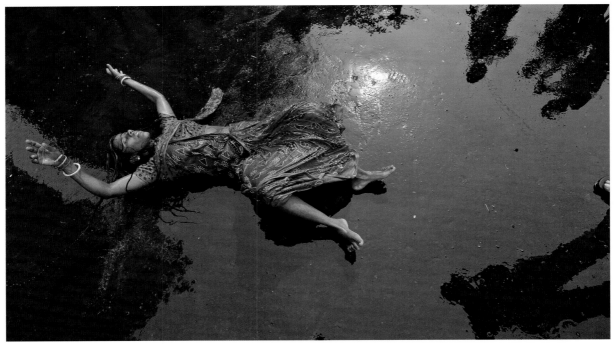

SOMNATH CHAKRABORTY / PRACTICE FOR THE DONDI RITUAL — CALCUTTA, WEST BENGAL, INDIA

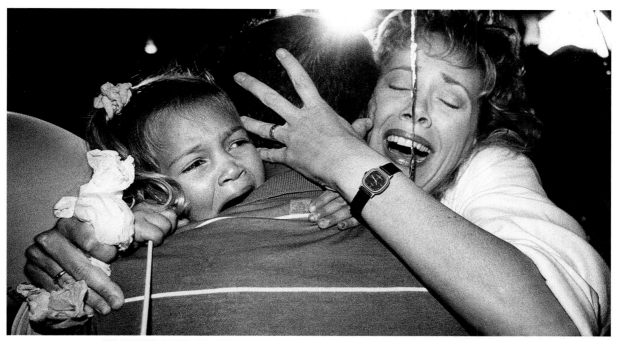

JOHN WARNER / A RELEASED HOSTAGE EMRACES HIS FAMILY. A BALLOON STRING IS CAUGHT IN THE EMBRACE. — INDIANAPOLIS, INDIANA

»HOSTAGE RELEASE

What is going on? Who is this person? Why so much emotion? This is an absolutely brilliant and real moment. A telephoto shot of this scene would not have put the viewer inside the moment like this close-up does. Proximity, plus emotion, plus a candid moment equal a great picture. Accomplishing all of this while shooting at a news event, as this photographer did, is a tremendous feat. The subject and the action are always unpredictable, but your job is to capture them. That's why it's essential to know your gear, to be prepared, and to be hyperaware of all that's going on.

HOW TO SHOOT AT A NEWS EVENT

- **The use of flash was essential** in creating this image. It lit the subjects cleanly and clearly, and set them apart from the background.

- **Anticipating the action** is key to taking great photographs.

- **When shooting in a crowd,** figure out the best place to stand to get your shot. Pick your angle carefully to reveal the most compelling aspects of the subject or scene.

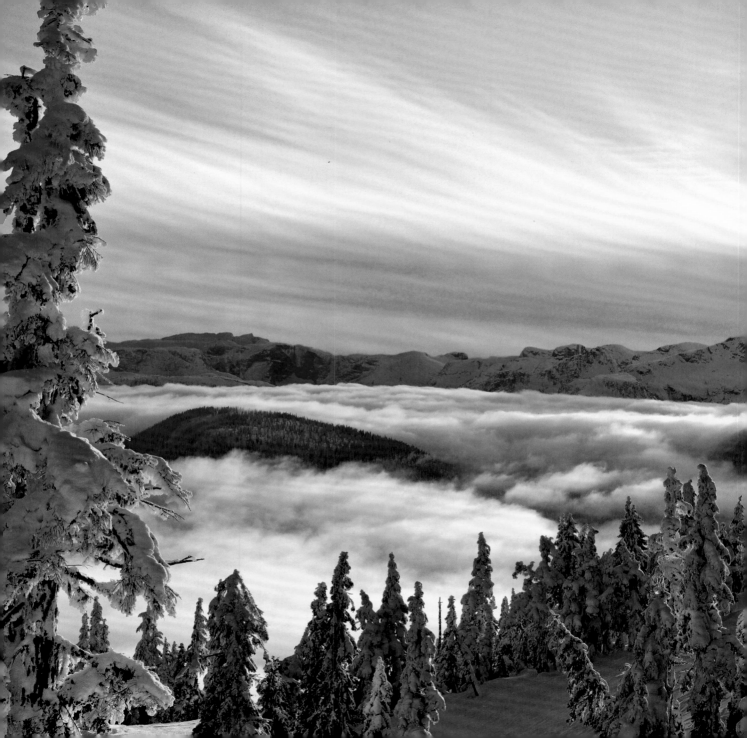

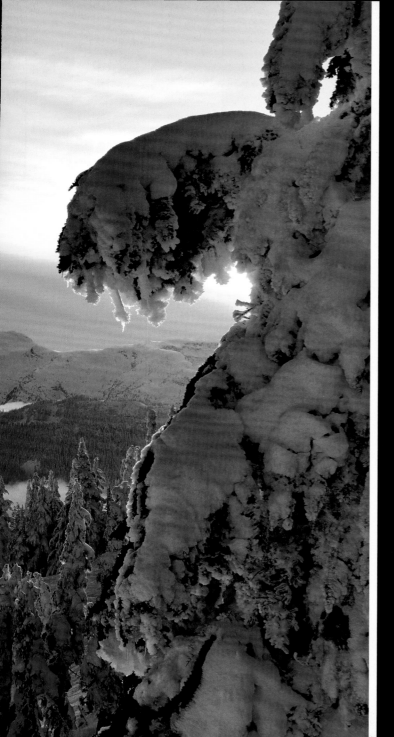

IMAGINE IF

BY MONICA CLARE CORCORAN

DARE TO DREAM

Reimagine your life. These three words make some people smile and others shudder with anxiety. This assignment is an opportunity to daydream like you did as a kid. It's a chance to find your North Star—that person, place, or thing that calls to you. Take a picture of something that launches you in the direction of your dreams. Maybe it's a friend achieving a seemingly impossible goal, or a Death Valley sunset inspiring you to reconsider your path, or an antique rocking chair on a farm porch in Vermont that makes you yearn for simplicity.

Have you ever put a photo somewhere so that you could see it every day? Maybe it serves as a motivational tool and helps you keep your eyes on the prize. This is your chance to take that picture for yourself. What is your prize? What does living your dream look like? It's never too late to try something new and to go down a different path. Let out the photo in your mind.

Photography can inspire us to reach higher and to dream bigger. It can show us the possibilities in life. Once you've determined your life's dream, visualize yourself in that place, with that person, doing that thing you love.

Get creative with this assignment. You can play with light, reflections, or time lapse to give your photo a more dreamy or conceptual feeling. Put yourself in the picture, either literally or figuratively. I'm partial to photos that are more than what they seem and allow the viewer to imagine the rest of the story. What am I really looking at, and what does it mean?

Follow your dreams. Be inspired. And let your imagination run free. When you get that shot that says it all, take the next step and write a caption. Can you put the importance of the image or feeling into words? Perhaps that will take you one step closer to making your dream come true.

ABOUT THE ASSIGNMENT EDITOR

Monica Clare Corcoran, NATIONAL GEOGRAPHIC YOUR SHOT

Corcoran is an award-winning photography producer with more than 15 years of experience in visual storytelling. She is the senior managing editor of Your Shot, National Geographic's photo community.

JAMES HILGENBERG — OBERSTDORF, BAVARIA, GERMANY

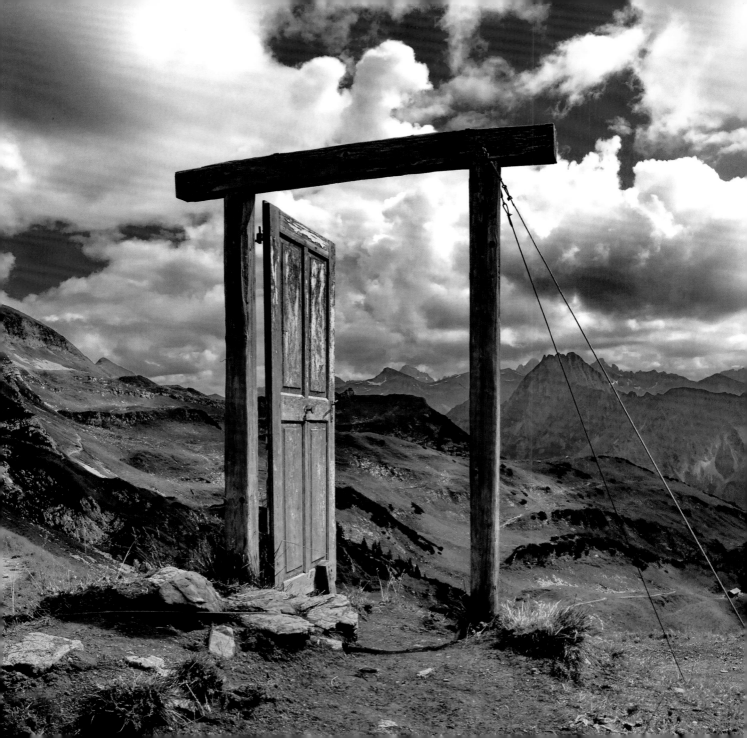

»LAMU DREAMER

The layers of this image come together perfectly to tell a story—or many different stories—if you use your imagination. The photographer uses composition and lighting to draw us in and to focus our attention on the main character. The barefoot young woman, bathed in light and frozen in action, pops out of the foreground. She dribbles her ball and dreams of her future beyond these streets. The photo inspires us to think about the subject's life and to consider our own. The shrouded woman walking in the shadows adds another element to the story and provides a bit of tension. Meanwhile, the moving figure anchors the background and allows your eye to wander around the frame and take in the entire scene. But perhaps the most powerful aspect of this photo is that it presents two women on completely different life paths.

THE PHOTOGRAPHER'S STORY

"Sauda has always dreamed of playing football [soccer] since she was three years old and has held on to this dream, despite growing up in a culture that doesn't really encourage dreams of this nature. She loves to dribble and freestyle on the narrow streets of Lamu, in coastal Kenya, with passersby admiring her skill and love for the game. She's a girl of very few words, but her energy is as big and beautiful as her future. I think it's just a matter of time before her dream becomes her reality." —Migz Nthigah

LAMU, KENYA

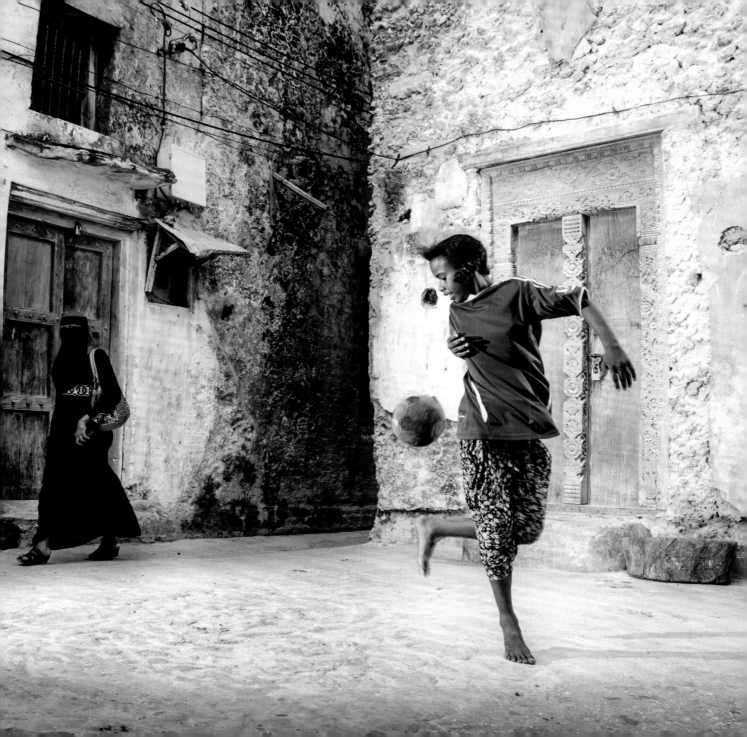

»−35°F **IN ALASKA**

Self-portraits are unique opportunities for a photographer to tell his or her own story at the moment it is happening. In this photo, the photographer is frozen in time, encrusted in ice and snow, and standing outside in the elements after hours of exertion. What is this man thinking as he looks away from the camera? The eerie blue light on his face signals the end to another day alone in the wilderness. Is his look one of determination or despair? By coming in close and leaving very little of the environment in the frame, the photographer gives the viewer nothing to look at but himself. This is unsettling yet intentional. The photographer's choices have created a moody image that entrances the viewer.

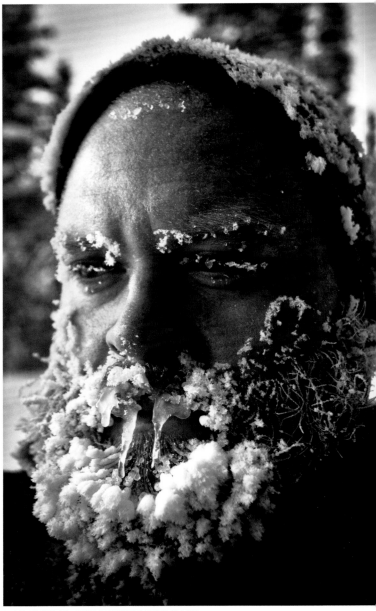

JACOB W. FRANK — DENALI NATIONAL PARK, ALASKA

HOW TO SHOOT A SELFIE

• **Be intentional.** What do you want the viewer to feel? Should you look away from the camera or stare directly into it? Each strategy can mean something different.

• **Set the mood.** Think about how light dramatically alters a scene and plays with the viewer's emotions.

• **Share your soul.** A good self-portrait should offer insight into who you are at that moment.

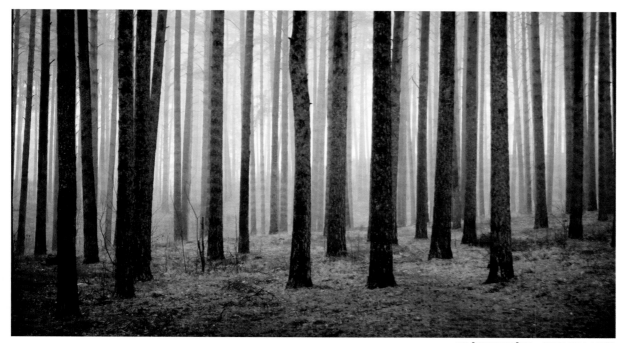

»WOODS **OF LATVIA**

These woods are both inviting and slightly off-putting. Fog descends on row after row of limbless tree trunks standing at attention like sentinels. The dreamy scene beckons viewers closer and dares them to step inside. What lurks in this forest? The hazy light plays with your mind and tricks the eye: Is this landscape never ending? The tall, thin trunks take up every inch as they repeat across the frame, and the viewer continues to scan the photo in search of something in this seemingly empty environment. In this photo devoid of humans, viewers can easily place themselves in this magical mystery world.

HOW TO MAKE MAGIC

- **When shooting outside,** take into account the time of day and the weather. These elements can turn an otherwise ordinary scene into a fantasy.

- **Compose the shot** in your camera and not after the fact by cropping the photo. Create with purpose. It shows in the final product.

- **Sometimes leaving** a landscape empty is better than waiting for someone to walk by.

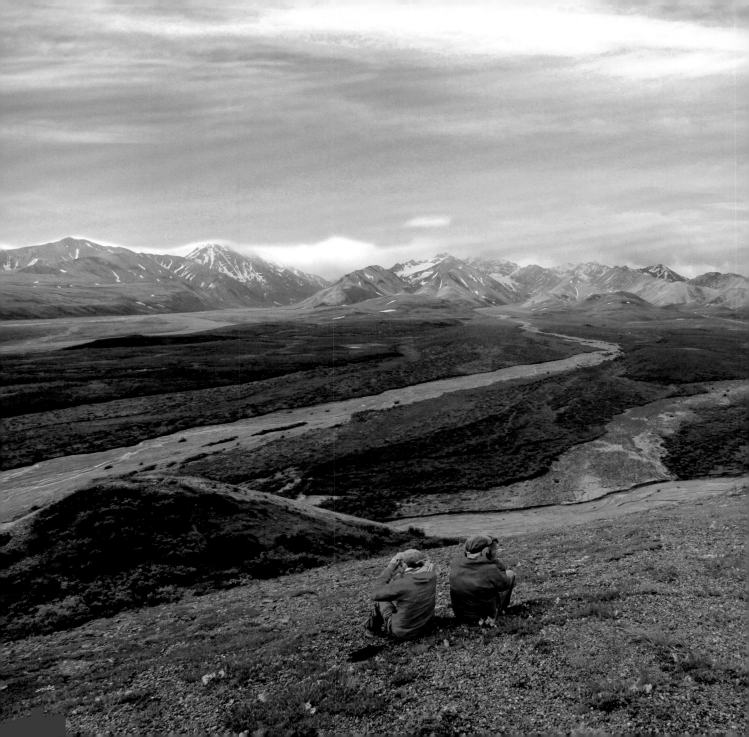

»THE RED **COATS**

There are certain factors—like the weather—that a photographer simply cannot control. This means it's important to know what you *can* control and plan accordingly. Traveling to Alaska's Denali National Park in late summer means that the landscape will be green and lush, that the water from the mountains will rush through the valley, and that other travelers will be there.

Being in the right place at the right time is usually a lot of hard work in addition to a bit of luck. Add in two people wearing almost identical blue caps and red jackets, and you've got a great scene. The photographer easily could have overlooked the couple and shot a beautiful landscape image. However, taking a step back and incorporating them into the frame made the photo more memorable and the story richer.

HOW TO GO BEYOND THE POSTCARD

• **Find your focal point.** Look for an element—it can be a person, an animal, or even an inanimate object—that will draw viewers in and let them focus on something immediately.

• **Take a step back.** Don't always go for the obvious. Look for different angles. Spend time taking in the scene and allowing it to unfold. Then shoot like mad.

VINEETH RAJAGOPAL — FAIRBANKS, ALASKA

»FLYING **ORIGAMI**

My initial reaction to this photo: How was this accomplished? But very quickly after that come feelings of joy and whimsy—and memories of playing in make-believe worlds where anything was possible and everything was full of wonder. Some photos make you feel like a kid again, even for just a moment. The shallow depth of field blurs out the background and lets you focus on the origami swan and the outstretched hands. Are the cupped hands waiting to catch the swan, or did they just let it go? The inner kid in me doesn't sweat the details and starts dreaming about paper swans flying up, up, and away.

• **What's important?** Shallow depth of field blurs the foreground and the background, eliminates distracting elements, and highlights the subject.

• **When photographing** a person, experiment with how changing the depth of focus alters the mood of the image.

• **Have fun.** Don't worry about the result. Enjoy the process and learn new photographic techniques. Mistakes can turn into masterpieces.

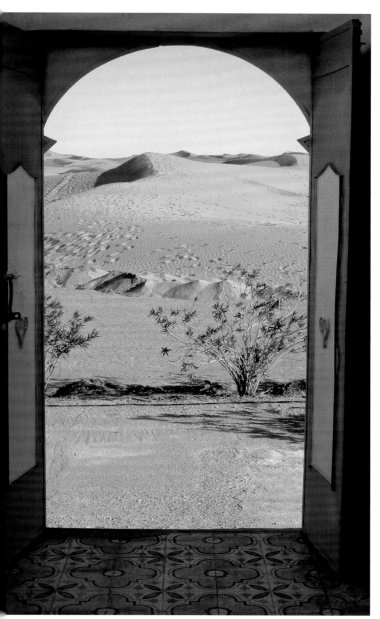

CLAIRE ROBINSON — SAHARA, AFRICA

»BEHIND **EACH DOOR**

This creative composition shows the much photographed Sahara in a unique way. Door frames, arches, and tunnels can add a sense of mystery and adventure to an image. Where will this path lead? Who will I meet, and what will I encounter? If you aim to create images that have narrative, you need to spark the viewer's curiosity. The more questions the viewer has, the better. This type of photo makes us ponder and stay awhile as we visualize the story. Because the desert is framed in a doorway, we also learn a little about who lives there. The tiles, colors, and door design provide bits of information about the desert dwellers. And the photographer gets out of the harsh sunlight and takes you along, thus creating an easy entry into the photo.

HOW TO ADAPT IN THE FIELD

• **Turn negatives into positives.** A sudden rainstorm could actually be a blessing in disguise.

• **Don't take yourself** or your subject too seriously. You might be so busy worrying that you miss the perfect shot.

• **Keep moving.** Walk around and get a good sense of the place you are in. Notice the details. Take in your surroundings, and keep shooting.

»HOME ONCE MORE

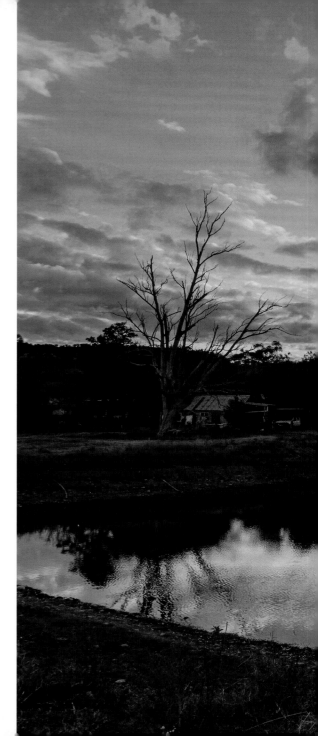

Dramatic weather and a body of water can be a powerful combination in a photograph. The reflection in the pond creates a window into the past, present, and future of this seemingly unchanged place. Even without the caption, you can feel the emotions in this image, as they stimulate your imagination. Maybe this photo affects me emotionally because I lived for a short time on the farm where my father was born. Or maybe it's that we had a dog—like the one in the photo—who would stand next to our creek and look back at us. When it comes to photography, the reasons why you like a particular image are wholly subjective and very personal. But as the photographer, you should be thinking about what best tells the story about this particular person, place, or thing. Strive for photos that make you want to look at them again and again, because their story is never ending—photos that allow the viewer to imagine if . . .

THE PHOTOGRAPHER'S STORY

"It seems so long ago that I spent my childhood with this scenery, that it almost seems a dream. It's a piece, however important, of my imagination—memories that fade in and out of my mind. Is what I recall of this place what happened? Have I re-created it? What I do know is that when I return, strong emotions that I can't explain overwhelm me. Nostalgia runs deep. I love my new home; however, the home of my childhood will forever run wild in my imagination." —James Abbott

SCONE, NEW SOUTH WALES, AUSTRALIA

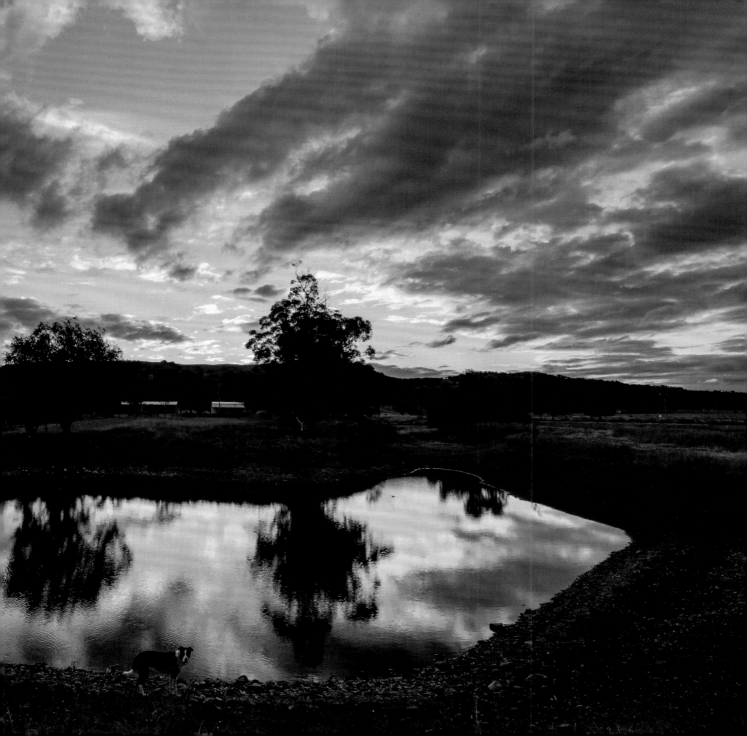

Glossary

APERTURE The adjustable opening inside of the lens that allows light to pass through. Measured in f-stops (a higher number signifies a smaller opening), aperture controls the depth of field in a photo.

ASPECT RATIO The ratio of width to height in an image or image sensor.

AUTOFOCUS A mode in which the camera automatically focuses on the subject in the center of the frame.

BOKEH The aesthetic quality visible in blurred, or out-of-focus, areas of an image. This term comes from the Japanese word for "fuzziness."

BRACKETING Taking a series of photos of the same subject at different exposures.

BURST MODE Also known as continuous mode, a setting that allows a digital camera to take several shots in less than a second.

CABLE SHUTTER RELEASE A mechanical or electronic cable used to trigger a mounted camera without touching it directly.

COMPRESSION The process used to decrease the size of a digital image file by combining or averaging data.

CONTRAST The range of brightness of a subject; the difference between the lightest and darkest parts of an image. A scene with high contrast includes both extreme highlights and very dark shadows.

DEPTH OF FIELD The distance between the nearest and farthest objects that appear in sharp focus in a photo.

DIGITAL ZOOM A camera function that digitally magnifies the center of the frame.

DISTORTION An optical change that causes straight lines near the edges of an image to be bent, either inward (known as pin-cushioning) or outward (known as barreling). When the perspective in a photo is unusual, some people refer to this as distorted perspective.

DSLR (DIGITAL SINGLE-LENS REFLEX) An electronically operated camera that uses mirrors to show the potential image through the viewfinder.

DYNAMIC RANGE The range of darkest to lightest parts of an image.

EXPOSURE The total amount of light that reaches the camera's sensor while taking a photograph.

FILTER A piece of colored and/or coated glass or plastic, placed in front of the camera lens, that alters or enhances the light reaching the sensor.

FLARE A degradation of picture quality, caused by reflections inside the lens, that reduces contrast or forms unwanted patches of light.

FOCUS Clear definition of a photo element and its outlines; lack of blurriness.

F-STOP The setting of a lens's aperture, which is equal to the focal length divided by the diameter of the aperture. The smaller the number, the larger the lens opening.

HISTOGRAM A bar graph showing the relative number of pixels in different brightness ranges in a digital image, from dark to light.

HUE The overall color of a photo.

ISO A standard for image sensor rating; the higher the number, the more light sensitive the sensor becomes. ISO stands for International Standards Organization, which sets the standards used to rate the speed or light sensitivity of film. Now the term is used to measure sensitivity of digital camera sensors.

MACRO Photography of small subjects at a very short distance. The image on the sensor is close to the real-life size of the subject, or even larger.

MEGAPIXEL (MP) One million pixels; a unit of modern digital camera resolution.

METADATA Mechanical information that a digital camera automatically attaches to each image.

NOISE The digital equivalent of grain in film photography, noise occurs when photographs are shot with a high ISO in low light.

PANORAMA A picture with an exceptionally wide field of view, created either by an ultra wide-angle lens or digital composite.

PIXEL Abbreviation for picture (*pix-*) element (*-el*). Pixels are the smallest bits of information that combine to form a digital image. The more pixels, the higher the resolution.

POSTPRODUCTION EDITING Using software to make adjustments to a photo after the image has been captured.

PRIME LENS A lens with a fixed focal length (as opposed to a zoom lens, which has variable focal length).

RAW FILE A type of image file that captures the maximum amount of data possible, allowing photographers to manipulate the image as they like in postproduction.

RED-EYE Red dots that appear in a person's eyes in a photograph. Red-eye occurs when light from a camera's flash reflects in the retinas.

RESOLUTION A measurement of the ability to resolve fine detail; the amount of information included in an image (in pixels). Determines the clarity and sharpness of a printed photograph.

SATURATION The intensity of color in an image.

SENSOR A chip with light-sensitive pixels that converts an optical image into an electric signal. The larger the sensor and the more pixels it has, the more information the sensor collects.

SHUTTER The mechanism built into the lens or camera that controls how much light reaches the sensor. It opens to expose the sensor to light entering through the lens aperture, and then it closes.

SHUTTER SPEED The speed of the shutter as it opens and closes (to allow light to reach the sensor). Expressed in seconds or fractions of a second, such as 1/60 or 1/250.

STROBE An electronic flash unit that produces an intense, short-duration burst of light.

TELEPHOTO LENS A lens that offers focal lengths longer than the standard. Often used to refer to any long lens.

WHITE BALANCE A control used to balance the color of an image to the scene's color so that the lighting looks natural.

WIDE-ANGLE LENS A lens with a focal length shorter than normal for the format, or any lens whose angle of view is wider than about 50 degrees.

ZOOM LENS A lens with variable, user-controlled focal length (as opposed to a prime lens, which has fixed focal length).

The Photographer's Notebook

FRONT OF BOOK

- **PP. 2-3 Eric Peterson** LOCATION: Woodland Hills, California *

- **PP. 4-5 Shamim Tirmizi** LOCATION: Dhaka, Bangladesh CAMERA: Nikon D5100 FOCAL LENGTH: 55mm SHUTTER SPEED: 1/320 sec APERTURE: f/13 ISO: 400

- **PP. 6-7 Aggelos Zoupas** LOCATION: Skála Rachoníou, East Macedonia, and Thrace, Greece CAMERA: Nikon D5100 FOCAL LENGTH: 44mm SHUTTER SPEED: 1/640 sec APERTURE: f/7.1 ISO: 200

- **P. 8 Kevin Dietrich** LOCATION: Anchorage, Alaska *

- **P. 11 Lynn Johnson** LOCATION: Dimen, Guizhou Province, China CAMERA: Leica M FOCAL LENGTH: 21mm SHUTTER SPEED: 1/250 sec APERTURE: f/5.6 ISO: 400

- **P. 12 Konstadinos Xenos** LOCATION: Not available CAMERA: Nikon D700 FOCAL LENGTH: 120mm SHUTTER SPEED: 1/15 sec APERTURE: f/5.6 ISO: 3200

TOOL KIT

- **PP. 16-17 Mike Black** LOCATION: Conowingo, Maryland CAMERA: Canon EOS-1D X FOCAL LENGTH: 800mm SHUTTER SPEED: 1/1600 sec APERTURE: f/14 ISO: 12800

- **P. 22 Patrick Bagley** LOCATION: Arlington, Virginia CAMERA: Canon EOS-5D Mark II (left) FOCAL LENGTH: 24mm SHUTTER SPEED: 1/60 sec APERTURE: f/13 ISO: 100 (right top) FOCAL LENGTH: 24mm SHUTTER SPEED: 1/50 sec APERTURE: f/4 ISO: 100 (right bottom) FOCAL LENGTH: 105mm SHUTTER SPEED: 1/50 sec APERTURE: f/4 ISO: 100

- **P. 23 Moshe Demri** LOCATION: New York, New York *

- **P. 26 Veronika Kolev** *

- **P. 27 Gaston Lacombe** LOCATION: Pelči, Rucavas Novads, Latvia CAMERA: Canon EOS 5D Mark III FOCAL LENGTH: 130mm SHUTTER SPEED: 1/640 sec APERTURE: f/6.3 ISO: 400

- **P. 29 Glenn Barclay** LOCATION: Parkdale, Montana CAMERA: Not available FOCAL LENGTH: 4.3mm SHUTTER SPEED: 100/99999 sec APERTURE: f/4 ISO: 80

- **P. 30 Leonardo Neves** LOCATION: Teahupoo, Tahiti CAMERA: Canon EOS 7D FOCAL LENGTH: 10mm SHUTTER SPEED: 1/1250 sec APERTURE: f/5.6 ISO: 200

- **P. 31 Mark Bridgwater** LOCATION: Stewart Island, New Zealand *

- **P. 32 LEFT PJ van Schalkwyk** LOCATION: Muizenberg, Western Cape, South Africa CAMERA: Canon EOS 5D FOCAL LENGTH: 23mm SHUTTER SPEED: 1/80 sec APERTURE: f/8 ISO: 50

- **P. 32 RIGHT Cedric Favero** LOCATION: Pichingoto, Cusco, Peru CAMERA: Sony ILCE-7 FOCAL LENGTH: 53mm SHUTTER SPEED: 1/100 sec APERTURE: f/22 ISO: 200

- **P. 33 Oscar Ruiz Cardeña** LOCATION: San Buenaventura, Ixtapaluca, Mexico CAMERA: Sony Cyber-shot FOCAL LENGTH: 14.1mm SHUTTER SPEED: 1/500 sec APERTURE: f/4.5 ISO: 320

- **P. 34 David Tao** LOCATION: Queanbeyan, New South Wales, Australia CAMERA: Canon EOS 5D Mark III FOCAL LENGTH: 35mm SHUTTER SPEED: 1/80 sec APERTURE: f/2 ISO: 320

- **P. 35 TOP Larry Beard** LOCATION: Newport Beach, California *

- **P. 35 MIDDLE Sophie Porritt** LOCATION: Airton, England, United Kingdom CAMERA: Canon EOS 7D FOCAL LENGTH: 15mm SHUTTER SPEED: 1 sec APERTURE: f/20 ISO: 100

- **P. 35 BOTTOM Jr. Marquina** LOCATION: Malibu, California CAMERA: Canon EOS REBEL T1i FOCAL LENGTH: 21mm SHUTTER SPEED: 20 sec APERTURE: f/22 ISO: 100

- **P. 36 LEFT Emiliano Capozoli** LOCATION: São Gabriel da Cachoeira, Amazonas, Brazil *

- **P. 36 RIGHT B. Yen** LOCATION: Bacolod City, Western Visayas, Philippines CAMERA: Not available FOCAL LENGTH: 17mm SHUTTER SPEED: Not available APERTURE: f/2.79 ISO: 800

- **P. 37 Thomas Nord** LOCATION: Birmingham, Alabama CAMERA: Canon EOS 5D Mark II FOCAL LENGTH: 100mm SHUTTER SPEED: 1/80 sec APERTURE: f/2.8 ISO: 3200

- **P. 39 Patrick Bagley** LOCATION: Baltimore, Maryland CAMERA: Canon EOS 7D FOCAL LENGTH: 24mm SHUTTER SPEED: 1/60 sec APERTURE: f/6.3 ISO: 200

THE ASSIGNMENTS

- **PP. 40-41 Tracey Buyce** LOCATION: La Paz, Bolivia CAMERA: Canon EOS 5D Mark III FOCAL LENGTH: 200mm SHUTTER SPEED: 1/1250 sec APERTURE: f/5 ISO: 640

CATCH THE LIGHT

- **PP. 42-43 Samrat Goswami** LOCATION: Bishnupur, West

Bengal, India CAMERA: Nikon D7000 FOCAL LENGTH: 22mm SHUTTER SPEED: 1/250 sec APERTURE: f/10 ISO: 200

• **P. 45 Himal Reece** LOCATION: Bridgetown, Saint Michael, Barbados CAMERA: Canon EOS 7D FOCAL LENGTH: 78mm SHUTTER SPEED: 1/250 sec APERTURE: f/4.5 ISO: 100

• **PP. 46–47 Ken Dyball** LOCATION: Walvis Bay, Erongo, Namibia CAMERA: Nikon D7000 FOCAL LENGTH: 300mm SHUTTER SPEED: 1/40 sec APERTURE: f/13 ISO: 200

• **P. 48 Carol Worrell** LOCATION: Mount Vernon, Washington CAMERA: Canon EOS REBEL T2i FOCAL LENGTH: 90mm SHUTTER SPEED: 1/200 sec APERTURE: f/18 ISO: 400

• **P. 49 Natalia Pryanishnikova** LOCATION: Al Ghardaqah, Al Bahr al Ahmar, Egypt CAMERA: Canon EOS 5D FOCAL LENGTH: 15mm SHUTTER SPEED: 1/320 sec APERTURE: f/8 ISO: 320

• **PP. 50–51 Freddy Booth** LOCATION: Hawaii CAMERA: Canon GoPro HERO3 FOCAL LENGTH: 2.77mm SHUTTER SPEED: 1/503 sec APERTURE: f/2.8 ISO: 100

• **P. 52 Karin Eibenberger** LOCATION: Dobbiaco, Trentino-Alto Adige, Italy CAMERA: Canon EOS 5D Mark III FOCAL LENGTH: 18mm SHUTTER SPEED: 1/125 sec APERTURE: f/13 ISO: 200

• **P. 53 Alexis Gerard** LOCATION: San Mateo, California CAMERA: Sony DSC-RX100 FOCAL LENGTH: 20.85mm SHUTTER SPEED: 1/100 sec APERTURE: f/4 ISO: 125

• **PP. 54–55 Spencer Black** LOCATION: Brevard, North Carolina CAMERA: Nikon D35 FOCAL LENGTH: 31mm SHUTTER SPEED: 35 sec APERTURE: f/2.8 ISO: 3200

SELF-PORTRAIT
• **PP. 56–57 Mrittika Purba** LOCATION: Not available CAMERA: Nikon D7000 FOCAL LENGTH: 32mm SHUTTER SPEED: 1/6 sec APERTURE: f/4.8 ISO: 800

• **P. 59 Estefanía Hernández** LOCATION: Not available CAMERA: Canon EOS 5D FOCAL LENGTH: 50mm SHUTTER SPEED: 1/25 sec APERTURE: f/1.8 ISO: 160

• **PP. 60–61 Kevin Prodin** LOCATION: Yangjia, Shanghai Shi, China CAMERA: Nikon D800E FOCAL LENGTH: 24mm SHUTTER SPEED: 1/60 sec APERTURE: f/11 ISO: 100

• **P. 62 Helene Barbe** LOCATION: Jan Juc, Victoria, Australia CAMERA: HP Photosmart B110 *

• **P. 63 Tytia Habing** LOCATION: Watson, Illinois *

• **PP. 64–65 Lex Schulte** LOCATION: Ewinkel, North Brabant, Netherlands CAMERA: Nikon D90 FOCAL LENGTH: Not available

SHUTTER SPEED: 13/10 sec APERTURE: Not available ISO: 200

• **P. 66 Amanda Dawn O'Donoughue** LOCATION: Gainesville, Florida CAMERA: Canon EOS 6D FOCAL LENGTH: 50mm SHUTTER SPEED: 1/1250 sec APERTURE: f/1.4 ISO: 1000

• **P. 67 Darcie Naylor** LOCATION: Phoenix, Arizona CAMERA: Nikon D7000 FOCAL LENGTH: 18mm SHUTTER SPEED: 1/250 sec APERTURE: f/22 ISO: 800

• **PP. 68–69 Margaret Smith** LOCATION: Not available CAMERA: Not available FOCAL LENGTH: 100mm SHUTTER SPEED: 1/125 sec APERTURE: f/8 ISO: Not available

HOME
• **PP. 70–71 Carl Yared** LOCATION: Dbayeh, Mont-Liban, Lebanon CAMERA: Canon EOS 5D Mark III FOCAL LENGTH: 24mm SHUTTER SPEED: 5 sec APERTURE: Canon EOS 5D Mark III ISO: 1000

• **P. 73 Larry Deemer** LOCATION: Chéticamp, Nova Scotia, Canada CAMERA: Canon PowerShot D20 FOCAL LENGTH: 5mm SHUTTER SPEED: 1/640 sec APERTURE: f/3.9 ISO: 200

• **PP. 74–75 Rui Caria** LOCATION: Praia da Vitória, Azores, Portugal CAMERA: Nikon D4 FOCAL LENGTH: 200mm SHUTTER SPEED: 1/800 sec APERTURE: f/2.8 ISO: 125

• **P. 76 Anneke Paterson** LOCATION: Austin, Texas CAMERA: Canon EOS 5D Mark II FOCAL LENGTH: 16mm SHUTTER SPEED: 3/10 sec APERTURE: f/2.8 ISO: 3200

• **P. 77 Justin A. Moeller** LOCATION: Gardēz, Paktia, Afghanistan CAMERA: Canon EOS 7D FOCAL LENGTH: 200mm SHUTTER SPEED: 1/80 sec APERTURE: f/5.6 ISO: 320

• **PP. 78–79 Levan Adikashvili** LOCATION: Tbilisi, Republic of Georgia CAMERA: Nikon D200 FOCAL LENGTH: 135mm SHUTTER SPEED: 1/250 sec APERTURE: f/4.2 ISO: 250

• **P. 80 Sotia Douka** LOCATION: Rotterdam, Netherlands CAMERA: Nikon D5000 FOCAL LENGTH: 18mm SHUTTER SPEED: 1/125 sec APERTURE: f/5.6 ISO: 320

• **P. 81 Urdoi Catalin** LOCATION: Not available CAMERA: Canon EOS 100D FOCAL LENGTH: 15mm SHUTTER SPEED: 1/25 sec APERTURE: f/4.5 ISO: 800

• **PP. 82–83 Amy Sacka** LOCATION: Detroit, Michigan CAMERA: Canon EOS 5D Mark III FOCAL LENGTH: 26mm SHUTTER SPEED: 1/250 sec APERTURE: f/10 ISO: 200

SPONTANEOUS ADVENTURE
• **PP. 84–85 Danilo Dungo** LOCATION: Rainbow Bridge, Tokyo, Japan CAMERA: Nikon D800 FOCAL LENGTH: 12mm SHUTTER SPEED: 1/2 sec APERTURE: f/16 ISO: 200

• **P. 87 Douglas Gimesy** LOCATION: Torres del Paine National Park, Magallanes, Chile CAMERA: Olympus E-M5 FOCAL LENGTH: 35mm SHUTTER SPEED: 1/4000 sec APERTURE: f/4.5 ISO: 640

• **P. 88 Yasha Shantha** LOCATION: Pinnawala, Sri Lanka CAMERA: Canon EOS 50D FOCAL LENGTH: 80mm SHUTTER SPEED: 1/100 sec APERTURE: f/5.6 ISO: 100

• **P. 89 Sarah Choi** LOCATION: Hong Kong, China CAMERA: Leica X2 FOCAL LENGTH: 24mm SHUTTER SPEED: 1/30 sec APERTURE: f/2.8 ISO: 320

• **PP. 90–91 Julia Cumes** LOCATION: Dennis, Massachusetts CAMERA: Canon EOS 5D Mark II FOCAL LENGTH: 34mm SHUTTER SPEED: 1/30 sec APERTURE: f/3.2 ISO: 4000

• **P. 92 Steve Demeranville** LOCATION: Seattle, Washington CAMERA: Nikon D800 FOCAL LENGTH: 82mm SHUTTER SPEED: 1/1500 sec APERTURE: f/5 ISO: 250

• **P. 93 Serge Bouvet** LOCATION: Pralognan-la-Vanoise, Rhône-Alpes, France *

• **PP. 94–95 Shahnewaz Karim** LOCATION: Dhaka, Bangladesh CAMERA: Nikon D300S FOCAL LENGTH: 35mm SHUTTER SPEED: 1/30 sec APERTURE: f/14 ISO: 500

• **P. 96 Jay Mantri** LOCATION: Earth's stratosphere (above southern California) CAMERA: GoPro3 *

• **P. 97 Charlie Nuttelman** LOCATION: Supai, Arizona *

THE ANIMALS WE LOVE
• **PP. 98–99 Hasib Wahab** LOCATION: Jahājmāra, Chittagong, Bangladesh CAMERA: Canon EOS REBEL T2i FOCAL LENGTH: 70mm SHUTTER SPEED: 1/400 sec APERTURE: f/4 ISO: 100

• **P. 101 Juan C. Torres** LOCATION: Playa de Guayanilla, Puerto Rico CAMERA: Canon EOS 7D FOCAL LENGTH: 10mm SHUTTER SPEED: 1/15 sec APERTURE: f/22 ISO: 200

• **P. 102 Nirmalya Chakraborty** LOCATION: Central India CAMERA: Sony DSC-HX1 FOCAL LENGTH: 50.6mm SHUTTER SPEED: 1/320 sec APERTURE: f/4.5 ISO: 125

• **P. 103 Kristoffer Vaikla** LOCATION: Suurupi, Harjumaa, Estonia CAMERA: Canon EOS 5D Mark II FOCAL LENGTH: 105mm SHUTTER SPEED: 1/125 sec APERTURE: f/4 ISO: 125

• **PP. 104–105 Takeshi Marumoto** LOCATION: Tokyo, Japan CAMERA: Sony ILCE-7R FOCAL LENGTH: 400mm SHUTTER SPEED: 1/125 sec APERTURE: f/5.6 ISO: 1600

• **P. 106 Stéphanie Amaudruz** LOCATION: Thailand CAMERA: Nikon D5000 FOCAL LENGTH: 55mm SHUTTER SPEED: 1/60 sec APERTURE: f/8 ISO: 200

• **P. 107 Hannah Harvey** LOCATION: Massachusetts CAMERA: Apple iPhone 5 FOCAL LENGTH: 2.18mm SHUTTER SPEED: 1/30 sec APERTURE: f/2.4 ISO: 80

• **PP. 108–109 Julia Cumes** LOCATION: Kāziranga, Assam, India *

• **P. 110 Jose A. San Luis** LOCATION: Kalinga, Cagayan Valley, Philippines CAMERA: Nikon D5100 FOCAL LENGTH: 36mm SHUTTER SPEED: 1/30 sec APERTURE: f/5 ISO: 640

• **P. 111 Aslam Saiyad** LOCATION: Pandharpur, Maharashtra, India CAMERA: Canon EOS 500D FOCAL LENGTH: 23mm SHUTTER SPEED: 1/400 sec APERTURE: f/3.5 ISO: 200

AFTER MIDNIGHT
• **PP. 112–113 Csaba Horvath** LOCATION: Köptanya, Somogy, Hungary *

• **P. 115 Juan Osorio** LOCATION: New York, New York CAMERA: Canon EOS 7D FOCAL LENGTH: 24mm SHUTTER SPEED: 1/80 sec APERTURE: f/4 ISO: 1250

• **PP. 116–117 John Warner** LOCATION: Boulder River, Montana CAMERA: Nikon D700 FOCAL LENGTH: 23mm SHUTTER SPEED: 30.75 sec APERTURE: f/5.6 ISO: 1600

• **P. 118 Alejandro Merizalde** LOCATION: New York, New York CAMERA: Nikon D610 FOCAL LENGTH: 28mm SHUTTER SPEED: 1/13 sec APERTURE: f/4.2 ISO: 2500

• **P. 119 Michael Wagner** LOCATION: Albany, New York *

• **PP. 120–121 Adrian Miller** LOCATION: Campbell River, British Columbia, Canada CAMERA: Canon EOS 60D FOCAL LENGTH: 50mm SHUTTER SPEED: 30 sec APERTURE: f/1.8 ISO: 200

• **P. 122 Joydeep Dam** LOCATION: Darmstadt, Hesse, Germany CAMERA: Fujifilm FinePix HS10 HS11 FOCAL LENGTH: 8.9mm SHUTTER SPEED: 1/5 sec APERTURE: f/3.6 ISO: 100

• **P. 123 Ronn Murray** LOCATION: Fairbanks, Alaska CAMERA: Canon EOS 5D Mark III FOCAL LENGTH: 20mm SHUTTER SPEED: 1/125 sec APERTURE: f/16 ISO: 6400

FOODSCAPES
• **PP. 124–125 Nicole Louis** LOCATION: Hôi An, Quang Nam, Vietnam CAMERA: Canon EOS 1000D FOCAL LENGTH: 39mm SHUTTER SPEED: 1/160 sec APERTURE: f/9 ISO: 400

• **P. 127 Soma Chakraborty Debnath** LOCATION: West Bengal, India CAMERA: Nikon D90 FOCAL LENGTH: 50mm SHUTTER SPEED: 1/500 sec APERTURE: f/1.8 ISO: 400

• **PP. 128–129 Kári Jóhannsson** LOCATION: Krabi, Thailand CAMERA:

Nikon D7000 FOCAL LENGTH: 30mm SHUTTER SPEED: 1/160 sec APERTURE: f/6.3 ISO: 200

P. 130 Ali Hamed Haghdoust LOCATION: Legalān, East Azerbaijan, Iran CAMERA: Canon EOS 30D FOCAL LENGTH: 22mm SHUTTER SPEED: 1/160 sec APERTURE: f/4 ISO: 400

P. 131 Kaushal Singh LOCATION: Lucknow, Uttar Pradesh, India *

PP. 132–133 Joshua Van Lare LOCATION: Yangon, Myanmar CAMERA: Canon EOS 600D FOCAL LENGTH: 28mm SHUTTER SPEED: 1/125 sec APERTURE: f/6.3 ISO: 400

P. 134 Srimanta Ray LOCATION: Kailāshahar, Tripura, India CAMERA: Canon EOS 30D FOCAL LENGTH: 43mm SHUTTER SPEED: 1/125 sec APERTURE: f/6.3 ISO: 400

P. 135 Mitul Shah LOCATION: Ahmedabad, Gujarat, India CAMERA: Nikon D90 FOCAL LENGTH: 17mm SHUTTER SPEED: 1/500 sec APERTURE: f/2.8 ISO: 400

PP. 136–137 Wesley Thomas Wong LOCATION: Harbin, Heilongjiang, China CAMERA: Sony DSC–RX100 FOCAL LENGTH: 10.91mm SHUTTER SPEED: 1/80 sec APERTURE: f/2 ISO: 400

LOVE SNAP
PP. 138–139 Ankit Narang LOCATION: Delhi, India CAMERA: Canon EOS 5D Mark III FOCAL LENGTH: 41mm SHUTTER SPEED: 1/4000 sec APERTURE: f/2.8 ISO: 200

P. 141 Elizabeth Flora Ross LOCATION: United States CAMERA: Apple iPhone 5S FOCAL LENGTH: 4.12mm SHUTTER SPEED: 1/30 sec APERTURE: f/2.2 ISO: 160

PP. 142–143 Rafael Hernandez LOCATION: Pemba, Cabo Delgado, Mozambique *

P. 144 Thompson Gurrero LOCATION: Kokrajhar, Assam, India CAMERA: Nokia N8-00 FOCAL LENGTH: 5.898mm SHUTTER SPEED: 3450/1000000 sec APERTURE: f/2.797 ISO: 105

P. 145 Lori Coupez LOCATION: Chico, California CAMERA: Apple iPhone 4S FOCAL LENGTH: 4.28mm SHUTTER SPEED: 1/20 sec APERTURE: f/4.2 ISO: 125

PP. 146–147 Karla Maria Sotelo LOCATION: Arteaga, Coahuila, Mexico CAMERA: Canon EOS 5D Mark II FOCAL LENGTH: 85mm SHUTTER SPEED: 1/5000 sec APERTURE: f/3.5 ISO: 640

P. 148 Brandy Metzger LOCATION: Shreveport, Louisiana CAMERA: Canon EOS 60D FOCAL LENGTH: 50mm SHUTTER SPEED: 1/160 sec APERTURE: f/2 ISO: 320

P. 149 Meyrem Bulucek LOCATION: Savannah, Georgia *

PP. 150–151 Peter Frank LOCATION: Not available CAMERA: Nikon D7000 FOCAL LENGTH: 50mm SHUTTER SPEED: 1/60 sec APERTURE: f/3.5 ISO: 500

I HEART MY CITY
PP. 152–153 Ander Aguirre LOCATION: Lisbon, Portugal CAMERA: Canon EOS 5D Mark II FOCAL LENGTH: 15mm SHUTTER SPEED: 1/125 sec APERTURE: f/7.1 ISO: 200

P. 155 Karl Duncan LOCATION: Amsterdam, Netherlands CAMERA: Nikon D700 FOCAL LENGTH: 24mm SHUTTER SPEED: 1/80 sec APERTURE: f/2.8 ISO: 3200

PP. 156–157 Philippa D. LOCATION: Istanbul, Turkey CAMERA: Canon EOS 5D Mark II FOCAL LENGTH: 24mm SHUTTER SPEED: 1/25 sec APERTURE: f/4 ISO: 800

P. 158 Andrea Jako Giacomini LOCATION: Los Angeles, California CAMERA: Sony NEX-6 FOCAL LENGTH: 16mm SHUTTER SPEED: 1/50 sec APERTURE: f/2.8 ISO: 1600

P. 159 Bin Yu LOCATION: Luwan, Shanghai Shi, China CAMERA: Canon EOS 5D Mark III FOCAL LENGTH: 24mm SHUTTER SPEED: 47 sec APERTURE: f/13 ISO: 50

PP. 160–161 Tony Ramos LOCATION: Munich, Bavaria, Germany CAMERA: Nikon D3200 FOCAL LENGTH: 18mm SHUTTER SPEED: 1/13 sec APERTURE: f/13 ISO: 800

P. 162 Richard Vdovjak LOCATION: Huangshan, China *

P. 163 Sigita Sica LOCATION: Riga, Latvia CAMERA: Pentax K100D Super FOCAL LENGTH: 43mm SHUTTER SPEED: 1/90 sec APERTURE: f/8 ISO: 200

PP. 164–165 Mat Rick LOCATION: San Francisco, California CAMERA: Canon EOS 5D Mark II FOCAL LENGTH: 35mm SHUTTER SPEED: 1/50 sec APERTURE: f/2.8 ISO: 800

BIODIVERSITY
PP. 166–167 Azim Mustag LOCATION: Maldives CAMERA: Nikon D90 FOCAL LENGTH: 12mm SHUTTER SPEED: 1/125 sec APERTURE: f/8 ISO: 200

P. 169 Rafael Pires LOCATION: Portugal CAMERA: Canon EOS 400D FOCAL LENGTH: 17mm SHUTTER SPEED: 1/800 sec APERTURE: f/2.8 ISO: 800

PP. 170–171 Sebastian-Alexander Stamatis LOCATION: Denmark *

P. 172 Shai Oron LOCATION: Eilat, Southern District, Israel CAMERA: Olympus E-PL1 FOCAL LENGTH: 42mm SHUTTER SPEED: 1/160 sec APERTURE: f/11 ISO: 100

• **P. 173 Lucas Firgau** LOCATION: Buabeng-Fiema Monkey Sanctuary, Ghana *

• **PP. 174–175 Vitor Hugo Moura** LOCATION: Lausanne, Vaud, Switzerland *

• **P. 176 Cheryl Burnham** LOCATION: Not available CAMERA: Nikon D700 FOCAL LENGTH: 105mm SHUTTER SPEED: 1/80 sec APERTURE: f/13 **ISO**: 800

• **P. 177 Daiga Robinson** LOCATION: Finse, Norway CAMERA: Nikon COOLPIX P4 FOCAL LENGTH: 7.5mm SHUTTER SPEED: 1/295 sec APERTURE: f/6.1 **ISO**: 50

• **PP. 178–179 Shane Kalyn** LOCATION: Prince George, British Columbia, Canada CAMERA: Nikon D90 FOCAL LENGTH: 70mm SHUTTER SPEED: 1/125 sec APERTURE: f/5.3 **ISO**: 200

FAMILY PORTRAIT
• **PP. 180–181 Monika Strzelecka** LOCATION: Poland CAMERA: Nikon D700 FOCAL LENGTH: 35mm SHUTTER SPEED: 1/100 sec APERTURE: f/6.3 **ISO**: 1250

• **P. 183 Marc Manabat** LOCATION: North Hollywood, California CAMERA: Fujifilm X100S FOCAL LENGTH: 23mm SHUTTER SPEED: 1/500 sec APERTURE: f/2.8 **ISO**: 1600

• **PP. 184–185 Vasile Tomoiaga** LOCATION: Bucharest, Romania CAMERA: Canon EOS 1000D FOCAL LENGTH: 18mm SHUTTER SPEED: 1/200 sec APERTURE: f/5.6 **ISO**: 800

• **P. 186 Adelina Iliev** LOCATION: Burgas, Bulgaria CAMERA: Canon EOS 5D Mark II FOCAL LENGTH: 28mm SHUTTER SPEED: 1/13 sec APERTURE: f/5 **ISO**: 1000

• **P. 187 Adrian Crapciu** LOCATION: Not available CAMERA: Canon EOS 60D FOCAL LENGTH: 24mm SHUTTER SPEED: 1/1600 sec APERTURE: f/2.8 **ISO**: 160

• **PP. 188–189 Sean Scott** LOCATION: Gold Coast, Queensland, Australia CAMERA: Canon EOS 5D Mark III FOCAL LENGTH: 14mm SHUTTER SPEED: 1/640 sec APERTURE: f/13 **ISO**: 200

• **P. 190 Andrew Lever** LOCATION: Bournemouth, England, United Kingdom CAMERA: Nikon D200 FOCAL LENGTH: 55mm SHUTTER SPEED: 1/320 sec APERTURE: f/5.6 **ISO**: 100

• **P. 191 Karine Puret** LOCATION: Paris, France CAMERA: Canon EOS 5D Mark II FOCAL LENGTH: 35mm SHUTTER SPEED: 1/60 sec APERTURE: f/4.5 **ISO**: 125

• **PP. 192–193 Abir Choudhury** LOCATION: Calcutta, West Bengal, India CAMERA: Nikon D90 FOCAL LENGTH: 18mm SHUTTER SPEED: 1/400 sec APERTURE: f/4 **ISO**: 200

THE MOMENT
• **PP. 194–195 Diego Fabriccio Diaz Palomo** LOCATION: Acatenango Volcano, Guatemala CAMERA: Canon EOS Rebel T3 FOCAL LENGTH: 18mm SHUTTER SPEED: 89 sec APERTURE: f/4.5 **ISO**: 100

• **P. 197 Betty Catharine Hygrell** LOCATION: Tengboche Monastery, Nepal CAMERA: Leica V-LUX 20 FOCAL LENGTH: 8.5mm SHUTTER SPEED: 1/30 sec APERTURE: f/3.8 **ISO**: 500

• **PP. 198–199 Christy Dickinson-Davis** LOCATION: Denver, Colorado CAMERA: Canon EOS Rebel T3 FOCAL LENGTH: 50mm SHUTTER SPEED: 1/500 sec APERTURE: f/1.8 **ISO**: 200

• **P. 200 Barbara Beltramello** LOCATION: Itaparica Island, Bahia, Brazil CAMERA: Nikon D5000 FOCAL LENGTH: 38mm SHUTTER SPEED: 1/2500 sec APERTURE: f/4.8 **ISO**: 200

• **P. 201 Bridgena Barnard** LOCATION: Kgalagadi, Botswana CAMERA: Nikon D700 FOCAL LENGTH: 850mm SHUTTER SPEED: 1/4000 sec APERTURE: f/6.7 **ISO**: 1600

• **PP. 202–203 Sebastião Correia de Campos** LOCATION: Monte Estoril, Lisbon, Portugal *

• **P. 204 Pyiet Oo Aung** LOCATION: Ngwe Saung Beach, Pathein, Ayeyarwady, Myanmar *

• **P. 205 J. Goodman** LOCATION: Venice Beach, California CAMERA: Canon EOS Rebel T3i FOCAL LENGTH: 110mm SHUTTER SPEED: 1/800 sec APERTURE: f/4.5 **ISO**: 200

• **PP. 206–207 Courtney Platt** LOCATION: George Town, Cayman Islands *

EMBRACE THE UNTAMED
• **PP. 208–209 Ido Meirovich** LOCATION: Ne'ot Mordekhay, Northern District, Israel CAMERA: Nikon D300 FOCAL LENGTH: 190mm SHUTTER SPEED: 1/500 sec APERTURE: f/5.6 **ISO**: 280

• **P. 211 Terry Shapiro** LOCATION: Livermore, Colorado CAMERA: Nikon D700 FOCAL LENGTH: 58mm SHUTTER SPEED: 1/90 sec APERTURE: f/8 **ISO**: 200

• **PP. 212–213 Ian Rutherford** LOCATION: Etosha National Park, Namibia CAMERA: Canon EOS 7D FOCAL LENGTH: 289mm SHUTTER SPEED: 1/1600 sec APERTURE: f/10 **ISO**: 2000

• **P. 214 Paul Weeks** LOCATION: Rhododendron, Oregon *

• **P. 215 Jeremy Aerts** LOCATION: Daegu, South Korea CAMERA: Sony NEX-5N FOCAL LENGTH: 69mm SHUTTER SPEED: 1/125 sec APERTURE: f/5.6 **ISO**: 1250

• **PP. 216–217 Manish Mamtani** LOCATION: Joshua Tree National

- **P. 259 Anibal Trejo** LOCATION: Sant Quintí de Mediona, Catalonia, Spain *

- **PP. 260–261 Tracey Buyce** LOCATION: Lake George, New York CAMERA: Canon EOS5D Mark III FOCAL LENGTH: 35mm SHUTTER SPEED: 1/800 sec APERTURE: f/2.5 ISO: 1600

- **P. 262 Somnath Chakraborty** LOCATION: Calcutta, West Bengal, India CAMERA: Nikon D7000 FOCAL LENGTH: 12mm SHUTTER SPEED: 1/1000 sec APERTURE: f/6.3 ISO: 200

- **P. 263 John Warner** LOCATION: Indianapolis, Indiana *

IMAGINE IF
- **PP. 264–265 Ann Nygren** LOCATION: Not available CAMERA: Nikon D5000 FOCAL LENGTH: 38mm SHUTTER SPEED: 1/400 sec APERTURE: f/10 ISO: 200

- **P. 267 James Hilgenberg** LOCATION: Oberstdorf, Bavaria, Germany *

- **PP. 268–269 Migz Nthigah** LOCATION: Lamu, Kenya CAMERA: Nikon D5100 FOCAL LENGTH: 18mm SHUTTER SPEED: 1/200 sec APERTURE: f/7.1 ISO: 640

- **P. 270 Jacob W. Frank** LOCATION: Denali National Park, Alaska CAMERA: Canon EOS 5D Mark II FOCAL LENGTH: 29mm SHUTTER SPEED: 1/160 sec APERTURE: f/4 ISO: 400

- **P. 271 Helēna Spridzāne** LOCATION: Berǵi, Riga, Latvia CAMERA: Canon EOS 600D FOCAL LENGTH: 50mm SHUTTER SPEED: 1/30 sec APERTURE: f/0 ISO: 200

- **PP. 272–273 Vineeth Rajagopal** LOCATION: Fairbanks, Alaska CAMERA: Canon EOS Rebel T2i FOCAL LENGTH: 10mm SHUTTER SPEED: 1/200 sec APERTURE: f/14 ISO: 400

- **P. 274 Tommy Seo** LOCATION: United States CAMERA: Canon EOS 5D Mark III FOCAL LENGTH: 24mm SHUTTER SPEED: 1/200 sec APERTURE: f/1.4 ISO: 250

- **P. 275 Claire Robinson** LOCATION: Sahara CAMERA: Panasonic DMC-TZ30 FOCAL LENGTH: 9.7mm SHUTTER SPEED: 1/640 sec APERTURE: f/4.6 ISO: 100

- **P. 276 James Abbott** LOCATION: Scone, New South Wales, Australia CAMERA: Nikon D5100 FOCAL LENGTH: 11mm SHUTTER SPEED: 1/40 sec APERTURE: f/9 ISO: 100

Acknowledgments

National Geographic Books would like to thank our talented colleagues at Your Shot, Monica Clare Corcoran, Jeanne Modderman, Stephen Mefford, and Keith Jenkins, who have been tremendous partners in creating this book, and who nurture and inspire the Your Shot photography community every day. Many thanks to National Geographic photographer Lynn Johnson for her beautiful introduction, and for lending us her expertise in the creation of this book. We would also like to extend our deepest appreciation to the National Geographic photographers and experts who participated in this book: John Burcham, Diane Cook, Penny De Los Santos, Jay Dickman, Peter Essick, Ben Fitch, Becky Hale, Evelyn Hockstein, Len Jenshel, Ed Kashi, Alexa Keefe, Elizabeth Krist, David Liittschwager, Sarah Polger, Sadie Quarrier, Cory Richards, Robin Schwartz, Maggie Steber, Mark Thiessen, and Susan Welchman. You are all the heart and soul of this book.

Getting Your Shot

Prepared by the Book Division

Hector Sierra, *Senior Vice President and General Manager*

Lisa Thomas, *Senior Vice President and Editorial Director*

Jonathan Halling, *Creative Director*

Marianne R. Koszorus, *Design Director*

Robin Terry-Brown, *Senior Editor*

R. Gary Colbert, *Production Director*

Jennifer A. Thornton, *Director of Managing Editorial*

Susan S. Blair, *Director of Photography*

Meredith C. Wilcox, *Director, Administration and Rights Clearance*

Staff for This Book

Elisa Gibson, *Art Director*

Patrick Bagley, *Illustrations Editor*

Michelle Cassidy, Zachary Galasi, *Editorial Assistants*

Marshall Kiker, *Associate Managing Editor*

Judith Klein, *Senior Production Editor*

Lisa A. Walker, *Production Manager*

Galen Young, *Rights Clearance Specialist*

Katie Olsen, *Design Production Specialist*

Nicole Miller, *Design Production Assistant*

Bobby Barr, *Manager, Production Services*

Rahsaan Jackson, *Imaging*

Since 1888, the National Geographic Society has funded more than 12,000 research, exploration, and preservation projects around the world. National Geographic Partners distributes a portion of the funds it receives from your purchase to National Geographic Society to support programs including the conservation of animals and their habitats.

National Geographic Partners
1145 17th Street NW
Washington, DC 20036-4688 USA

Become a member of National Geographic and activate your benefits today at natgeo.com/jointoday.

For information about special discounts for bulk purchases, please contact National Geographic Books Special Sales: specialsales@natgeo.com

For rights or permissions inquiries, please contact National Geographic Books Subsidiary Rights: bookrights@natgeo.com

ISBN 978-1-4262-1870-5 (special sales edition)

Library of Congress Cataloging-in-Publication Data
Getting your shot : stunning photos, how-to tips, and endless inspiration from the pros.
 pages cm
Includes bibliographical references.
 ISBN 978-1-4262-1534-6 (paperback)
 1. Photography--Miscellanea. 2. Photography--Technique. 3. Photography, Artistic. I. National Geographic Society (U.S.)
 TR146.G45 2015
 303.3--dc23
 2014047188

Printed in China
17/RRDS/1

Additional Credits

Front cover: (birds in hand) Lynn Johnson/National Geographic Creative; (horses) Verdrana Tafra; (dog) Raffaele Montepaone. Back cover: (otters) Roman Golubenko. Interior: 11, Lynn Johnson/National Geographic Creative; 20, Sashkin/Shutterstock; 21, MrGarry/Shutterstock; 24 (LE), tap10/iStockphoto; 24 (RT), servickuz/iStockphoto; 25 (LE), ekinyalgin/iStockphoto; 25 (RT), LeventKonuk/iStockphoto.com.

NATIONAL GEOGRAPHIC

WELCOME TO THE WORLD'S
PHOTO HUB

YOURSHOT.NATIONALGEOGRAPHIC.COM

Welcome to Your Shot, National Geographic's photo community. Our mission is to tell stories collaboratively through big, bold photography and expert curation. Get tips from National Geographic photographers. Go on assignments created by our editors. Be published by National Geographic.

THIS IS YOUR SHOT. JOIN THE COMMUNITY TODAY.

There are more ways than ever to get involved in our vibrant photography community. Share your best shots with us or take an online course. Browse through galleries and gorgeous books. Take a photo trip or workshop. Join us!

For photo fiends everywhere, visit National Geographic at PROOF.nationalgeographic.com, NATGEOFOUND.tumblr.com, INSTAGRAM.com/natgeo, NATGEOCOURSES.com, and NGEXPEDITIONS.com.

CHECK OUT OUR PHOTOGRAPHY BOOKS FOR INSPIRATION AND WONDER.

AVAILABLE WHEREVER BOOKS ARE SOLD